DRAWING CRIME NOIR

FOR COMICS & GRAPHIC NOVELS

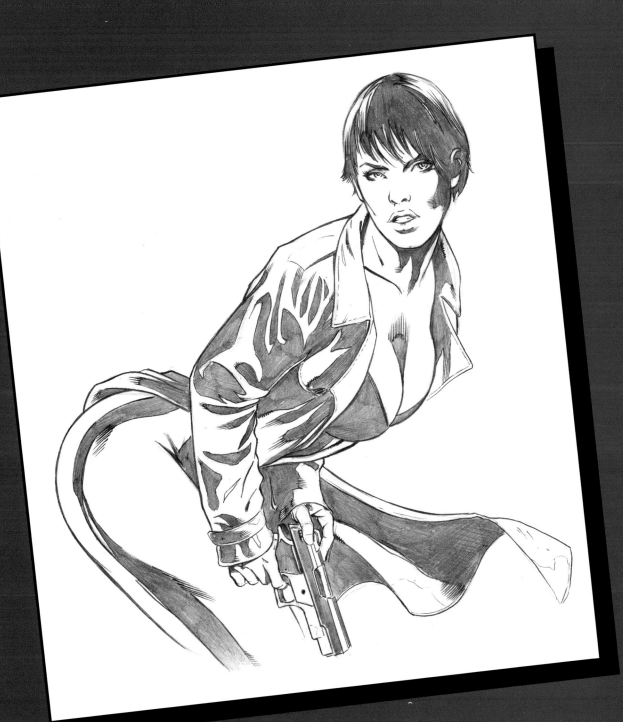

DRAWING CRIME NOIR

FOR COMICS & GRAPHIC NOVELS

CHRISTOPHER HART

WATSON-GUPTILL PUBLICATIONS/NEW YORK

FOR A BROWN-EYED GIRL I MET IN A SMALL PLACE
ON THE EAST SIDE OF THE CITY.
IT'S ALWAYS BEEN YOU.

Executive Editor: Candace Raney
Editor: Michelle Bredeson
Design and color: MADA Design, Inc.

First published in 2006 by Watson-Guptill Publications,
a division of VNU Business Media, Inc.,
770 Broadway, New York, NY 10003
www.wgpub.com

Library of Congress Cataloging-in-Publication Data

Hart, Christopher.
 Drawing crime noir for comics and graphic novels / Christopher Hart.
 p. cm.
 ISBN-13: 978-0-8230-2399-8 (alk. paper)
 ISBN-10: 0-8230-2399-0 (alk. paper)
 1. Comic books, strips, etc.—Technique. 2. Drawing—Technique. 3. Film noir—Influence. I. Title.
 NC1764.H356 2006
 741.5—dc22

 2005030906

Printed in China

1 2 3 4 5 6 7 8 9 / 14 13 12 11 10 09 08 07 06

Contributing Artists:
Darryl Banks: Cover, 8–33
Clint Helinski: 110–113
Min Ku: 35–46, 114–119, 122–125, 142–143
Fabiano Neves: 1, 47–63, 66–67, 72–75, 136–141
Lou Manna: 34, 126–135
Carlo Pagulayan: 64–65, 82–90, 92–109
Kevin Sharpe: 68–71, 76–80, 120

Visit us at www.artstudiollc.com

CONTENTS

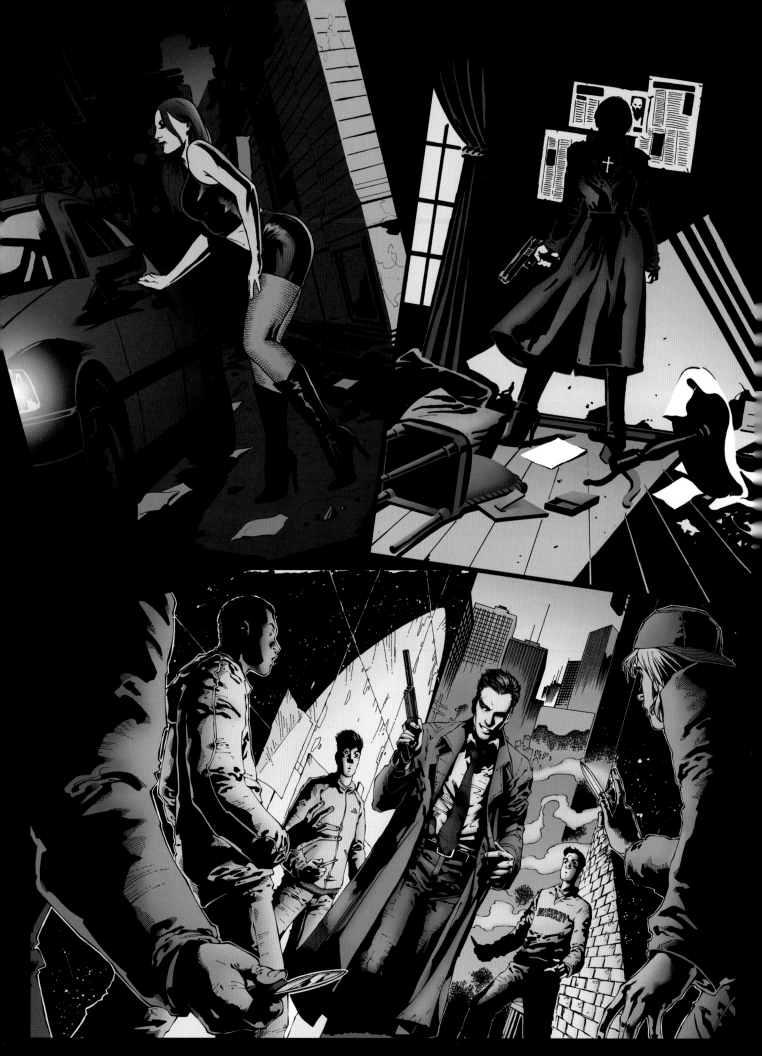

Crime noir is the most exciting and dangerous comic book style today. It's a modern take on a genre originally popularized by writers such as Jim Thompson and Raymond Chandler and films such as *The Maltese Falcon, The Asphalt Jungle,* and *The Sweet Smell of Success.* Modern crime noir is exploding in popularity through hit movies such as *Batman Begins* and graphic novels such as Frank Miller's *Sin City, A History of Violence,* and *Road to Perdition,* all of which have been made into star-packed major motion pictures. This genre focuses on the slick, rainswept streets of the city, shadowy figures, heartless women, men without conscience, reluctant heroes, and boulevards of fear. It's the desperation of ordinary men, and the loneliness of the action hero.

This book teaches the aspiring artist, as well as those with considerable drawing experience, how to create the stylish, moody world of crime noir. Extensive instruction is offered in the use of shadows and light to create suspense and intensity. And then there are the darkly charismatic characters and costumes of noir—the trench coats and sunglasses; the hit men who keep order in the city; the sexy women who would just as soon kill you as kiss you; the brooding costumed heroes; and more. You'll learn how to turn an ordinary comic book scene into a crime-noir scene, and how to draw the weapons criminals use to make crime pay.

Any book about the art of crime noir would be incomplete if it were only about the principles of drawing. Mood. Atmosphere. Style. They're what crime noir is all about. Style so thick you can cut it with a knife. Attitude so cynical, a smile looks the same as a snarl. Sure, we'll dive into all the techniques that make characters, scenes, and compositions great, but unlike other books on art instruction, we're going to enter the entire world of the genre, with its slang and first-person narrative tough talk. Along the way, we'll discover the storylines that accompany these sordid character types, and the secret agendas they keep hidden behind their opaque sunglasses, which will give you the ability to begin thinking about creating your own graphic novels and comics. So think of this as your own personal guided tour down the alleyways and side streets of a city called fear.

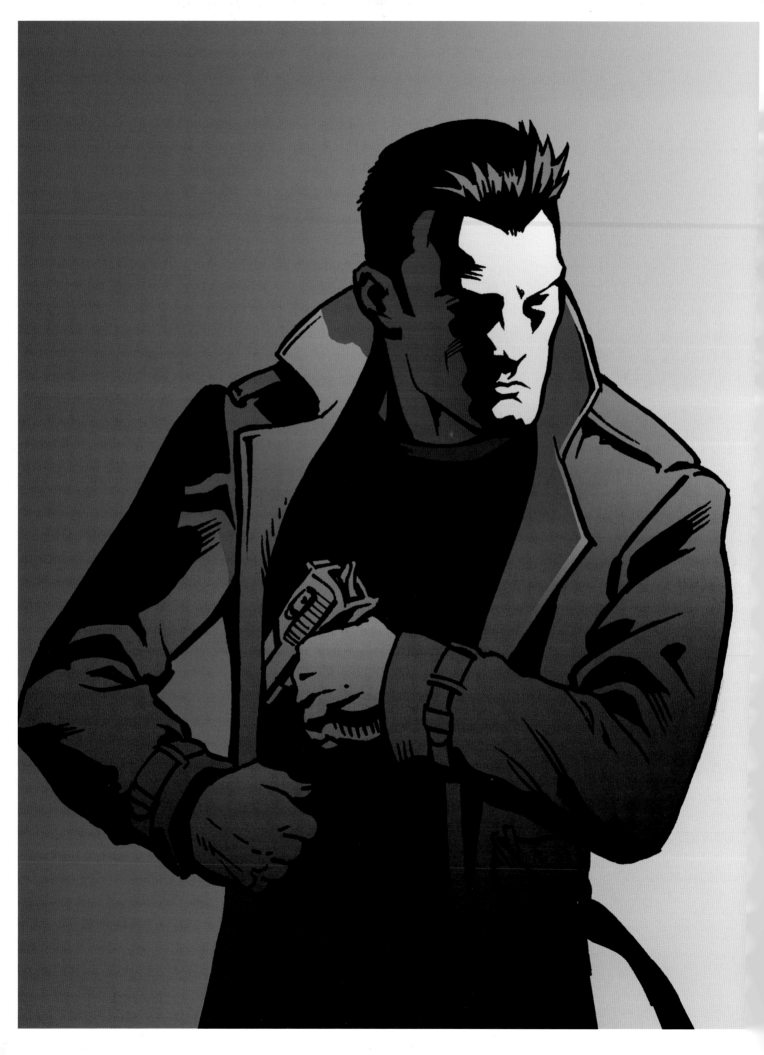

The Players

1

Yeah, that's me. The guy in the trench coat. I guess that makes me the hero of this book, if you wanna call me that. It's just that the last guy they called a hero ended up at room temperature. Listen, there are lots of comic artists. Not many of them can handle the streets of the cities I walk through, the streets that make up the hottest genre in comic books and graphic novels.

If you think you've got the guts to draw crime noir, pick up a pencil and I'll show you how. But stay close. There are a million ways to get lost in this city. That's why I made a special request that this section get broken down into basic parts. My request met with some initial resistance, but I can be very persuasive when I want. I helped the author to see my point. He came around.

First, we've got to chisel out a toughened face, one that's seen too much, one that hasn't been able to forget. Rugged cheekbones, deeply set eyes, a tight mouth, and a square chin give this character a dramatic look.

FRONT VIEW

SUNKEN AREAS

SUNKEN AREA

SHORTLY CROPPED HAIR

TEMPORAL LINE (LINE OF FOREHEAD)

GRIMACE BRINGS UP CHIN MUSCLE.

TRENCH COAT COLLAR UP

MUSCULAR DEFINITION IN FACE

THE EYE SOCKET IS A SUNKEN AREA, SET DEEP IN THE SKULL.

THE MALE HEAD IN PROFILE

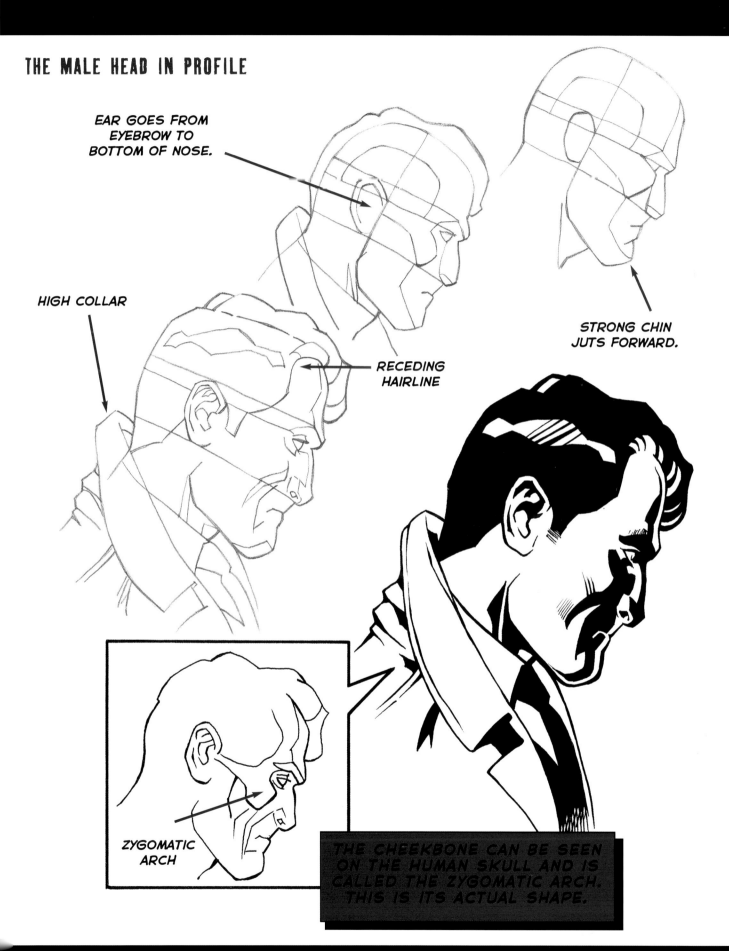

EAR GOES FROM EYEBROW TO BOTTOM OF NOSE.

HIGH COLLAR

RECEDING HAIRLINE

STRONG CHIN JUTS FORWARD.

ZYGOMATIC ARCH

THE CHEEKBONE CAN BE SEEN ON THE HUMAN SKULL AND IS CALLED THE ZYGOMATIC ARCH. THIS IS ITS ACTUAL SHAPE.

PIERCING EYES

Look into his eyes. What do you see? Small, black pools with flecks of light off to the sides. The tops of the eyeballs are cut off by heavy eyelids, creating a mild melancholy, while the downward tilt of the eyebrow adds an aggressive accent. It is a haunted look. Bleak. A man with such eyes is possessed by unseen demons. Somewhere deep in his hardened heart is an ache that has never healed.

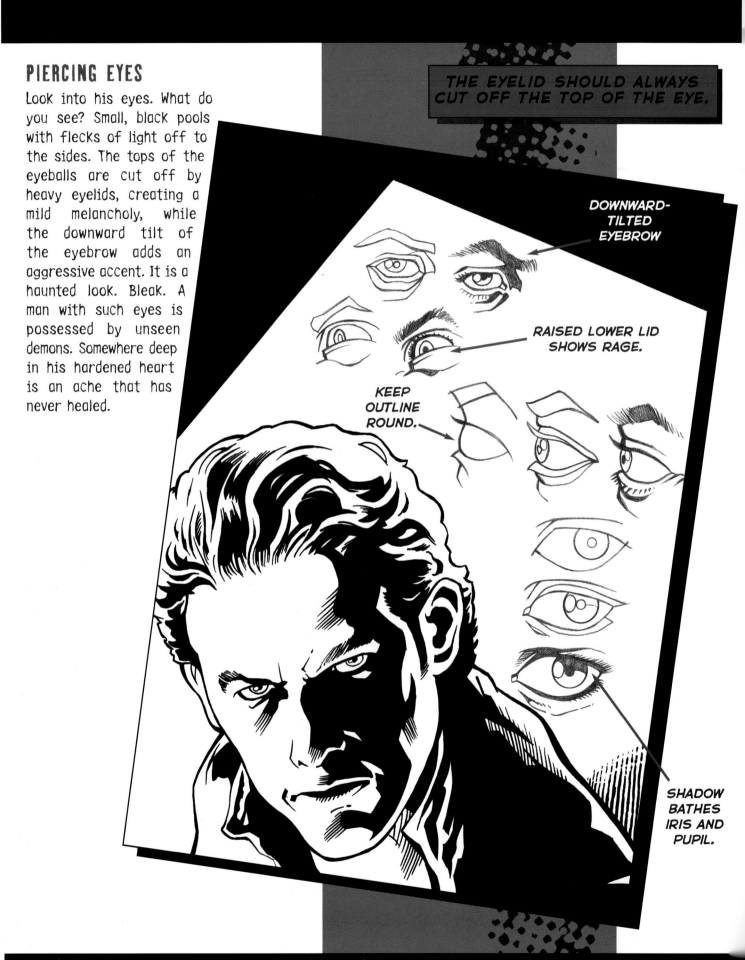

THE EYELID SHOULD ALWAYS CUT OFF THE TOP OF THE EYE.

DOWNWARD-TILTED EYEBROW

RAISED LOWER LID SHOWS RAGE.

KEEP OUTLINE ROUND.

SHADOW BATHES IRIS AND PUPIL.

THE MALE NOSE

I always say the nose is the toughest feature to draw, because there are so many subtle angles. I've seen lots of comic artists go by the wayside because they've underestimated the job.

Keep this in mind: These diagrams are meant to give you an understanding of the construction of the nose. Your drawing should be more natural, more fluid, less geometric. But if your drawing starts looking weird, go back and recheck these diagrams. Looking at the basic structure of the nose will help you figure out where you went off course.

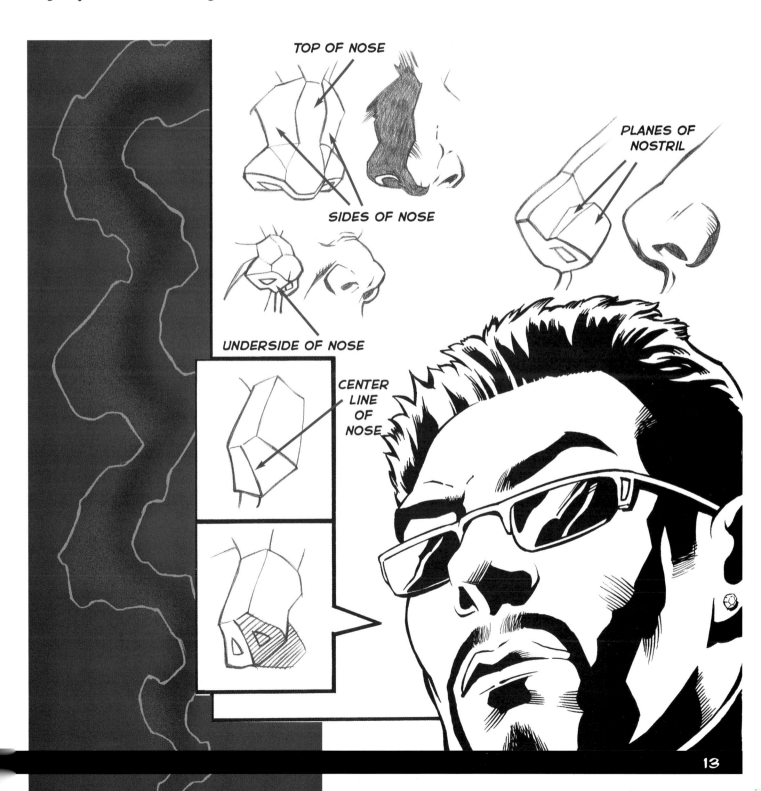

TOP OF NOSE

SIDES OF NOSE

PLANES OF NOSTRIL

UNDERSIDE OF NOSE

CENTER LINE OF NOSE

EXPRESSIVE MOUTHS

Fury, blood curdling screams, snarls, sneers, and dark smiles. For most people, they're the stuff of nightmares. For me, it's all in a day's work. If you want to play with the big boys, you have to be able to draw this way. Raw emotions. Bitter ironies. Check out the secrets on this page. You're gonna need them before we move on to more dangerous ground.

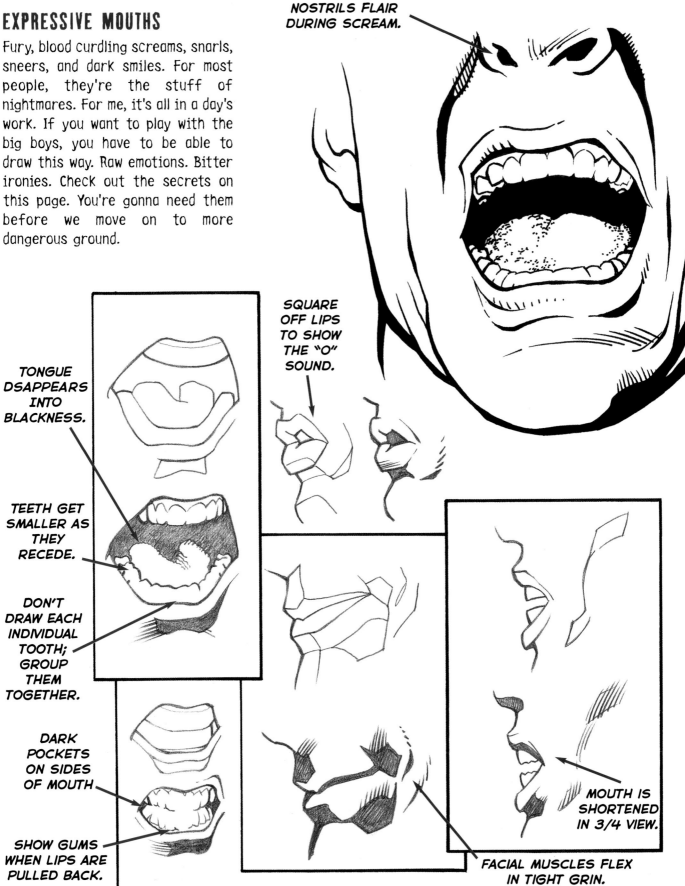

NOSTRILS FLAIR DURING SCREAM.

TONGUE DSAPPEARS INTO BLACKNESS.

TEETH GET SMALLER AS THEY RECEDE.

DON'T DRAW EACH INDIVIDUAL TOOTH; GROUP THEM TOGETHER.

SQUARE OFF LIPS TO SHOW THE "O" SOUND.

DARK POCKETS ON SIDES OF MOUTH

SHOW GUMS WHEN LIPS ARE PULLED BACK.

MOUTH IS SHORTENED IN 3/4 VIEW.

FACIAL MUSCLES FLEX IN TIGHT GRIN.

Crime noir isn't just about shadows or danger. It's also about attitude. Attitude that comes not just from the way that you draw an expression, but the way you present the character. Look at this finished, inked drawing of a beautiful female, who is looking at us as an animal looks at its prey. Besides the expression itself, what do you notice that gives her a dark charisma? Two things: Her head is angled so that she's looking *down* at us;

and her head is also cocked to the side. These two elements put her in the driver's seat, in a position to check us out. She is in control. She's a woman with a plan. And it won't end pretty—for her victim.

FRONT VIEW (3/4 ANGLE)

SHOW UNDERSIDE OF NOSE.

HIGH CHEEKBONES ARE ATTRACTIVE.

BRIDGE OF NOSE IS SHORTENED DUE TO PERSPECTIVE ("FORESHORTENING").

SHOW UNDERSIDE OF JAW.

SQUARE OUT BOTTOM OF CHIN IN A LOW-ANGLE POSE.

SQUARE OUT BOTTOM OF LOWER LIP.

THE FEMALE FACE IN PROFILE

A profile, strictly speaking, should show only one eye, because it's a straight side view. But we're not boy scouts here. Sometimes we cheat a little. It looks good to add a bit of the far eye—or sunglasses, as is the case here—to make the face look rounder, not so flat. Remember, eyeglasses and sunglasses are worn low on the face: They don't hide the eyebrows.

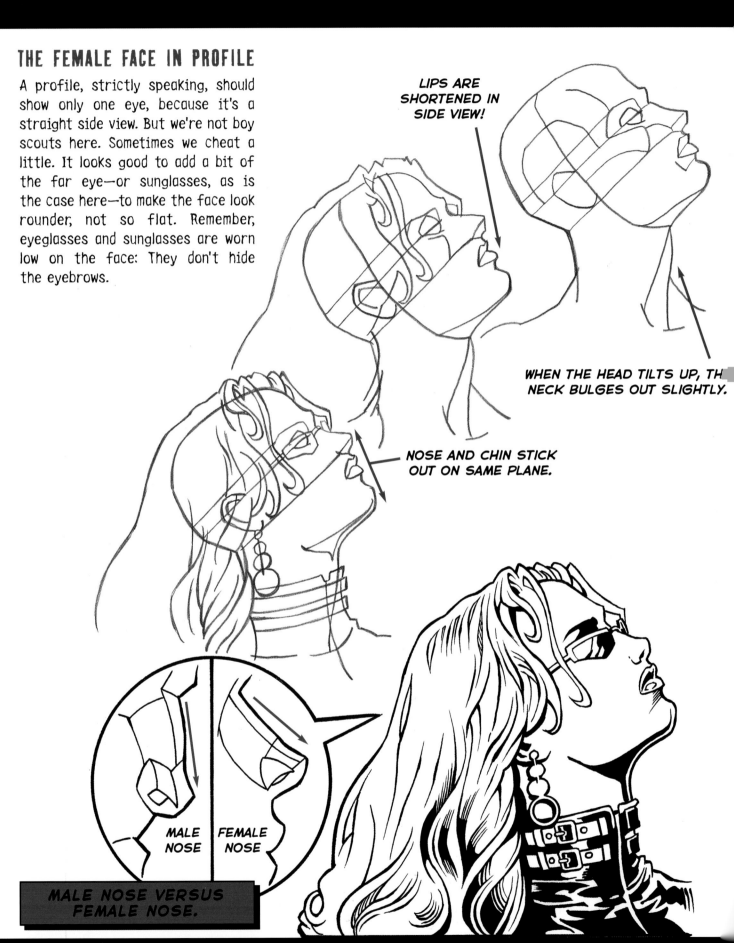

LIPS ARE SHORTENED IN SIDE VIEW!

WHEN THE HEAD TILTS UP, TH[E] NECK BULGES OUT SLIGHTLY.

NOSE AND CHIN STICK OUT ON SAME PLANE.

MALE NOSE

FEMALE NOSE

MALE NOSE VERSUS FEMALE NOSE.

EYES THAT DECEIVE

You could look into her eyes forever. Beautiful, smoldering bedroom eyes. They're eyes that have seen a lot of bad, but they still know how to well up at just the right moment, causing a man to let down his guard just long enough to find himself floating face down in the East River.

The key to drawing eyes of deception is threefold: pupils that hide halfway under the upper eyelids; eyelashes that sweep away from the eyes; and a deep shadow cast just under the eyelid, bathing the upper half of the pupil and the iris in blackness.

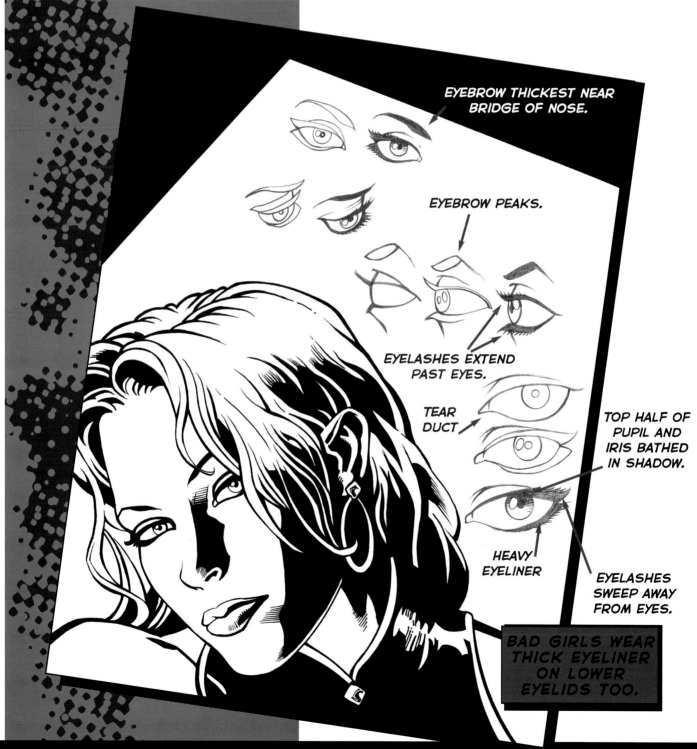

EYEBROW THICKEST NEAR BRIDGE OF NOSE.

EYEBROW PEAKS.

EYELASHES EXTEND PAST EYES.

TEAR DUCT

TOP HALF OF PUPIL AND IRIS BATHED IN SHADOW.

HEAVY EYELINER

EYELASHES SWEEP AWAY FROM EYES.

BAD GIRLS WEAR THICK EYELINER ON LOWER EYELIDS TOO.

THE FEMALE NOSE

You need a delicate touch to draw the female nose. What you leave out is as important as what you include. Some artists leave out the bridge of the nose altogether. Others leave out the covers of the nostrils, indicating only the holes. There are a million ways to draw it, which is what artists like to call "style." Comics are style. I'm not one of those guys to teach only the basics. You want just the basics, your local arts center will show you how to draw the figure. And bowls of fruit. If you like that kind of stuff.

The main thing to remember when drawing the nose is that it's a three-dimensional object stuck on top of the face. It's got its own sides and planes.

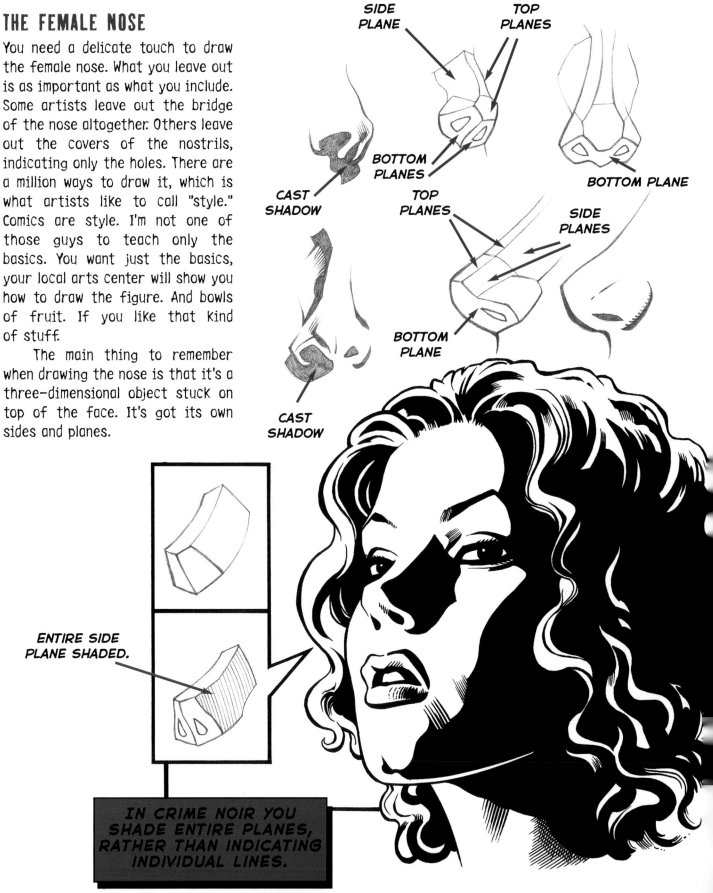

SIDE PLANE

TOP PLANES

BOTTOM PLANES

BOTTOM PLANE

CAST SHADOW

TOP PLANES

SIDE PLANES

BOTTOM PLANE

CAST SHADOW

ENTIRE SIDE PLANE SHADED.

IN CRIME NOIR YOU SHADE ENTIRE PLANES, RATHER THAN INDICATING INDIVIDUAL LINES.

KISS ME BEFORE YOU DIE— DRAWING FEMALE LIPS

It's been the fashion for the better part of two decades for women, especially in the West Side of Los Angeles, to inject their upper lips with collagen. The upper lip becomes unnaturally larger than the lower lip. This phony look isn't part of the down-to-earth, mean and gritty world of crime noir. Crime noir is a modern reinvention of the 1950s hardboiled detective genre, when the leading lady had luscious lips, and the lower lip glistened with moisture. That was damn sexy back then. And it's damn sexy now.

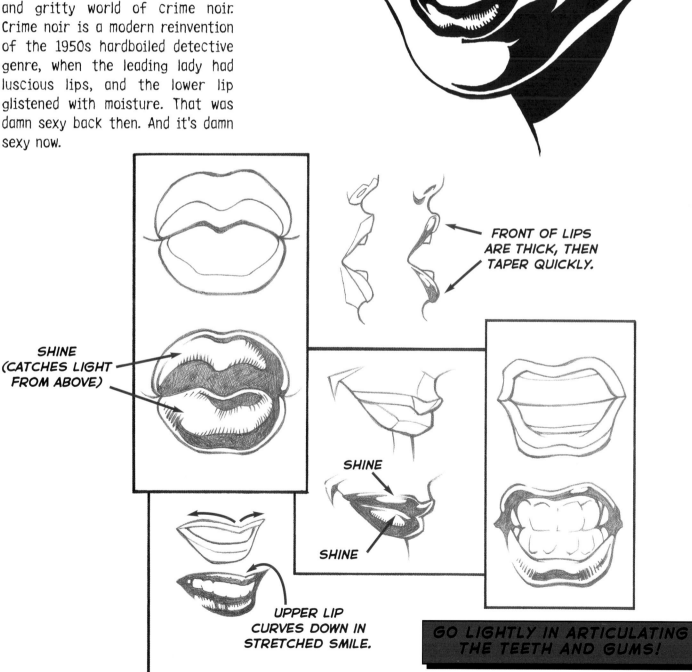

FRONT OF LIPS ARE THICK, THEN TAPER QUICKLY.

SHINE (CATCHES LIGHT FROM ABOVE)

SHINE

SHINE

UPPER LIP CURVES DOWN IN STRETCHED SMILE.

GO LIGHTLY IN ARTICULATING THE TEETH AND GUMS!

You can hide behind a pair of sunglasses, and no one can see who you're looking at, or tell what you're thinking. You see it a lot on the tough streets of the city. Hardened characters wear sunglasses even in the shadows. Scares the hell out of people to see a guy in a trench coat with a gun and sunglasses. Imagine him walking out of the darkness, calling your name, saying that you owe his boss the vig, knowing that you don't have it, knowing that only one of you is going to walk out of that alley alive.

Sunglasses, like any fashion, are a matter of personal taste. Even hired killers like to make an impression. Of course they only need to make it once. Some eyewear makes you look retro, some are futuristic, some can even make you look like a cop. Just make sure they don't make your character look like a tennis pro.

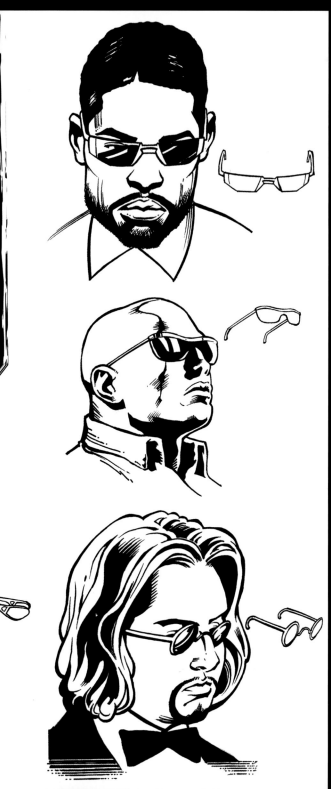

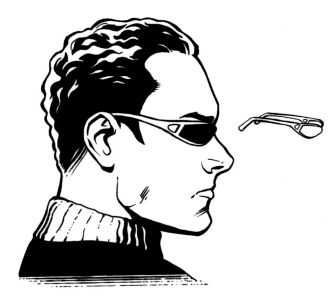

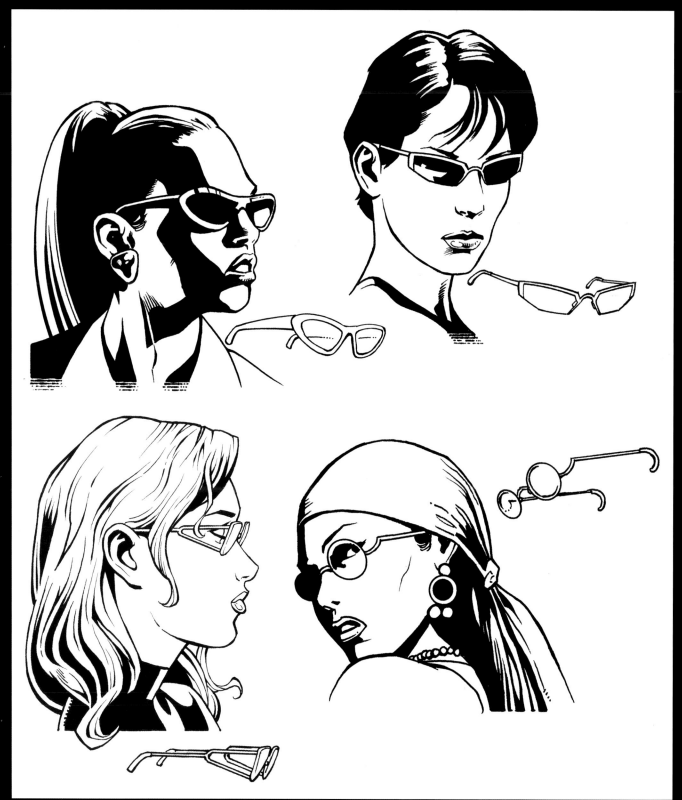

Before we tackle full figure poses, let's take a look at some comparisons. What makes a figure a crime noir figure instead of an ordinary Joe or Jane? It's not in the muscles, or in the proportions, but in the approach. It's style, a style brought about by shadow, attitude, posture, and props.

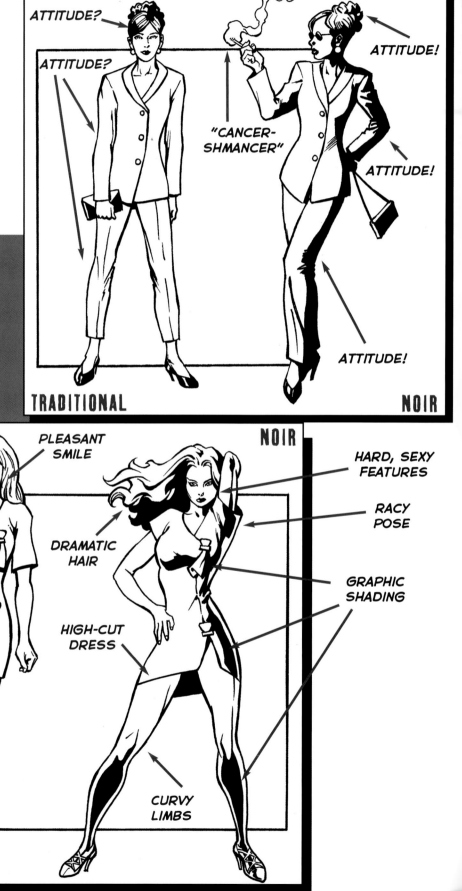

ATTITUDE?

ATTITUDE?

ATTITUDE!

"CANCER-SHMANCER"

ATTITUDE!

ATTITUDE!

TRADITIONAL

NOIR

TRADITIONAL

NOIR

PLEASANT SMILE

HARD, SEXY FEATURES

RACY POSE

HAIR CUT AT A MALL.

DRAMATIC HAIR

GRAPHIC SHADING

HIGH-CUT DRESS

CLOTHES LOOK LIKE THEY WERE PURCHASED FROM A CATALOG.

CURVY LIMBS

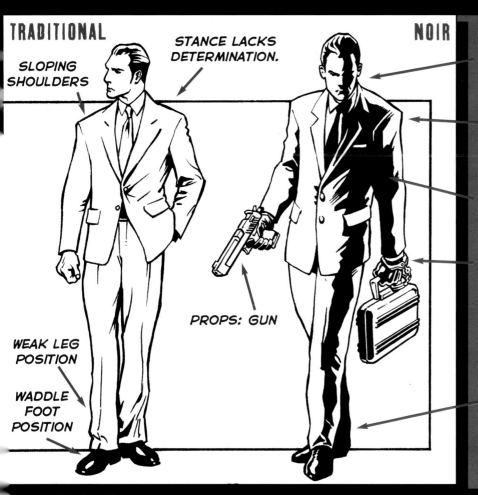

TRADITIONAL

NOIR

SLOPING SHOULDERS

STANCE LACKS DETERMINATION.

DOWNWARD TILT OF HEAD LOOKS PREDATORY.

HIGHER SHOULDERS— PURPOSEFUL POSE

BODY BATHED IN DEEP SHADOW.

PROPS: GUN

PROPS: ATTACHÉ CASE HANDCUFFED TO ARM

WEAK LEG POSITION

WADDLE FOOT POSITION

POSITION OF LEG SHOWS HE IS ON THE MOVE.

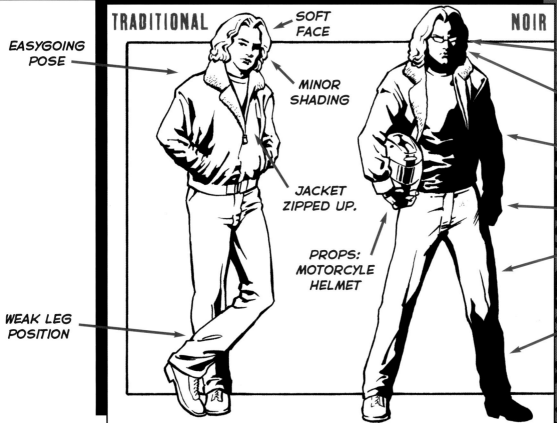

TRADITIONAL

SOFT FACE

NOIR

EASYGOING POSE

SUNGLASSES

MINOR SHADING

HALF OF FACE IN SHADOW.

HALF OF TORSO FALLS INTO BLACKNESS.

JACKET ZIPPED UP.

FIST CLENCHED.

PROPS: MOTORCYLE HELMET

LEGS APART— TOUGHER STANCE

WEAK LEG POSITION

LEG TRAILS OFF INTO SHADOW.

23

Good figure drawing is important in all styles of comic book art. Don't "sketch" a figure with short, choppy strokes. Work with longer, more confident pencil strokes. If you make a mistake, big deal. Most pros don't even bother to erase their mistakes. They just draw over them, then trace over their rough drawings when doing the final art. Most beginners constrict their lines, trying to get it right the first time, like they get points for that or something. Hey, cut yourself a break. I'm not a guy known to go easy on people, but I'm giving it to you straight: The rough sketch isn't the time to draw perfectly. It's the time to draw boldly, to experiment. As you clean it up, you blend it together so that the building blocks aren't as apparent. Then you costume it, and add flair and style. That's when you get into the nuances, and trick it out.

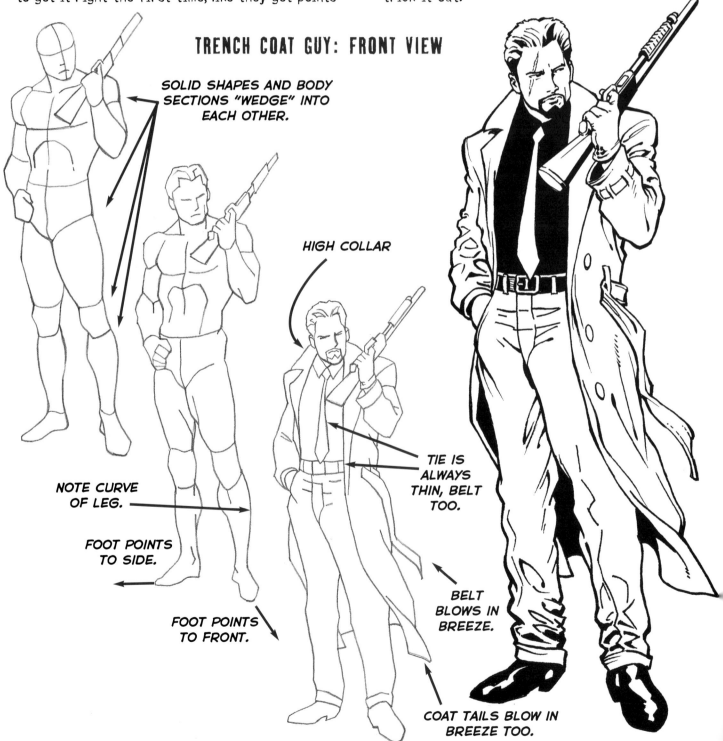

TRENCH COAT GUY: FRONT VIEW

SOLID SHAPES AND BODY SECTIONS "WEDGE" INTO EACH OTHER.

HIGH COLLAR

NOTE CURVE OF LEG.

FOOT POINTS TO SIDE.

FOOT POINTS TO FRONT.

TIE IS ALWAYS THIN, BELT TOO.

BELT BLOWS IN BREEZE.

COAT TAILS BLOW IN BREEZE TOO.

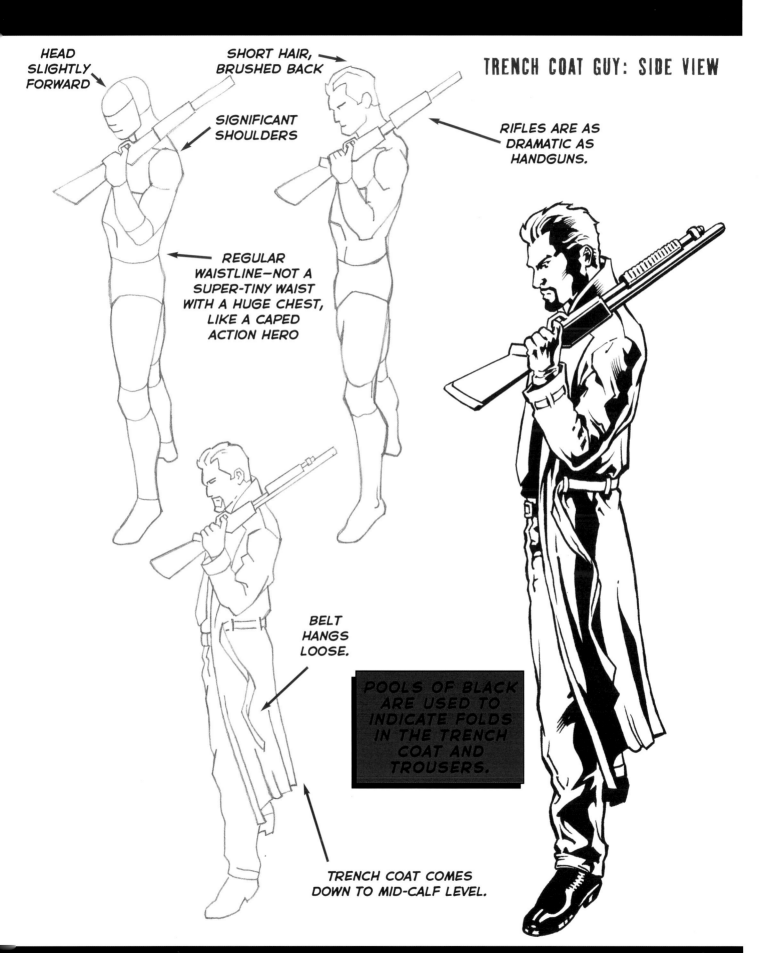

HEAD SLIGHTLY FORWARD

SHORT HAIR, BRUSHED BACK

SIGNIFICANT SHOULDERS

RIFLES ARE AS DRAMATIC AS HANDGUNS.

REGULAR WAISTLINE—NOT A SUPER-TINY WAIST WITH A HUGE CHEST, LIKE A CAPED ACTION HERO

BELT HANGS LOOSE.

POOLS OF BLACK ARE USED TO INDICATE FOLDS IN THE TRENCH COAT AND TROUSERS.

TRENCH COAT COMES DOWN TO MID-CALF LEVEL.

FEMALE ASSASSIN: FRONT VIEW

I don't know what it is with women these days, but the ones who work as hired killers have the best fashion sense. These beauties always visit the salon before a hit goes down. The sexually provocative killer is a well-established character type, which continues to be reinvented, and continues to succeed, in comics, graphic novels, movies, and television. Hey, there are worse ways to die.

Remember what we discussed earlier—the importance of poses with attitude. She can't do the job if she doesn't look confident. Hell, she can't even get the job if she doesn't look confident. You know the look. The one that says, today's your day, pal—your number's up.

WIDE SHOULDERS ADD POWER. BARE SHOULDERS ARE SEXY.

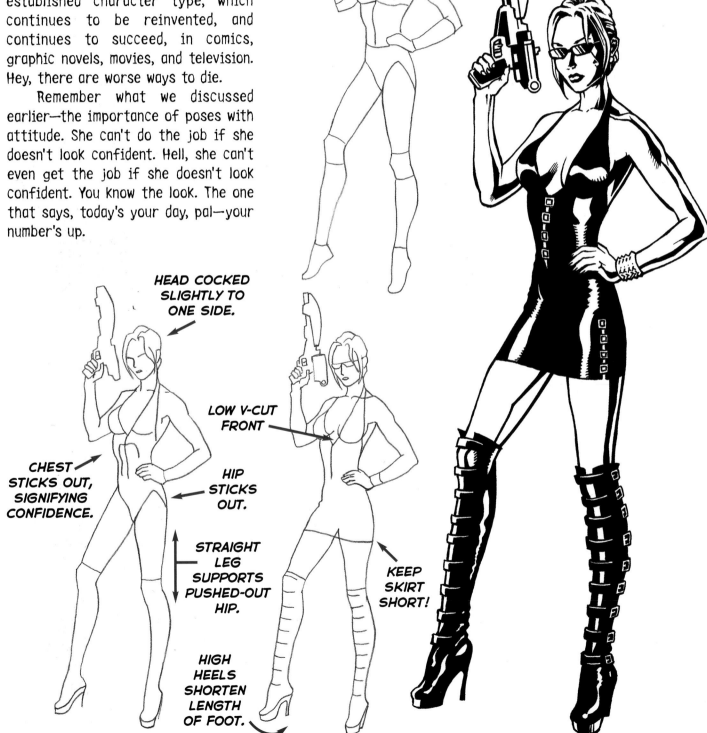

HEAD COCKED SLIGHTLY TO ONE SIDE.

CHEST STICKS OUT, SIGNIFYING CONFIDENCE.

LOW V-CUT FRONT

HIP STICKS OUT.

STRAIGHT LEG SUPPORTS PUSHED-OUT HIP.

KEEP SKIRT SHORT!

HIGH HEELS SHORTEN LENGTH OF FOOT.

FEMALE ASSASSIN: SIDE VIEW

There are only a few times when I lay down hard and fast rules, and this is one of them: Never draw a back as a straight line. This holds especially true for females. If you ever have a chance to look at a real skeleton, or even a model of one, you'll see that the spine is always significantly curved. Even if your character is standing at attention, the spine is still very much curved.

The more curved the back is, the more sultry the pose. With female characters, the place to begin an exaggerated spine curve is at the small of the back. Start by pushing the hips forward. That'll cause the whole body to realign itself in a very slinky posture.

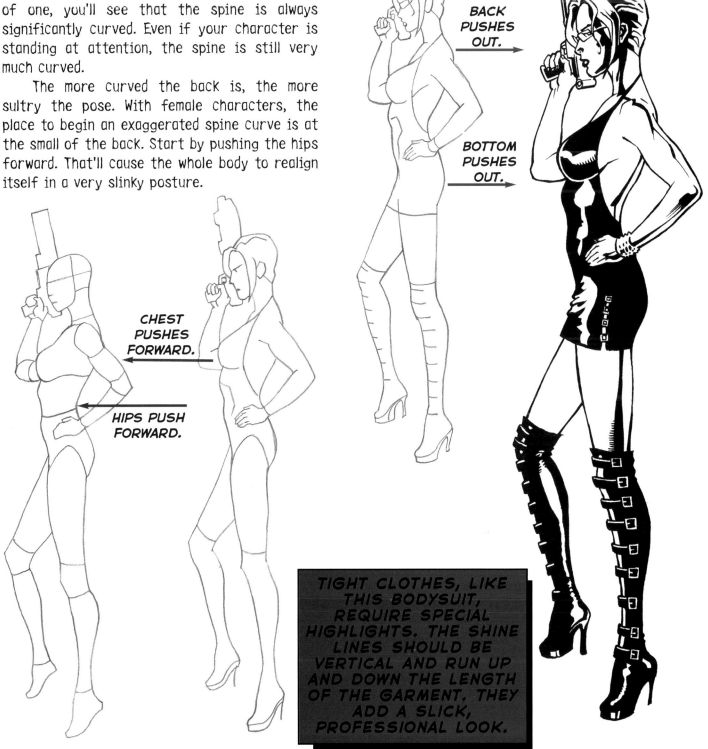

BACK PUSHES OUT.

BOTTOM PUSHES OUT.

CHEST PUSHES FORWARD.

HIPS PUSH FORWARD.

TIGHT CLOTHES, LIKE THIS BODYSUIT, REQUIRE SPECIAL HIGHLIGHTS. THE SHINE LINES SHOULD BE VERTICAL AND RUN UP AND DOWN THE LENGTH OF THE GARMENT. THEY ADD A SLICK, PROFESSIONAL LOOK.

In crime noir, your character isn't usually running around in spandex costumes. More often than not, he's got a trench coat on. Why? Because he's packing heat, for one. Second, it'd be kind of obvious if he were trying to mingle in an after-hours joint wearing a cape and carrying a shield and sword, except in some places in Greenwich Village. So we're in civilian clothes, but the kind that look like they come from a shop in Soho, or even some place in West Los Angeles. But never from a place where kids with iPods and names like Tiffany and Brett are buying the latest name brands.

Real clothes buckle and fold when you bend your arms and knees. They crease and twist when you turn at the waist. They bunch at the shoulders when you raise your arms. Take a look.

THE FOLDS OF THE SLEEVES

Look for simplified patterns in the folds. They're created from the pressure of the bend, like an accordion. Folds are small pockets that form inside the sleeve, and shadows gather there. These folds, or "pockets," do not always close. More often than not, they remain open, never quite completing a closed loop.

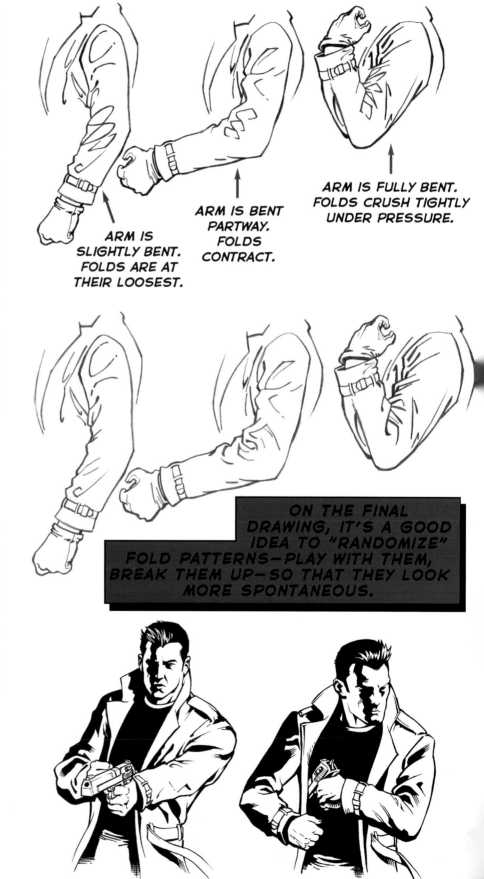

ARM IS SLIGHTLY BENT. FOLDS ARE AT THEIR LOOSEST.

ARM IS BENT PARTWAY. FOLDS CONTRACT.

ARM IS FULLY BENT. FOLDS CRUSH TIGHTLY UNDER PRESSURE.

ON THE FINAL DRAWING, IT'S A GOOD IDEA TO "RANDOMIZE" FOLD PATTERNS—PLAY WITH THEM, BREAK THEM UP—SO THAT THEY LOOK MORE SPONTANEOUS.

SHOULDER-JACKET FOLDS

The way jackets are cut makes it impossible for a guy to lift his arms without causing a series of small folds at the shoulders and collar simultaneously. Let's take a look and see how this happens.

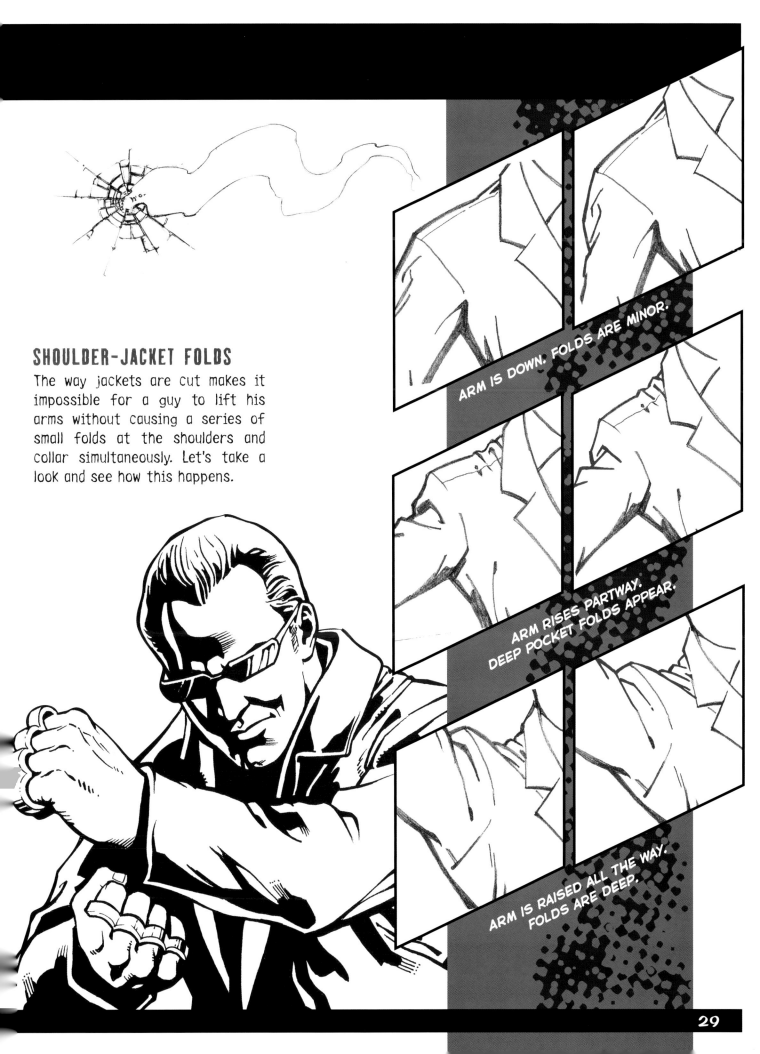

ARM IS DOWN. FOLDS ARE MINOR.

ARM RISES PARTWAY.
DEEP POCKET FOLDS APPEAR.

ARM IS RAISED ALL THE WAY.
FOLDS ARE DEEP.

29

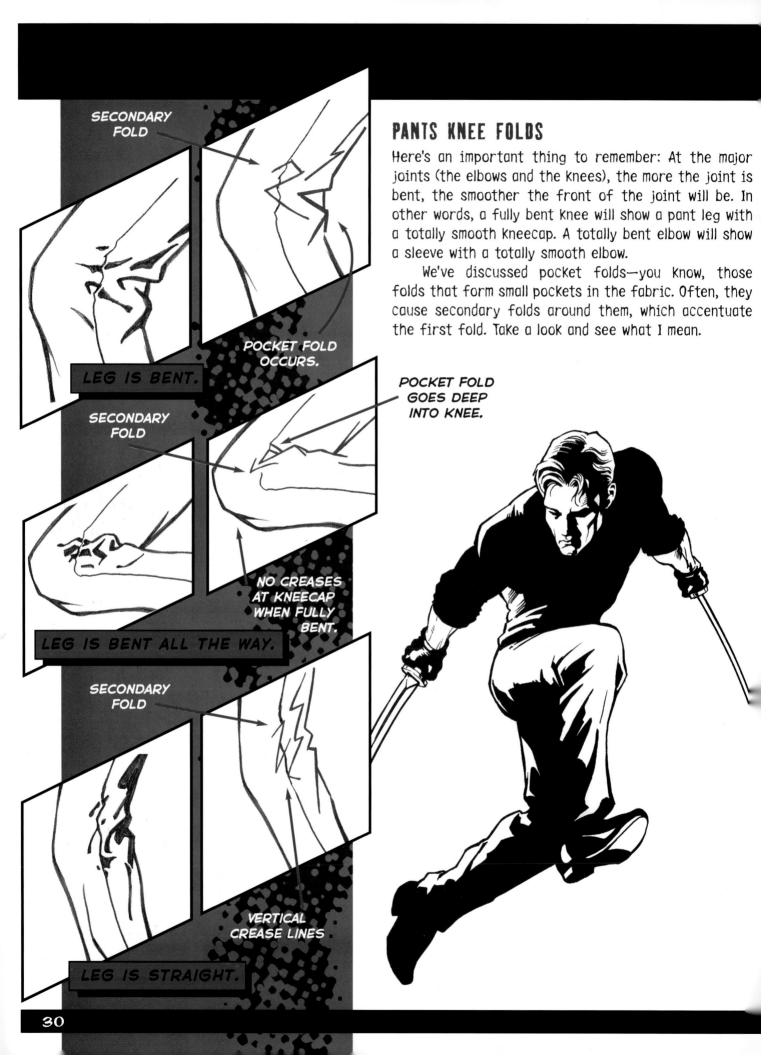

SECONDARY FOLD

POCKET FOLD OCCURS.

LEG IS BENT.

SECONDARY FOLD

SECONDARY FOLD

LEG IS BENT ALL THE WAY.

NO CREASES AT KNEECAP WHEN FULLY BENT.

SECONDARY FOLD

VERTICAL CREASE LINES

LEG IS STRAIGHT.

PANTS KNEE FOLDS

Here's an important thing to remember: At the major joints (the elbows and the knees), the more the joint is bent, the smoother the front of the joint will be. In other words, a fully bent knee will show a pant leg with a totally smooth kneecap. A totally bent elbow will show a sleeve with a totally smooth elbow.

We've discussed pocket folds—you know, those folds that form small pockets in the fabric. Often, they cause secondary folds around them, which accentuate the first fold. Take a look and see what I mean.

POCKET FOLD GOES DEEP INTO KNEE.

TORSO TWIST

The twist of the body, always a dramatic touch in a pose, usually causes a *diagonal* crease across the body. The greater the twist, the more pronounced the crease. These creases don't scatter randomly all over the shirt, however—only at the section where there is tension. Adding creases where there is no tension makes the shirt look wrinkled. Allow most of the shirt to remain smooth.

NO TWIST

HORIZONTAL CREASE

SLIGHT TWIST

DIAGONAL CREASES

MAJOR TWIST

SKIRT FOLDS

Natural stress marks stretch horizontally across a short, tight skirt, zigzagging from one side to the other, and gather in the middle. As a leg rises (for example, when it's crossed, or moves forward to run), the skirt compresses, crushing the zigzag folds into smaller, more random patterns. The hips are always full, pressing firmly against the skirt; no creases appear there.

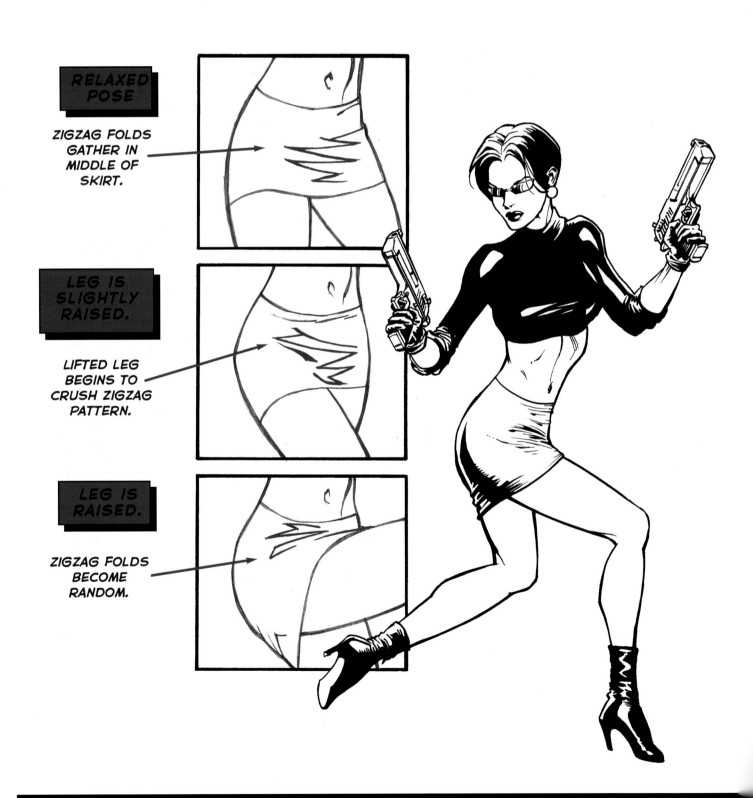

RELAXED POSE

ZIGZAG FOLDS GATHER IN MIDDLE OF SKIRT.

LEG IS SLIGHTLY RAISED.

LIFTED LEG BEGINS TO CRUSH ZIGZAG PATTERN.

LEG IS RAISED.

ZIGZAG FOLDS BECOME RANDOM.

TIGHT JEANS

Some women's pants look like they've been painted on. And because they're so tight, there's very little excess material to form the pocket folds you see on men's trousers and jacket sleeves. In the case of these skin-tight jeans, we're talking about smaller creases, which are the easiest to draw, and arguably the best to look at. These creases radiate outward from the point of stress, and quickly dissipate. Make sure you include the seam line that runs along the leg.

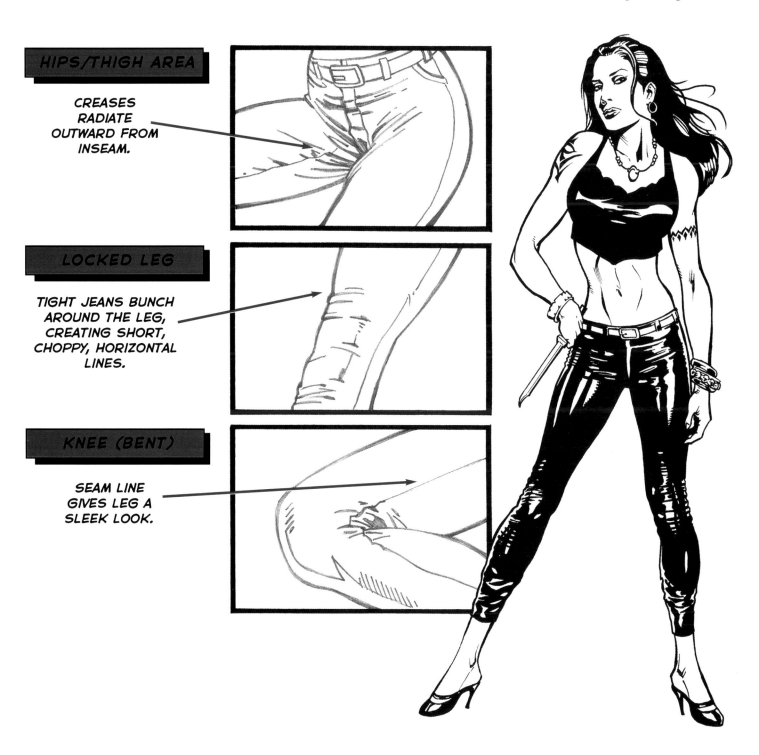

HIPS/THIGH AREA

CREASES RADIATE OUTWARD FROM INSEAM.

LOCKED LEG

TIGHT JEANS BUNCH AROUND THE LEG, CREATING SHORT, CHOPPY, HORIZONTAL LINES.

KNEE (BENT)

SEAM LINE GIVES LEG A SLEEK LOOK.

Bathed in Shadow

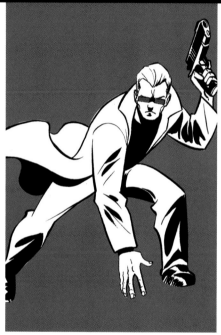

2

We could dance around this subject, touch on a few fine points, and call it quits. But then, where would you be, say, at 2:00 a.m., with a cup of coffee and a deadline staring you in the face? You could be looking at a blank piece of paper trying to draw a scene that requires deep shadows and and no idea where to start. That's not gonna happen on my watch.

The beauty of this section is twofold: One, we're going to avoid any hint of geometry and math. I never listened in math class and I don't expect you to now. This is a visual medium; it's not about drawing graphs. Everything that's demonstrated here is going to look like it does in comics. Two, it's complete. All the techniques you need to create the most dynamic shadows, the moodiest scenes, and most powerful, shadowy figures are included. I'm giving all of it to you, and I'm giving it to you straight. Are you with me? Good. You've got guts. I like that.

"High noon" might be dramatic for a gunfight at the OK Corral, but it would be bad timing for crime noir. The midday sun directly overhead casts only small shadows, translating into very little atmosphere. Yet shadows are the essential tools of crime noir. If that last sentence went by too fast, read it again. Shadows burn a lingering impression in the mind of the reader. For your character to be impressive, he needs to cast an impressive shadow, sometimes trailing him, or, sometimes, projected onto his victim.

Below are examples showing a comparison of how much more effective long shadows are than small ones. The long ones create a sense of tension, of impending danger, of loneliness and quiet, about to be disrupted by violence.

THE LARGER THE ANGLE OF THE LIGHT SOURCE, THE SHORTER THE SHADOW WILL BE.

THE SMALLER THE ANGLE OF THE LIGHT SOURCE, THE LONGER THE SHADOW WILL BE.

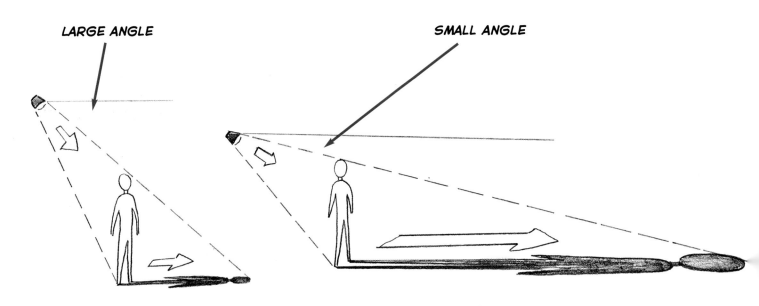

LARGE ANGLE

SMALL ANGLE

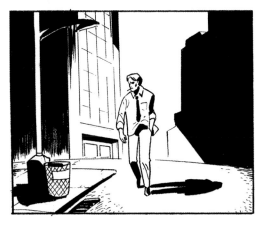

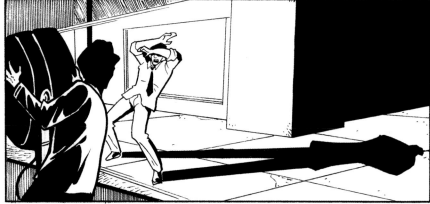

Since we're drawing long shadows, that means that the light is coming from a low angle, rather than from directly overhead. Light is "directional"—it comes from a particular direction. You've got to keep that in mind when drawing shadows. That's me,

below, smoking a cigarette. (I'm down to three packs a day, what do you want from me?) Notice that the front of my torso is in shadow. It follows, then, that the sun must be behind me. That leaves me no choice: My shadow's gotta fall in front of me.

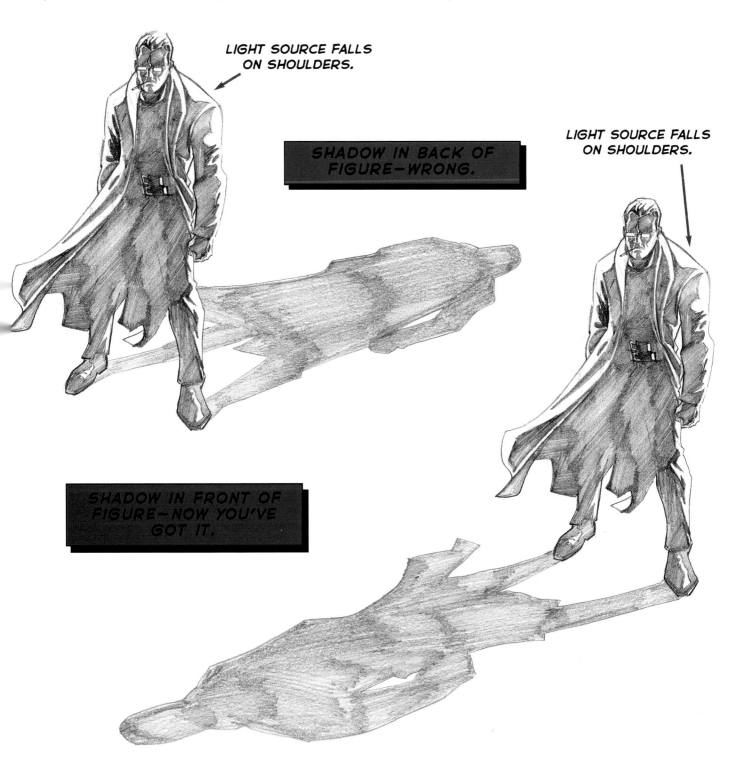

LIGHT SOURCE FALLS ON SHOULDERS.

SHADOW IN BACK OF FIGURE—WRONG.

LIGHT SOURCE FALLS ON SHOULDERS.

SHADOW IN FRONT OF FIGURE—NOW YOU'VE GOT IT.

"CORRECT" VERSUS GRAPHIC SHADOWS

Do you want to draw powerful comics, or do you want to get an A in art class? Newer artists are sometimes so concerned about drawing things correctly that their work ends up looking deadly dull—accurate as hell, but dull. Shadows are your bread and butter. So you better make 'em sing. If drawn strictly accurate, they're likely to obscure a lot of action, and create uninteresting patterns. Or you can work with the shadows as if they were part of the design of the scene. Now, which sounds better to you? Good answer. Enough of this teacher's pet stuff. Let's get back to work.

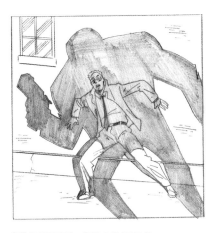

CORRECT SHADOWS

Here's how it looks if you're a stickler for realism. The shadow blankets the main character, so you can't see what's going on. The image loses all impact.

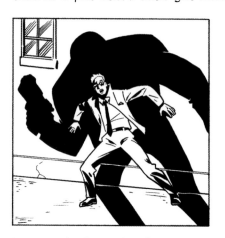

GRAPHIC SHADOWS

Here, you can take artistic license, which means you know the correct way, and chuck it anyway, because you want the scene to look good. Now the shadow omits the main character, which causes a startling contrast and underscores the terror of the scene. The shadow also frames the main character.

CORRECT SHADOWS

By correctly placing the light source to the left, and the shadows to the right, the woman's face becomes covered in darkness, resulting in a panel that shows the back of a guy and the shadow of a woman's face. Not much to go on.

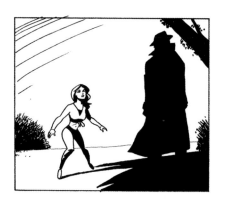

GRAPHIC SHADOWS

You can solve this by shifting the emphasis. The shadow didn't do a whit of good for the woman anyway. So let's just focus it on the man. And let's focus it on him big time, by putting him completely in silhouette, which enhances the sense of menace. Now we can remove the shadow from her face, but we'll attach her cast shadow to his cast shadow, locking them together in an uncomfortable alliance.

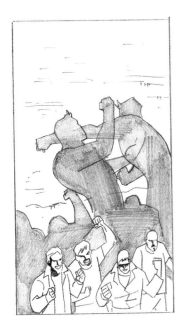

CORRECT SHADOWS

When two figures in shadow overlap, like these bruisers pummeling each other, it gets confusing because the shapes bleed into each other.

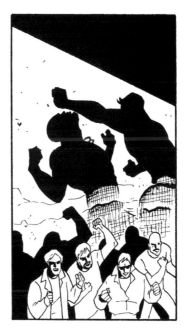

GRAPHIC SHADOWS

Separate the fighters, so that there's no overlap. Now the fight scene works clearly.

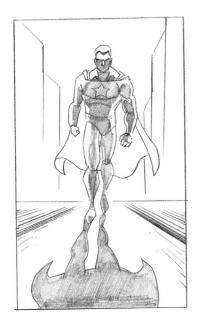

CORRECT SHADOWS

This cast shadow (remember, a "cast shadow" is one that is thrown, or "cast," onto an object, like a building or the ground) is correct, but unimpressive.

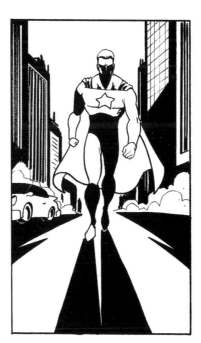

GRAPHIC SHADOWS

Sharp shadows—especially ones that widen out as they travel toward the reader—are much more dramatic.

What happens when a shadow hits something other than the ground? It usually does one of three things: It enlarges, which makes the subject look awesome; it wraps around the shape that it hits, making the object look solid; or it creates a cool-looking pattern, resulting in a graphic design. All of these effects greatly enhance the mood and atmosphere of a scene. Let's check out how they're created, and, even more important, how you can create them.

A HIGH OVERHEAD LIGHT SOURCE CASTS A SMALL SHADOW ON THE WALL.

A LIGHT SOURCE AT EYE LEVEL CASTS A SHADOW AS HIGH AS THE CHARACTER'S HEAD.

A LOW LIGHT SOURCE CREATES GIANT SHADOWS ON THE WALL.

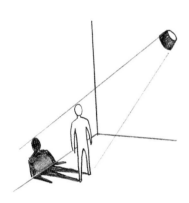

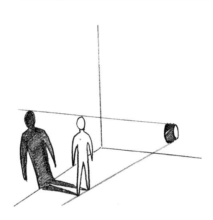

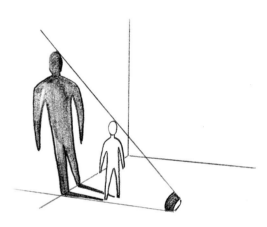

LIGHT FROM BELOW

Light shining up from below a figure creates enlarged shadows, plus spooky effects like bright light from below and shadows from above. An ominous, powerful look. Remember this one, you're gonna want to use it in your own work.

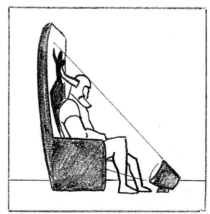

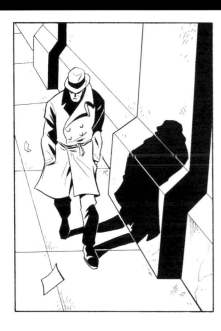

SHADOW CAST ON IRREGULAR SHAPE

The shadow should assume the irregular planes and angles of the wall.

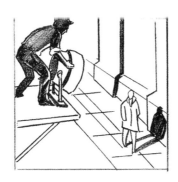

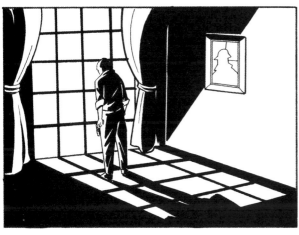

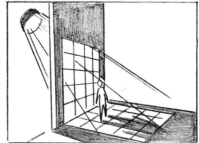

PATTERN SHADOWS

Venetian blinds, shutters, windowpanes—they all make good patterns for shadows. Try to warp the overall shape of the shadow so that it isn't a perfect square, which can be boring.

LOW-ANGLE LIGHT ON COLUMN

The column isn't large enough to contain the entire shadow, so the shadow bends around the column, and trails off, giving the illusion that the column is round. The low angle creates a larger shadow effect.

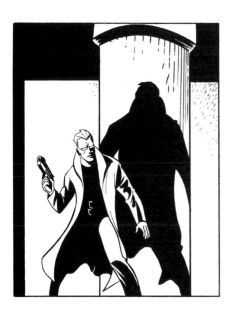

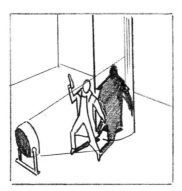

You've got to give your reader a feel for the environment. It makes a difference whether it's a cemetery or a biogenetics lab. Whether that's grass under your character's feet, or marble tiles, or water. The way you draw the shadows on the ground helps to convey that feeling. Here are some examples of shadows drawn to reflect textured surfaces.

TILE FLOOR: SCIENCE LAB

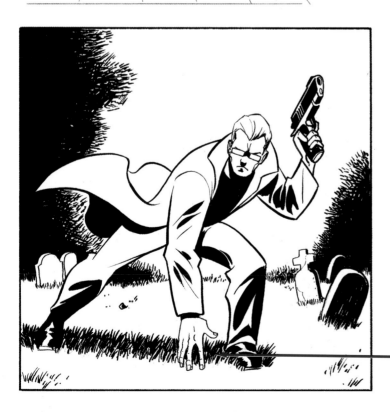

VERTICAL STREAKS FOR SLICK FLOORS

WOODED AREA: CEMETERY

SHORT PATCH OF GRASS BETWEEN THE LEGS

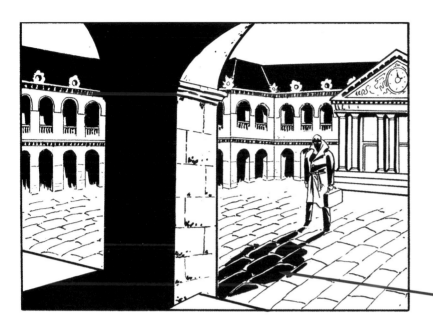

COBBLESTONES OR FLAGSTONES: EUROPEAN DROP-OFF POINT

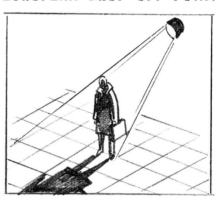

SHADOWS ARE BROKEN UP BY WHITE LINES.

WATER: SEWER TUNNEL

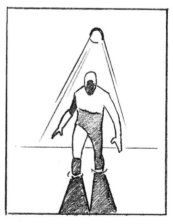

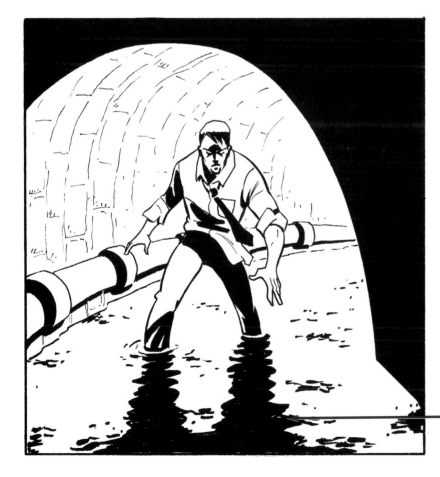

BLACK SQUIGGLY AREAS THAT EVENTUALLY MEET

Strictly speaking, a silhouette is a totally black figure. And that's fine for a menacing guy lurking in the shadows. But it's not always the best way to go when you're introducing a character. Who can remember a character totally in silhouette? Here's where you take artistic license again. Follow me on this.

When the light is super-intense, the resulting shadows will be stark. If you place that light directly over a figure, everything below him will fall into deep shadow. Place the light behind him, and everything in front of him falls into a pool of black. But blackness, without highlights, isn't dramatic. It's just plain dark. In order to give it character, we allow the light to bleed around the figure, nipping at the edges as well as weaving in and around him. Have a look for yourself.

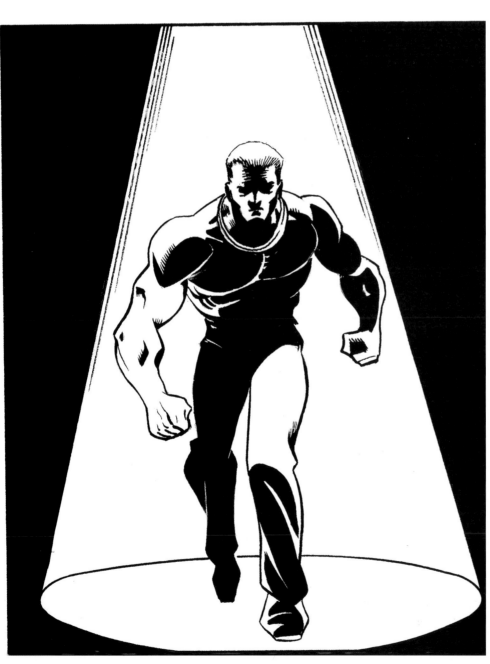

SPOTLIGHT:ESCAPING CON

A light from above tracks the fleeing killer. The leg that's out in front catches the spotlight, while the rear leg remains covered in shadow. The same thing happens to the arms as they rotate during the run. This alternating bit of contrast makes the pose more dramatic than if the figure were in the complete blackness of a strict silhouette.

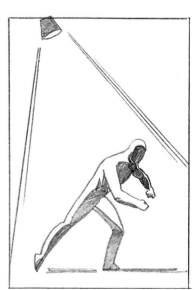

BLAZING LIGHT FROM BEHIND: THE ARSONIST

The figure falls dark, but the highlights of the fire flicker around him, illuminating the edges and making him appear even more ominous.

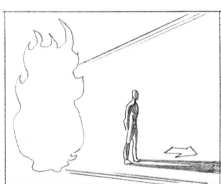

She's lovely to look at, but impossible to possess. Her type appears out of nowhere, and disappears just as mysteriously. Part of the mystery is that she's only three-quarters drawn. Some of her body trails off into the blackness of shadow, and is lost in the darkness. It's a good look, sultry and sexy. Don't forget about this technique. I wouldn't have told you about it if I didn't think you could use it, and do a good job of it. I'm giving you the inside advice you're not getting anywhere else. Just keep it low key, got me?

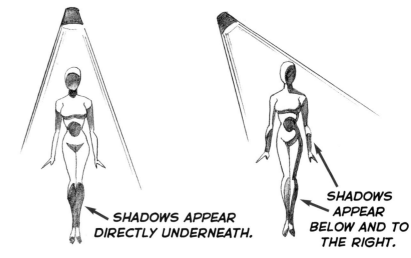

SHADOWS APPEAR DIRECTLY UNDERNEATH.

SHADOWS APPEAR BELOW AND TO THE RIGHT.

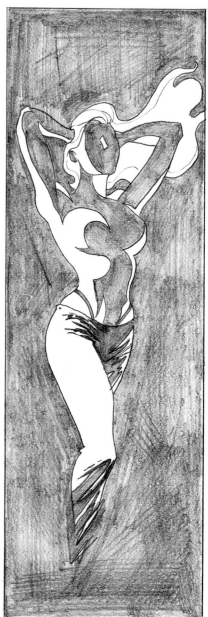

Any art instruction book can show you examples of important moments that call for specific types of shadows. That's all well and good. But there are lots of moments throughout a story when you're giving exposition—information—that allows the story to develop and unfold, where nothing specific is indicated. What do you do then? You still need to add shadows, because that's the genre, and because it makes the art look better.

Here's the dirty little secret most art instruction guys won't tell you: You don't always need a reason to add shadows. Yeah, that's right. Sometimes, you do it just because it looks good, and to heck with the light source, or lack thereof. Now don't go abusing the privilege. You can't shade a guy in one panel to make it look as if he's in solitary confinement in Attica, and in the next panel, light him as if he's on the beach. But no one's saying you can't add a little English to your drawings. I've never heard a comic book reader say, "That's the greatest splash page I've ever seen, but wait a minute—where's the secondary light source?"

POCKET OF HIGHLIGHT

Attractive women make a lot of hay with their eyes, so you don't want to cover either of them in shadow. Always leave a pocket of highlight for each eye, even if the rest of the face is blanketed in shadow.

SMALL SHADOWS

You want less shadow? That's a good approach, too. Simply limit it to a cast shadow thrown by the bridge of the nose and the chin.

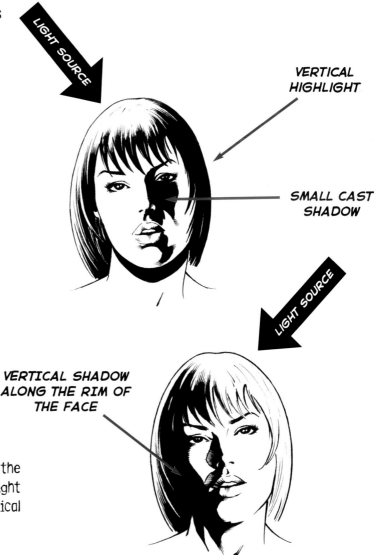

LIGHT SOURCE

PATCH OF HIGHLIGHT FOR THE EYE

DEEP SHADOW CAST

LIGHT SOURCE

VERTICAL HIGHLIGHT

SMALL CAST SHADOW

LIGHT SOURCE

VERTICAL SHADOW ALONG THE RIM OF THE FACE

MERGING SHADOWS

Shadows are cast to the left, from the nose and the chin; at the same time, shadows are cast to the right from behind the left of her head, squeezing a vertical highlight down her cheek. A nice effect.

You've got to get through him to see the boss. But first, expect a pat down. So don't be foolish enough to wear a wire, or the only thing you'll be seeing is the inside of a car trunk.

LIGHTING FROM BOTH SIDES

By lighting the character from the left *and* the right, you create small shadows down the middle of the face, resulting in dark areas around the eyes and mouth and giving the character a grave look.

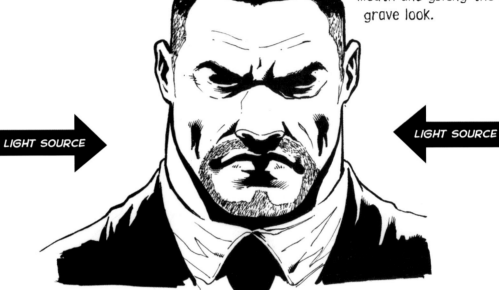

LIGHT SOURCE

LIGHT SOURCE

ONE-SIDED LIGHTING

Allowing one side of the face to fall into blackness creates a sinister look. Note how some of the shadow is allowed to invade the lighted side of the face as well, especially around the eyes.

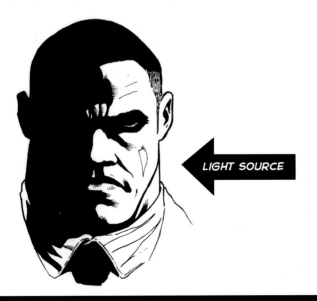

LIGHT SOURCE

LOW-ANGLE LIGHTING

Sometimes, especially with a thick, oddly formed character, symmetrical shadows create an almost mask-like appearance. To make the shadows symmetrical, place the light source in the middle of the face, directly below the chin.

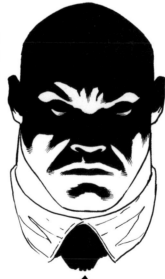

LIGHT SOURCE

You've got your good guy heroes in crime noir. The difference between them and the action heroes in regular comics is that the noir guys have shadows that give them a searing intensity, so that even though they're on the side of good, they lack humanity. Their souls are empty and heavy. You can see it in the way the shadows hit their faces, like glaring afternoon light on granite statues.

BASIC APPROACH

The near side is dark, the far side is light—that's the standard approach when you don't have a clear mandate from the light source. The reason you don't usually shade the far side of the face is that it makes it fade away, causing the reader's eye to get lazy and stop at the lighter, near side of the face. You want the reader to look deeper into the panel. Get the reader to look at the far side of the character's face by keeping the far side light and the near side dark.

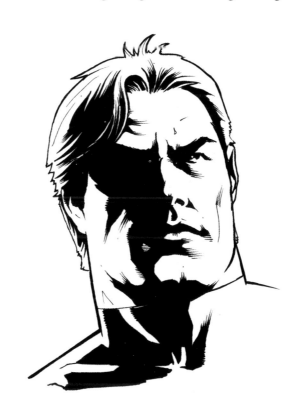

SUN-BAKED HERO

To get this look, blacken almost all of the features in shadow, leaving only enough of the face to see the boney structure of the skull, cheekbones, jaw, nose, and chin. It should look like a hot August day in the San Fernando Valley.

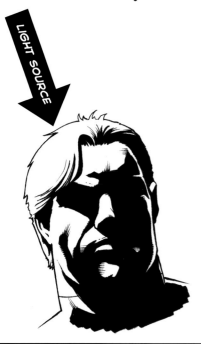

LIGHT SOURCE

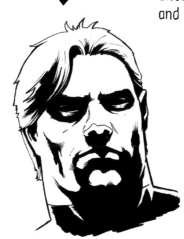

LIGHT SOURCE

SHADOWS CAST FROM FEATURES

Also a blazing hot day, with a super nova–like sun directly overhead. The overhead light source casts shadows onto the eyebrows, nose, lips, and cheekbones.

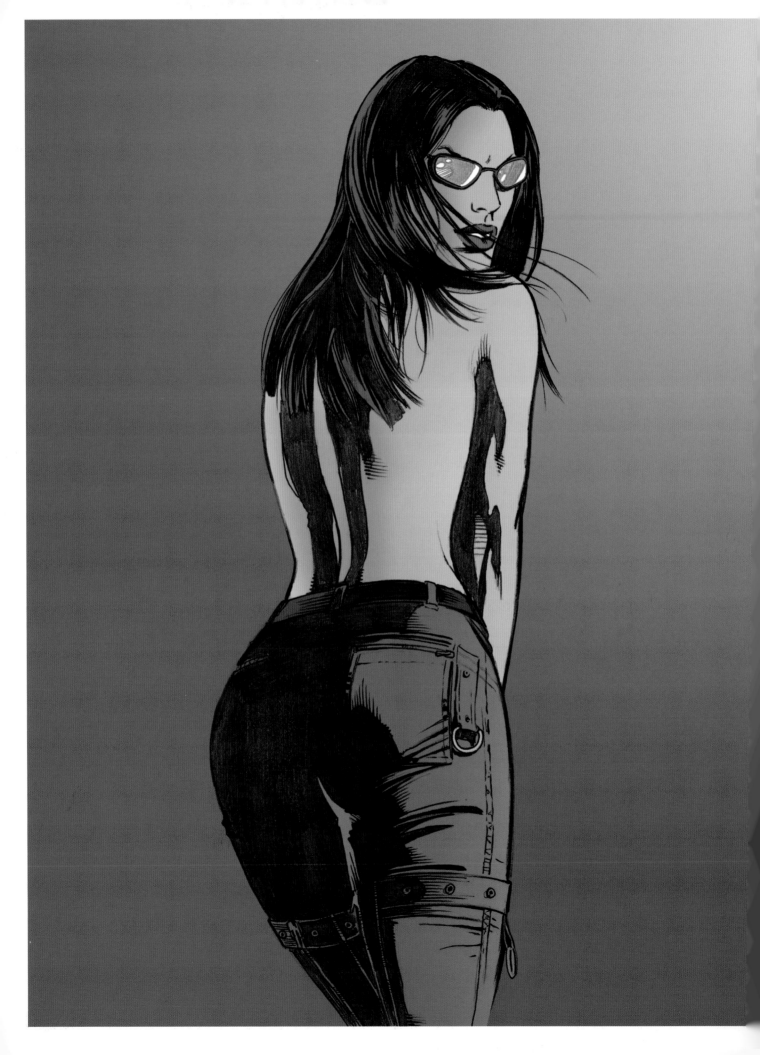

Sinful Women

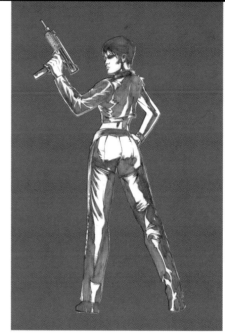

3

If you're looking for the "girl next door," you won't find her in this book, or in the crime noir genre. For these girls, it's strictly business. That's not to say that there's no romance going on in these pages. Sure there is. Just don't expect it to change anything. If you're the mark, you're going down, even if she thinks you're easy on the eyes.

Some of these women are pros, ladies of the evening. Well, we all gotta eat. But most of them are not. Some of them are employed as freelance cleaning women, you know, the kind who are paid to take out the trash—the human debris that accumulates in an unforgiving city, the bad luck crowd who once too often couldn't pay their debts. Then you've got the hangers-on. The has-beens and wannabes who are looking for a free ride to nowhere. And that's where they're going—fast. This chapter may look like a pretty avenue to cruise, but it's also got dangerous curves. So hang on.

GOODBYE, JOHNNY BOY

Breaking up is hard to do. A bullet is one way to end things. It's messy, but at least it prevents all that "It's not you, it's me" crap. Plus, now she can get into his computer files and steal the password to his Swiss bank account. And that's a nice salve for a broken heart.

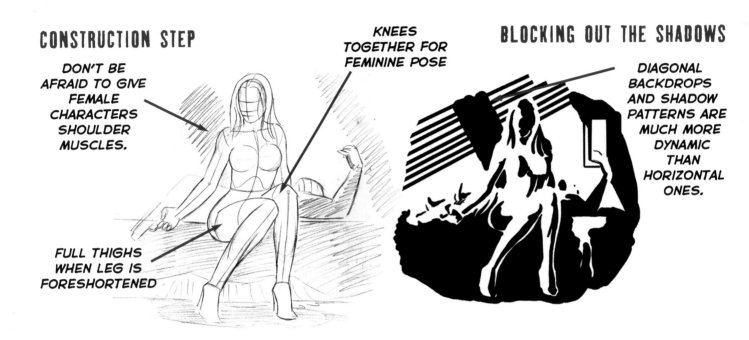

CONSTRUCTION STEP

DON'T BE AFRAID TO GIVE FEMALE CHARACTERS SHOULDER MUSCLES.

KNEES TOGETHER FOR FEMININE POSE

FULL THIGHS WHEN LEG IS FORESHORTENED

BLOCKING OUT THE SHADOWS

DIAGONAL BACKDROPS AND SHADOW PATTERNS ARE MUCH MORE DYNAMIC THAN HORIZONTAL ONES.

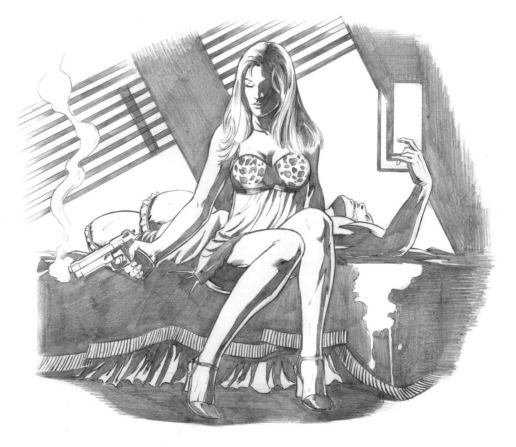

Stiletto Heels

Always elongate the leg by pointing the toes down. That gives them a sleek, sexy look. And stiletto heels are a great way to force the feet into that position, because they prop the heels up, which in turn causes the bridge of the foot to point downward, creating a single, unbroken line with the rest of the leg.

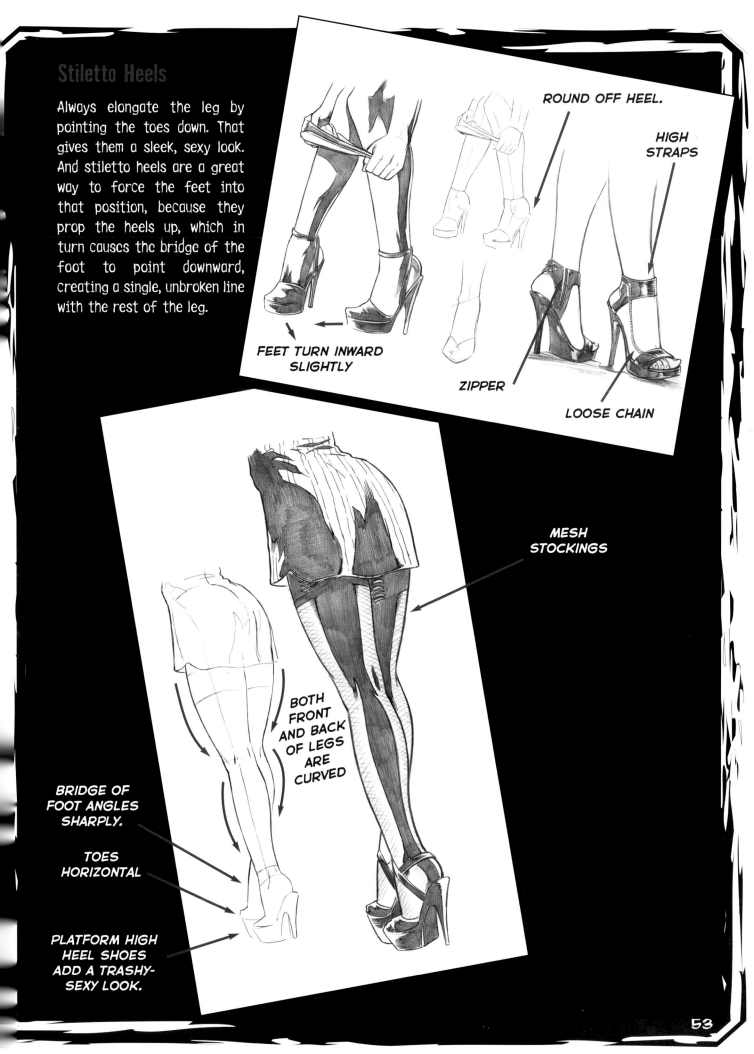

ROUND OFF HEEL.

HIGH STRAPS

FEET TURN INWARD SLIGHTLY

ZIPPER

LOOSE CHAIN

MESH STOCKINGS

BOTH FRONT AND BACK OF LEGS ARE CURVED

BRIDGE OF FOOT ANGLES SHARPLY.

TOES HORIZONTAL

PLATFORM HIGH HEEL SHOES ADD A TRASHY-SEXY LOOK.

All you've got to do is trust her for two hours. She's lined up her crew, all specialists. The gear is in the truck. The driver's waiting for her signal. This is the easy part. All you have to do is hand over the first half of the payment.

When she comes back with the software code, that's when it gets tricky. You'll owe her the balance of the cash. You'll have to get it for her. Then she'll swap you the code for the cash, and it'll be a successful transaction. Or she'll kill you and keep the code and the cash. But why would she do that? She doesn't know what the code is for; only you do. Still, she doesn't have to know in order to figure out that someone would be willing to buy it from her. The same people who want to buy it from you. Either way, you've gotta have that code. You need her. But can you trust her?

RAISED EYEBROWS FOR A DARK SMILE

SUNGLASSES TO HIDE BEHIND

FORWARD-LEANING POSTURE

HANDS MIMIC THE SHAPE OF A GUN.

TALL BOOTS

RETRO-STYLE FURNISHING— NOTHING "HOMEY" OR WARM

HEAVY SHADING AND LOTS OF STARK CONTRAST

SEVERE HEELS

SITTING WITH HER LEGS APART SHOWS SHE'S NO WALLFLOWER.

When this spider spins her web, she dresses it up all pretty to catch more flies. Negligees, stockings, teddies, and straps are all part of the mix. And, oh yeah, a 45. But you won't see that until it's too late.

Guns & Sex Appeal

The romance of the gun has been a part of movies and pulp novels for many years, just as it is for comics and graphic novels today. Like advertisements for automobiles that feature beautiful women standing beside sports cars, the combination of masculine and feminine exudes a raw sexuality that works well in the high-pitched world of crime noir.

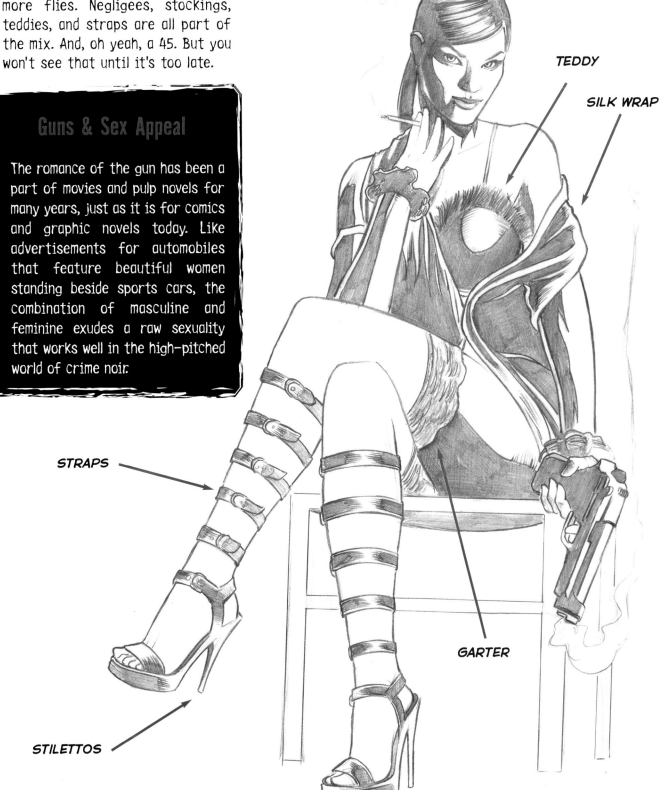

TEDDY

SILK WRAP

STRAPS

GARTER

STILETTOS

The women who work in the city's entertainment industry, from modeling to singing, never get their big break. The smart ones take night courses and end up working on Wall Street. The others are just hanging on. The torch singer is a gal who used to have the right looks and all the right moves. The boss still likes having her around, though there's a younger girl he's all worked up about. A gal like this needs a pot of coffee, a nice guy, and a ticket the hell out of this town.

Typically, the nightclub singer is tall with a lanky build. Square jawed, in the classical, good-looking sense. Long hair, maybe a bit too long for someone who's pushing forty. But she still has great collarbones and square shoulders, which she never hesitates to show off. Her narrow waist, combined with wide hips, always catches a man's attention. With those looks, she could have been a starlet, for fifteen minutes or so.

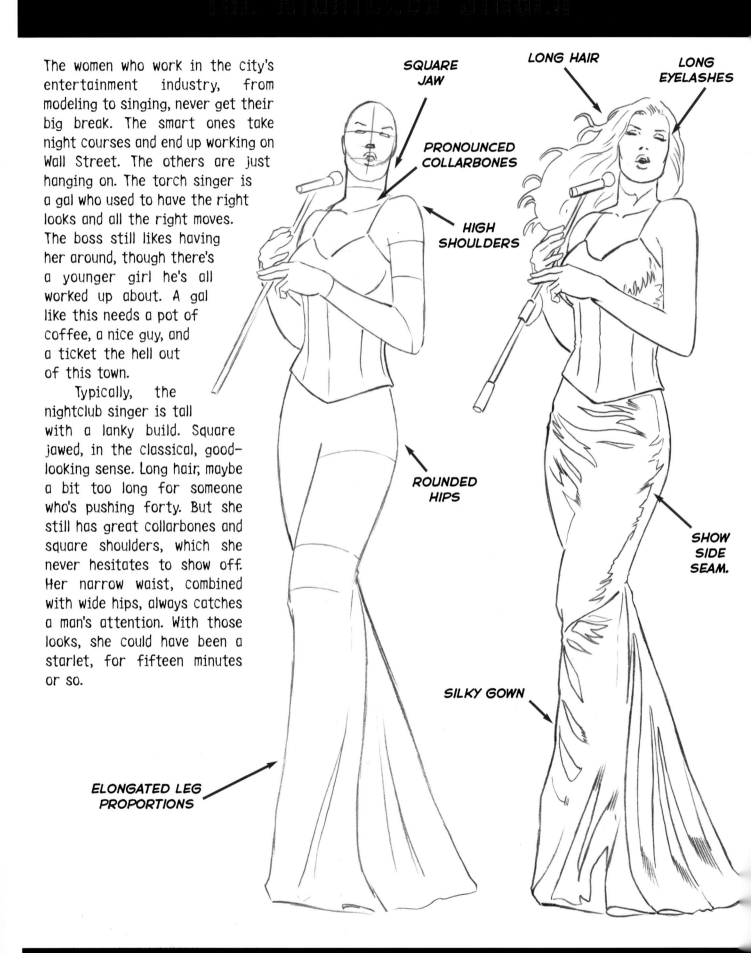

SQUARE JAW

LONG HAIR

LONG EYELASHES

PRONOUNCED COLLARBONES

HIGH SHOULDERS

ROUNDED HIPS

SHOW SIDE SEAM.

SILKY GOWN

ELONGATED LEG PROPORTIONS

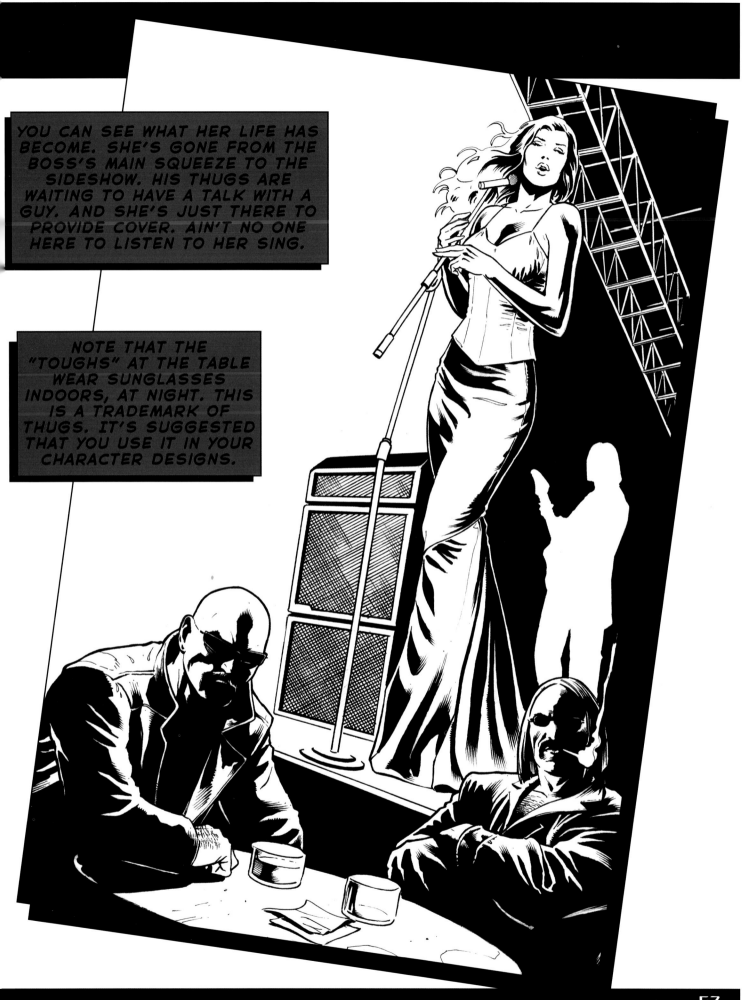

YOU CAN SEE WHAT HER LIFE HAS BECOME. SHE'S GONE FROM THE BOSS'S MAIN SQUEEZE TO THE SIDESHOW. HIS THUGS ARE WAITING TO HAVE A TALK WITH A GUY. AND SHE'S JUST THERE TO PROVIDE COVER. AIN'T NO ONE HERE TO LISTEN TO HER SING.

NOTE THAT THE "TOUGHS" AT THE TABLE WEAR SUNGLASSES INDOORS, AT NIGHT. THIS IS A TRADEMARK OF THUGS. IT'S SUGGESTED THAT YOU USE IT IN YOUR CHARACTER DESIGNS.

When someone's girlfriend is all mobbed up, it can be dangerous if she has a crush on you. If she's extremely attractive, your life isn't worth a nickel.

Here is the classic, seated pose that's used to snare a man. She doesn't care if her boyfriend is watching as she tries to catch the eye of the guy across the room. For her, it's all about power.

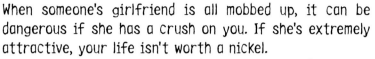

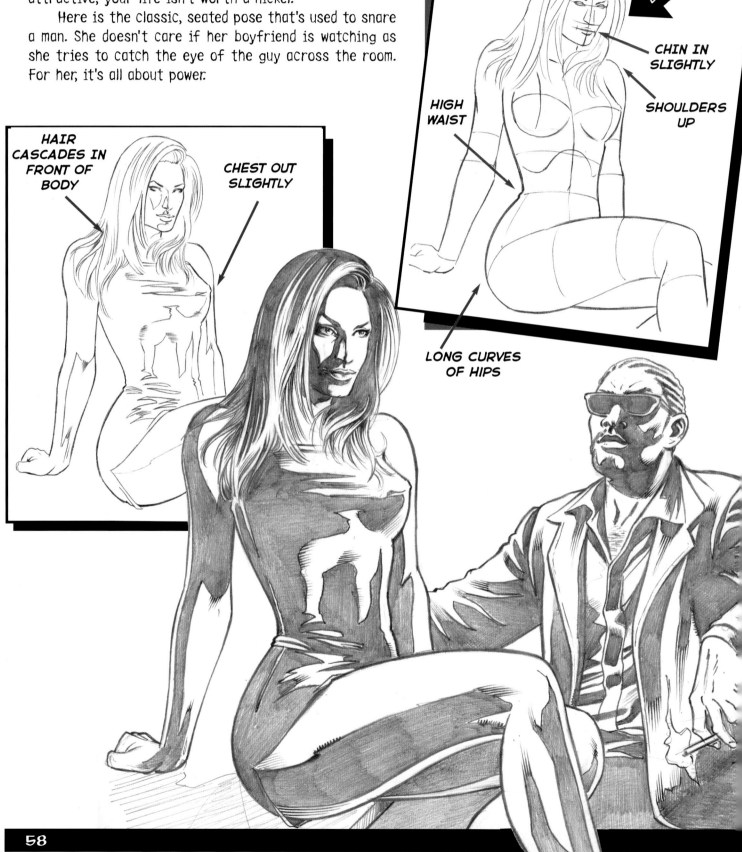

LIGHT SOURCE

CHIN IN SLIGHTLY

SHOULDERS UP

HIGH WAIST

LONG CURVES OF HIPS

HAIR CASCADES IN FRONT OF BODY

CHEST OUT SLIGHTLY

Hop on the back of her bike? Sure. I estimate it'll take a two-week road trip before your whole life unravels and you completely lose yourself in her. That's when she'll spring it on you. Some kind of plan. It'll involve someone who did her wrong, and naturally, you'll want to make things right. And this person will be heavily insured. Then the two of you can go off and live in luxury somewhere where no one can find you. If you're smart, you'll turn the tables on her at the last minute. But it's a dangerous play. It all depends on which of you is the smarter one. Well, pal, which is it?

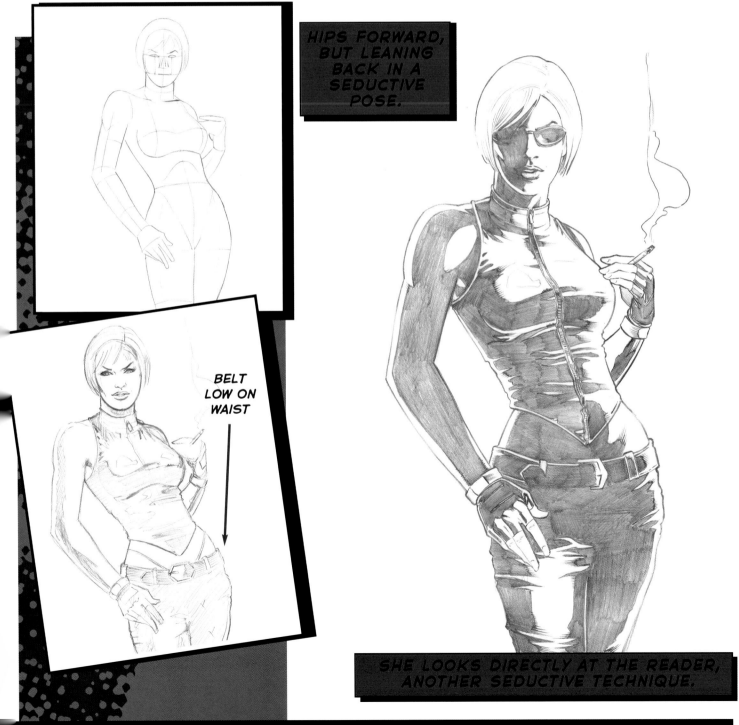

HIPS FORWARD, BUT LEANING BACK IN A SEDUCTIVE POSE.

BELT LOW ON WAIST

SHE LOOKS DIRECTLY AT THE READER, ANOTHER SEDUCTIVE TECHNIQUE.

Male characters get a lot of their power from their shoulders, so, naturally, artists depict them in poses with a lot of torso twist that highlights shoulder movement.

For women, hip movement provides the main thrust of a pose, so you want to emphasize that aspect in your drawings. The way to get the hips moving dynamically is not to twist or rotate them, but to raise or lower one side at a time. We do this by straightening one leg while bending the other.

How does that work? When you lock your knee, your leg straightens, which pushes the hip up. To compensate, the other side of the hip tilts down, causing the leg on that side to bend at the knee. This results in a dynamic look. Sometimes, the shoulders will tilt in the opposite direction of the hips, to act as a counterbalance. This is an attractive look.

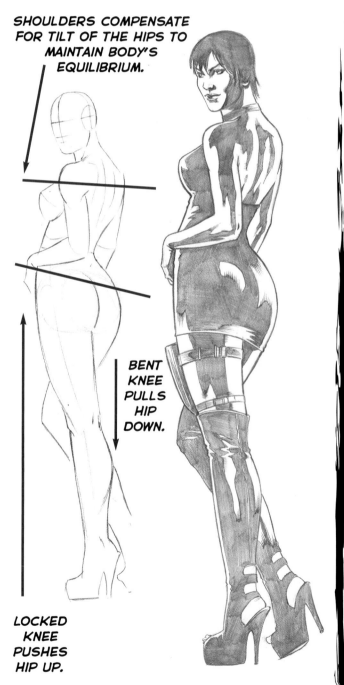

SHOULDERS COMPENSATE FOR TILT OF THE HIPS TO MAINTAIN BODY'S EQUILIBRIUM.

BENT KNEE PULLS HIP DOWN.

LOCKED KNEE PUSHES HIP UP.

Avoiding Twinning in a Pose

"Twinning" occurs when two parts of the body mirror each other. Look at her arms. The higher one is cocked at a 90-degree angle, while the lower one is held at a wider (obtuse) angle. That prevents the two arms from looking like mirror images of each other, or twinning. Twinning gives the reader the vague impression that the artist has run out of ideas and is duplicating him or herself.

Likewise, the two legs are also varied: One is locked, the other bent.

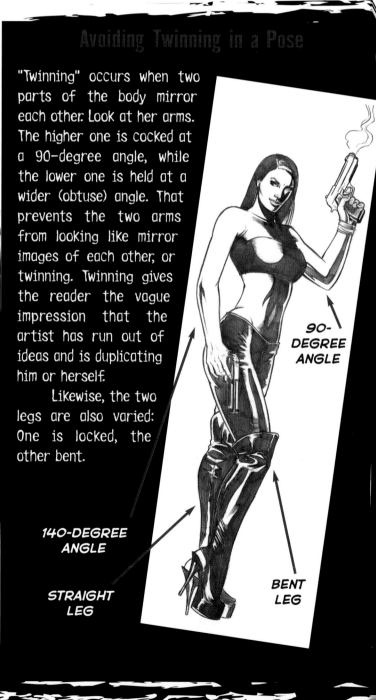

90-DEGREE ANGLE

140-DEGREE ANGLE

STRAIGHT LEG

BENT LEG

If you're standing in a bank line, and she enters the room and tells everyone to hit the floor, it would be a really good time to drop any attitude you might have about taking orders from females in a position of authority.

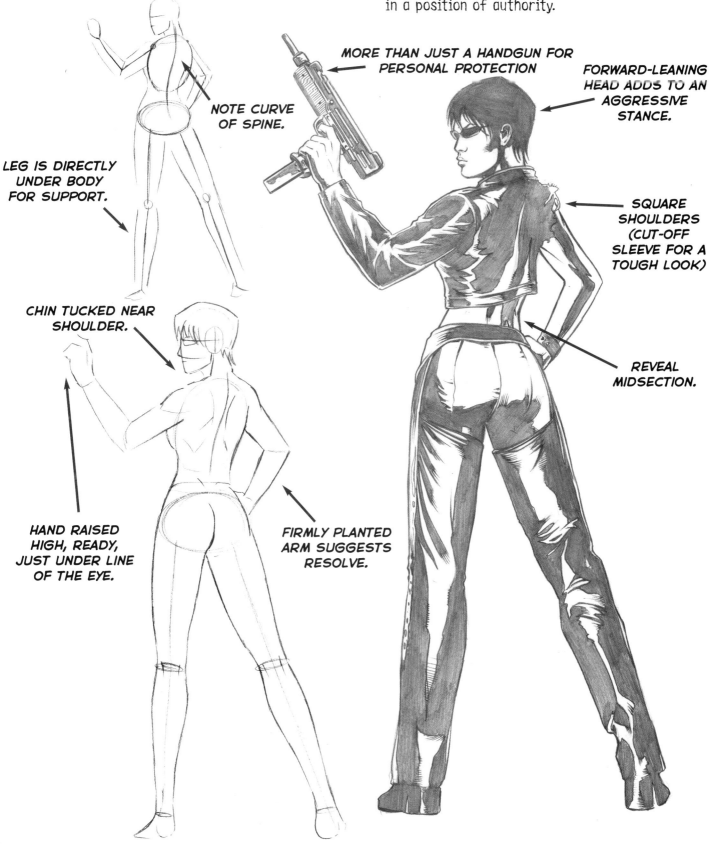

NOTE CURVE OF SPINE.

LEG IS DIRECTLY UNDER BODY FOR SUPPORT.

CHIN TUCKED NEAR SHOULDER.

HAND RAISED HIGH, READY, JUST UNDER LINE OF THE EYE.

FIRMLY PLANTED ARM SUGGESTS RESOLVE.

MORE THAN JUST A HANDGUN FOR PERSONAL PROTECTION

FORWARD-LEANING HEAD ADDS TO AN AGGRESSIVE STANCE.

SQUARE SHOULDERS (CUT-OFF SLEEVE FOR A TOUGH LOOK)

REVEAL MIDSECTION.

WORKING GIRLS

The girls who walk the streets are not the kind you bring home to meet Mom. But as bad as they are, they're nothin' compared to the johns who cruise the boulevards at night. These girls never know what world they're stepping into when they open the passenger door and step inside. Sometimes that door closes shut, and never opens again.

Drowning in the glare of neon lights, rent-by-the-hour motel signs, and flickering street lamps are a bunch of runaways squeezing out a

living and planning to quit for good, as soon as something happens. Although exactly what has to happen for them to quit, no one's figured out yet.

Subtlety is not their forte. Their clothes are tight, and they mean to show every curve. Their stance may be awkward, but it gets the job done. Not your standard leading character in comics and graphic novels, nonetheless, the working girl has an important role in establishing scenes on the seamier side of town, on a street corner full of busted dreams, in the city of night.

BASIC LINE OF ACTION BLOCKING OUT THE POSE ADDING COSTUMES AND FEATURE

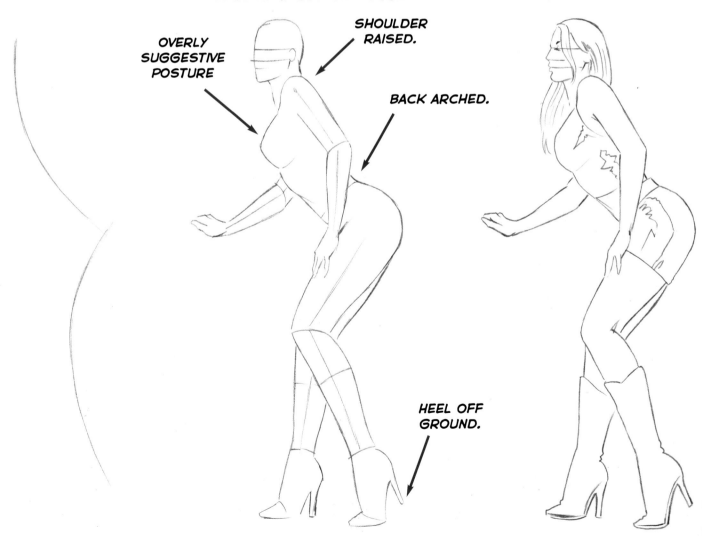

OVERLY SUGGESTIVE POSTURE

SHOULDER RAISED.

BACK ARCHED.

HEEL OFF GROUND.

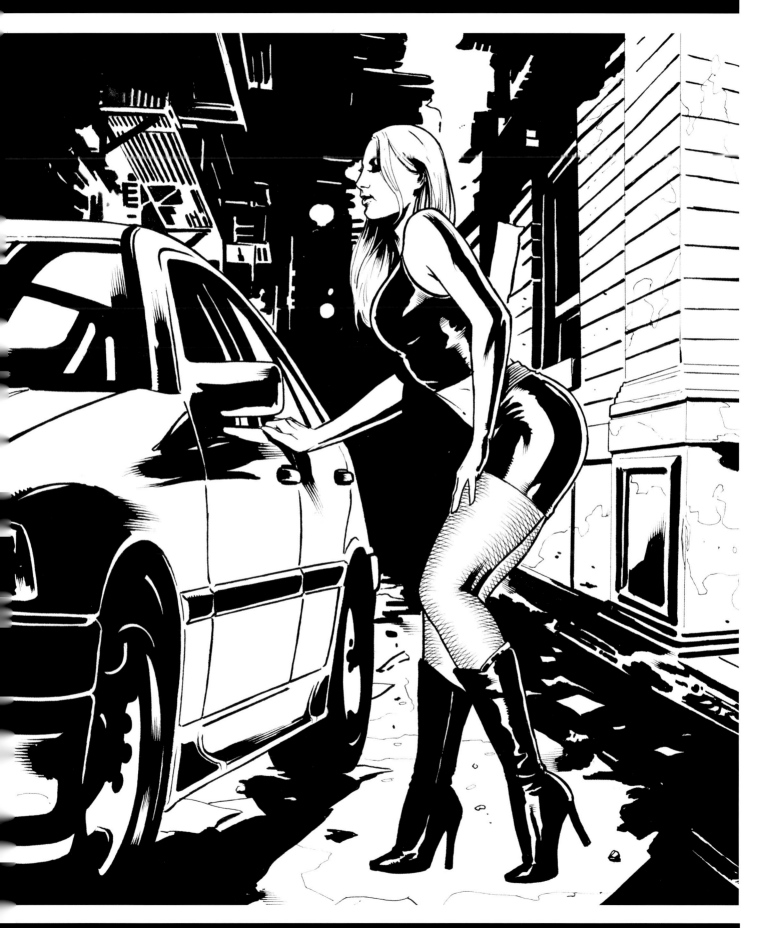

Coffee & Cigarettes

We're gonna to say goodbye for now to the women of sin, but we'll be back. There are more of them later in the book, scattered about in future chapters. But we've got places to go, things to do. Let's take just one last look back before we leave. I want you to see the subtle things you might've missed. The things that create the magic, the aura of the moment. The small things. The smoldering cigarettes. The steam rising from a cup of coffee, braiding its way up past a pair of beautiful bedroom eyes. It's finishing touches like this that'll give your work an edge.

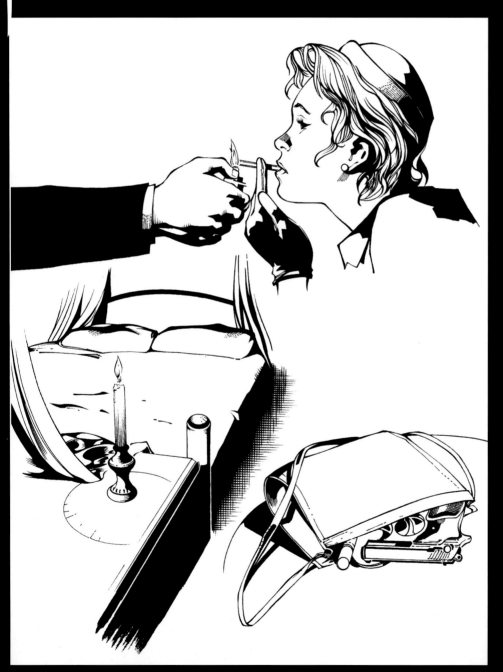

The Flash of a Lighter

A good ice breaker when you want a lady's attention, the flicker of fire adds a dramatic element, illuminating an otherwise dimly lit scene. The gloved hand is also a nice touch.

Candles and Curtains

The bedroom is laid out with special care and mystique.

Props in a Handbag

Lipstick, compact, and a Saturday night special. You don't even need to spell out what her intentions are, good or bad—a little danger always spruces up a scene.

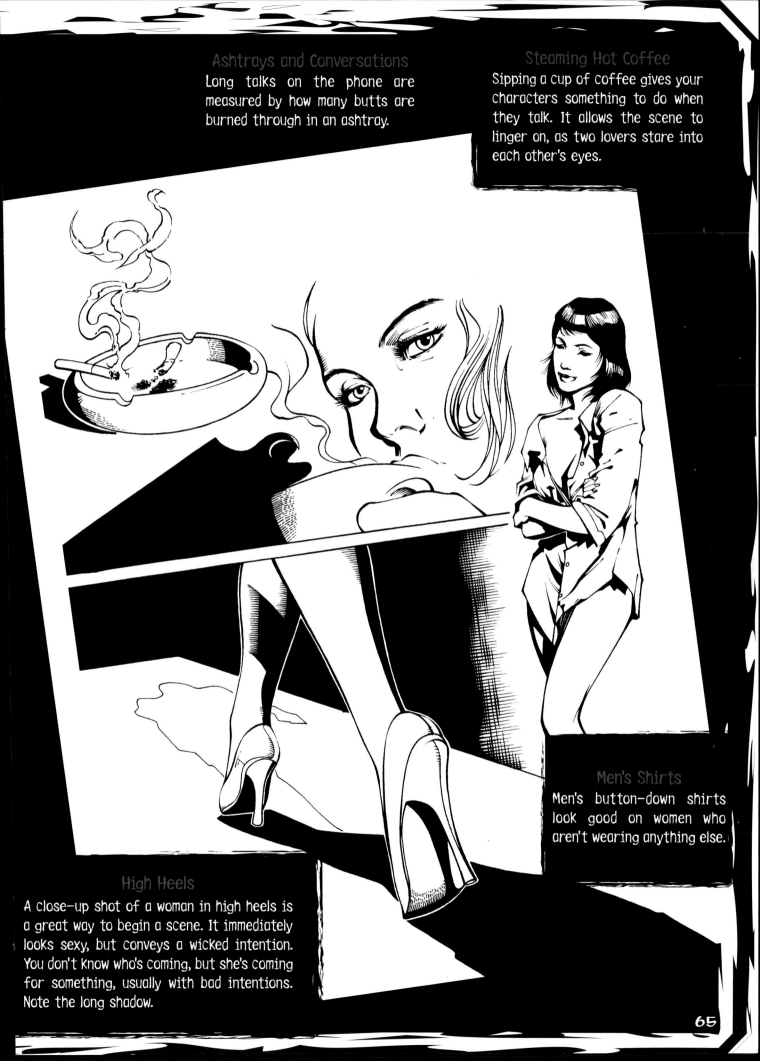

Ashtrays and Conversations

Long talks on the phone are measured by how many butts are burned through in an ashtray.

Steaming Hot Coffee

Sipping a cup of coffee gives your characters something to do when they talk. It allows the scene to linger on, as two lovers stare into each other's eyes.

Men's Shirts

Men's button-down shirts look good on women who aren't wearing anything else.

High Heels

A close-up shot of a woman in high heels is a great way to begin a scene. It immediately looks sexy, but conveys a wicked intention. You don't know who's coming, but she's coming for something, usually with bad intentions. Note the long shadow.

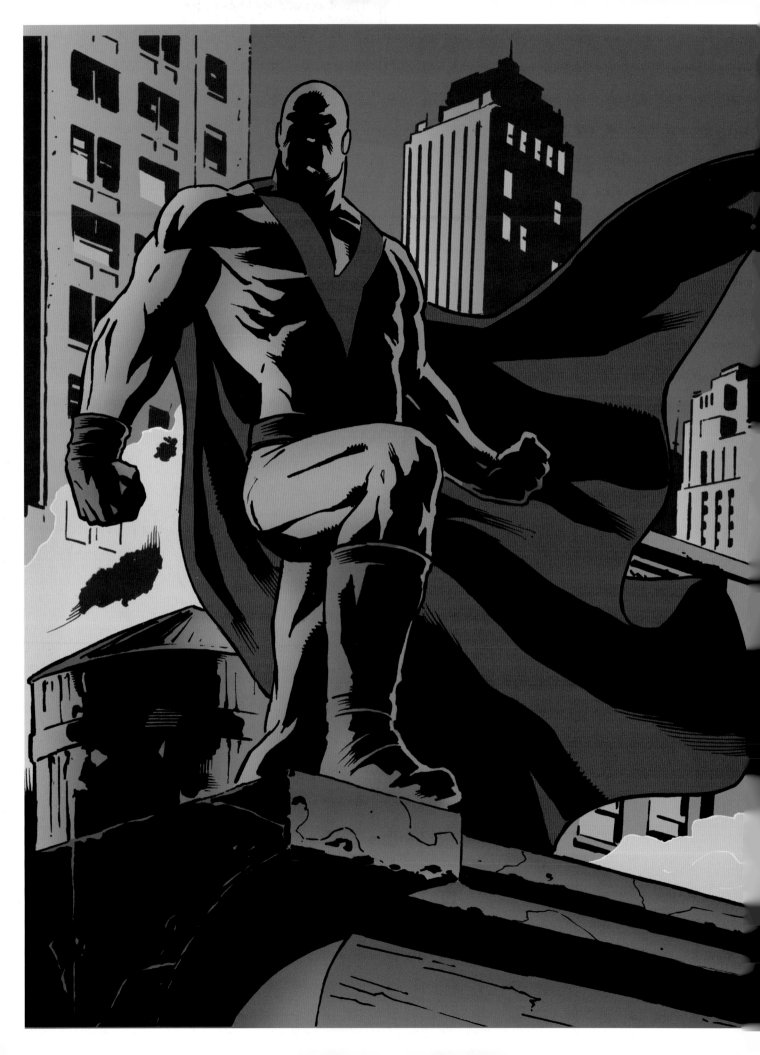

The Loneliness of the Costumed Hero

4

While the snow falls, someone is watching from the rooftops of the city. Inside the townhouses on Park Avenue, holiday cheer is being celebrated, but one man stands outside, apart. That's his job. He didn't ask for it. But no one else will take it. He works outside the law, bringing justice to a corrupt city. What does he want? Admiration? Pity? All he wants is to forget. But all he can remember is this thing called evil, which destroyed everything he ever loved. It's got to be stopped.

The costumed hero is perhaps the most tormented soul of crime noir, a stowaway from the action genre, where justice and valor are played with major chords. This hero is a tragic figure. He fights out of hatred, not for love of justice. He harbors a seething contempt for all things wicked and is always but a millimeter away from becoming that which he despises. It is the straddling of this fine line that makes this character so intriguing, so compelling . . . so haunting.

EXPRESSIONS OF THE HAUNTED

The emotions and expressions of noir-style costumed heroes must be portrayed as intense, and personal. Whatever the character is feeling, it must be seen as an experience so deep and profound that no other person can bridge the gap that separates him from the rest of humanity.

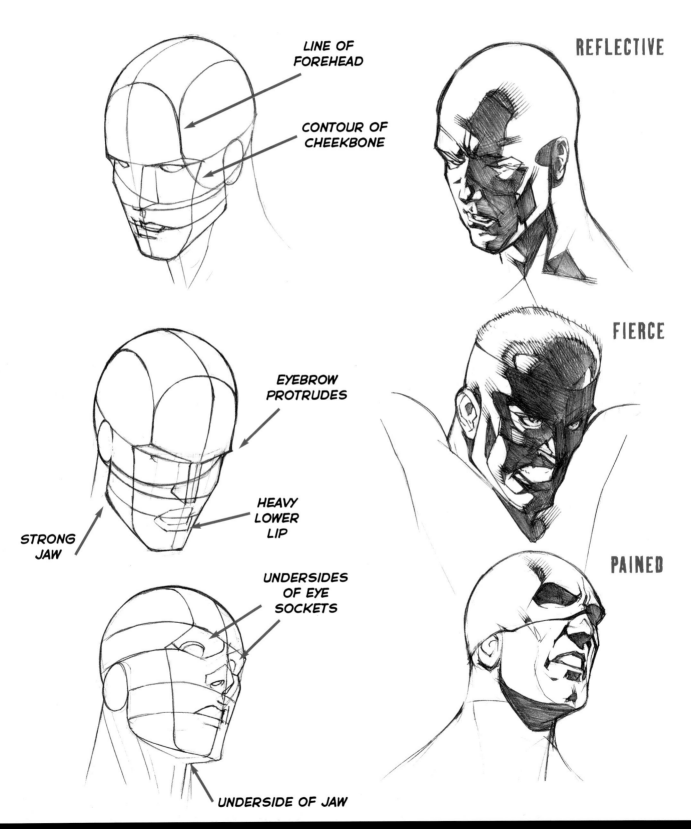

LINE OF FOREHEAD

CONTOUR OF CHEEKBONE

REFLECTIVE

EYEBROW PROTRUDES

HEAVY LOWER LIP

STRONG JAW

FIERCE

UNDERSIDES OF EYE SOCKETS

PAINED

UNDERSIDE OF JAW

THERE'S A GOOD DEAL OF SPACE BETWEEN BACK OF NECK AND BACK OF JAW.

IN THREE-QUARTER VIEW, NECK EXTENDS ALMOST TO THE "CENTERLINE" OF FACE.

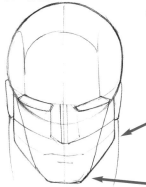

JAW IS WIDEST AT BOTTOM.

CONTOUR OF CHEEKLINE TRAVELS TO BOTTOM OF CHIN.

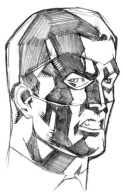

PENT-UP ANGER

GETTING READY

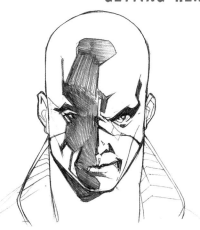

Drawing Clenched Teeth

Gritted teeth are used in highly charged expressions to convey explosive emotions. Here's how comic book pros draw teeth, making them gleam and fit together so perfectly.

Begin by drawing the three basic lines: the top of the teeth; the middle, where they meet; and the bottom of the teeth.

Draw the outline of the mouth and the gums. Note that both rows of teeth—the upper and the lower—are drawn on a curved guideline, because the mouth itself curves. It isn't a straight line straight across your face. It travels around your face.

Now erase the lines that separate most of the middle teeth, as in the example. That'll make 'em gleam.

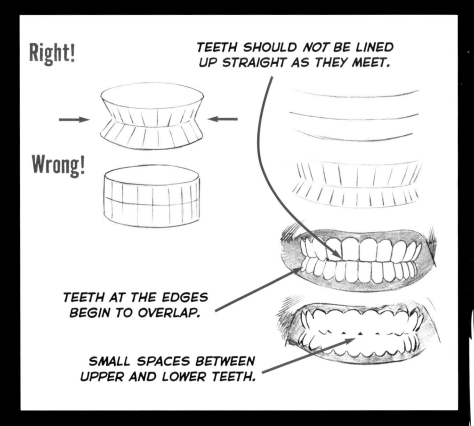

Right!

Wrong!

TEETH SHOULD *NOT* BE LINED UP STRAIGHT AS THEY MEET.

TEETH AT THE EDGES BEGIN TO OVERLAP.

SMALL SPACES BETWEEN UPPER AND LOWER TEETH.

69

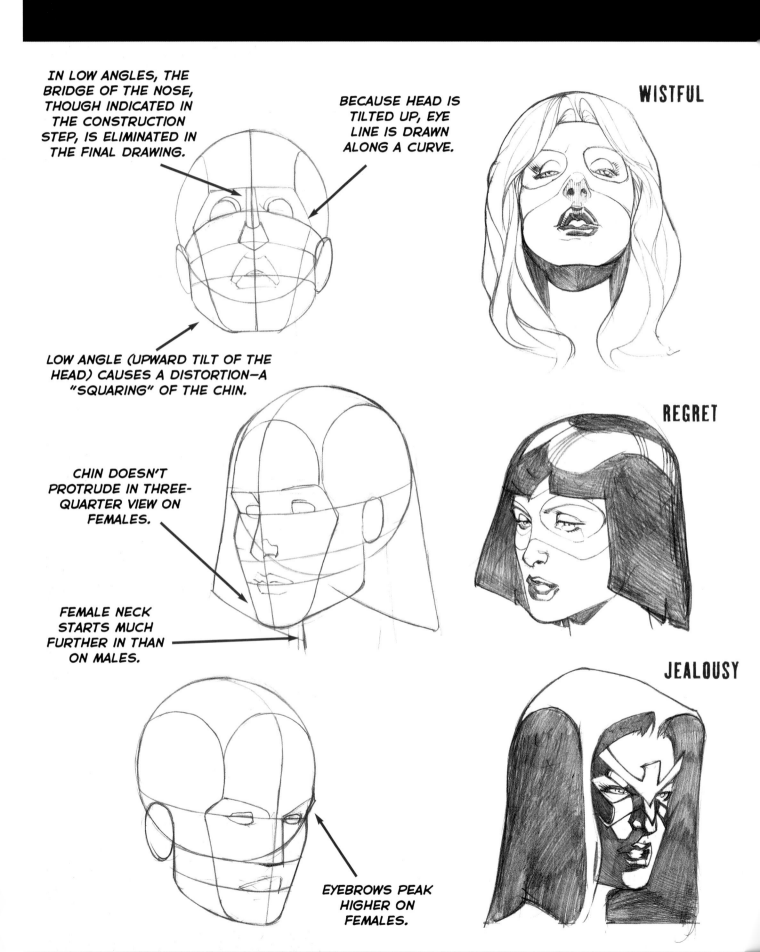

IN LOW ANGLES, THE BRIDGE OF THE NOSE, THOUGH INDICATED IN THE CONSTRUCTION STEP, IS ELIMINATED IN THE FINAL DRAWING.

BECAUSE HEAD IS TILTED UP, EYE LINE IS DRAWN ALONG A CURVE.

WISTFUL

LOW ANGLE (UPWARD TILT OF THE HEAD) CAUSES A DISTORTION—A "SQUARING" OF THE CHIN.

CHIN DOESN'T PROTRUDE IN THREE-QUARTER VIEW ON FEMALES.

REGRET

FEMALE NECK STARTS MUCH FURTHER IN THAN ON MALES.

JEALOUSY

EYEBROWS PEAK HIGHER ON FEMALES.

WHEN HEAD TILTS
DOWNWARD, EYE
LINE IS DRAWN
ALONG AN
UPWARD CURVE.

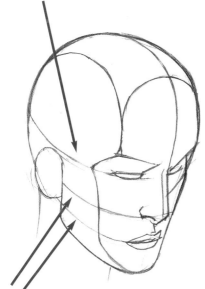

ALL OTHER GUIDELINES
ARE DRAWN ALONG
UPWARD CURVES, TOO.

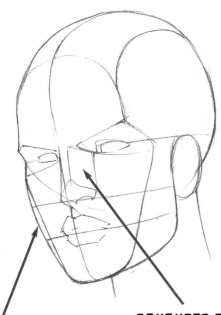

YOU CAN ALWAYS
BUILD OUT THE FACE
TO ADD SOFTNESS.

REMEMBER THAT THE
SIDE PLANE OF THE
NOSE IS ACTUALLY A
FAIRLY WIDE AREA.

SADNESS

VENGEFUL

Good guy or bad guy? In regular action-style comics the costume clues us in. Bad guy costumes are generally more elaborate. In noir, it's the shadows that reveal a character's inner demons. Here are a few more hardened expressions for you, awash in shadow.

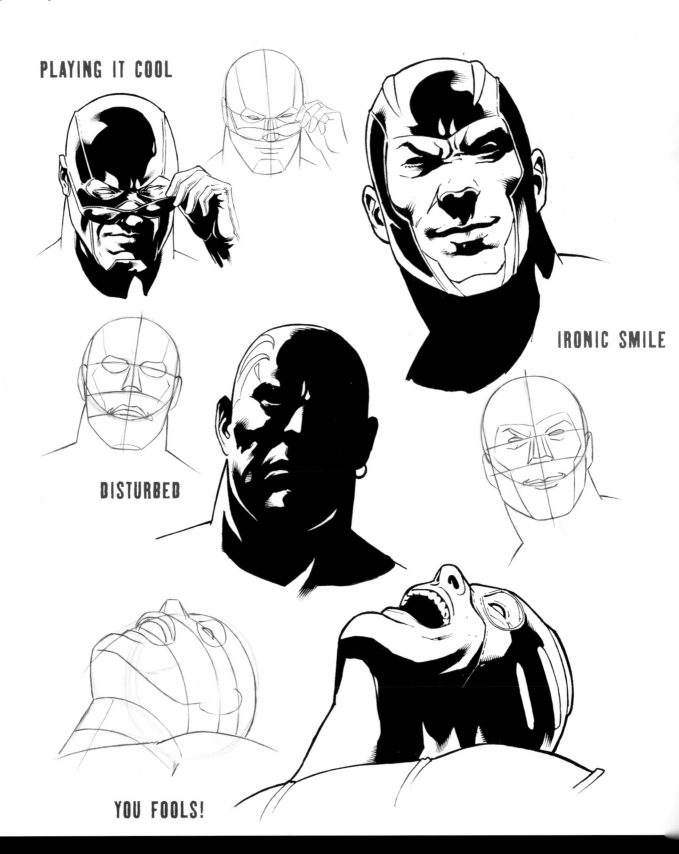

PLAYING IT COOL

IRONIC SMILE

DISTURBED

YOU FOOLS!

CLASSIC NOIR POSES: THE PRIMAL SCREAM

When the pain of rage becomes too much to contain, a man will break into a primal scream, unleashing a flood of violent emotions. This fury is either a precursor to a vicious attack, or the chest-beating version of a primitive victory dance. Either way, it's a terrifying moment, as all sanity has left our hero, who is possessed by passions beyond his ability to control. Every sinew of the characters body is tensed. He is quite literally mad. He may kill his enemies when he only means to subdue them.

This posture—arms out, ready to crush—mimics the great silverback gorilla. Every muscle in his body is flexed and squeezed together.

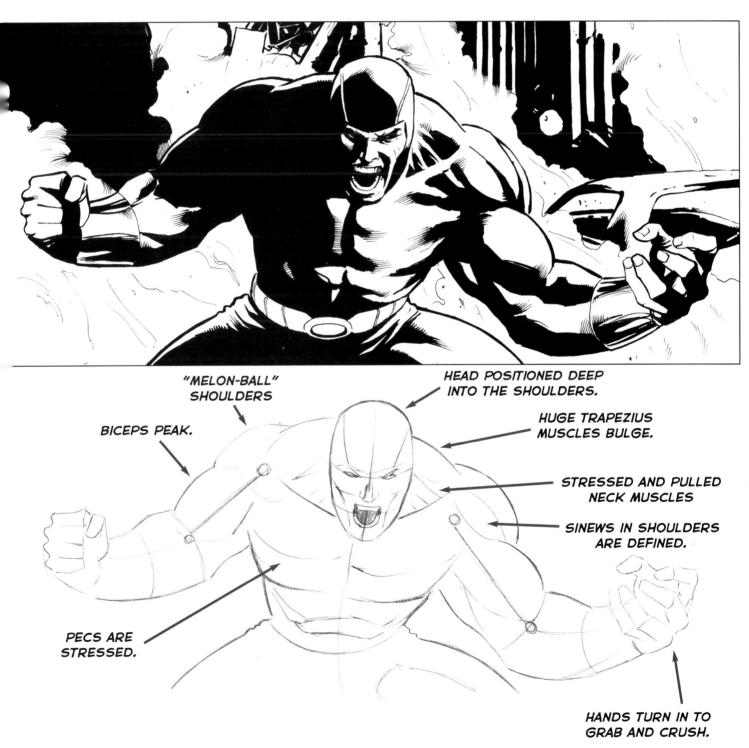

"MELON-BALL" SHOULDERS

HEAD POSITIONED DEEP INTO THE SHOULDERS.

BICEPS PEAK.

HUGE TRAPEZIUS MUSCLES BULGE.

STRESSED AND PULLED NECK MUSCLES

SINEWS IN SHOULDERS ARE DEFINED.

PECS ARE STRESSED.

HANDS TURN IN TO GRAB AND CRUSH.

Chosen to save mankind—but not himself. This is the foundation upon which noir heroes are built. His brooding is born not out of self-pity, but self-reliance. His soul can feel neither joy nor pain. He becomes a mythic figure, sacrificing himself for the good of others, but asking nothing, gaining nothing. Why does he do it? The answer lies in this question: What is his alternative?

The brooding figure is blanketed in shadow. Shadow is used as a mask, preventing even the reader from getting inside the mind and heart of the character. In the same way that no one could really get to know Raymond Chandler's famous noir private eye, Philip Marlow, the reader's experience of the costumed hero is defined by the walls he erects between himself and his humanity.

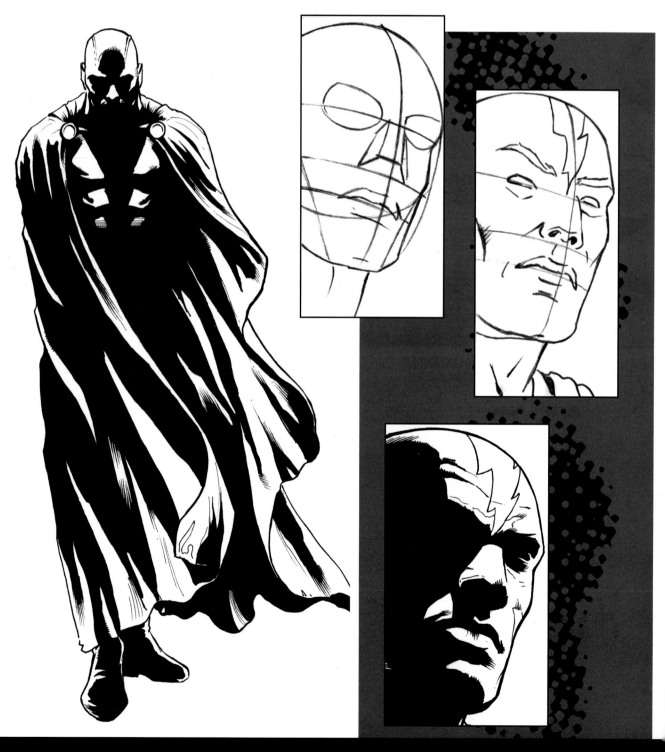

He can rescue her. He can comfort her. He can, and will, always protect her. He can touch her tenderly and wipe away her tears. But he cannot love her. His heart is too hard to give to one so innocent. He would not burden her with the fires that burn in his soul. She cannot understand. And she never will.

When you draw two lovers together, draw them as if he were protecting her with all the chivalrous, politically incorrect, gloriously romantic heroism you can conjure up. In return, she should nestle into his arms, safe and unafraid, while his attention remains vigilantly attuned to the dangers that lie ahead.

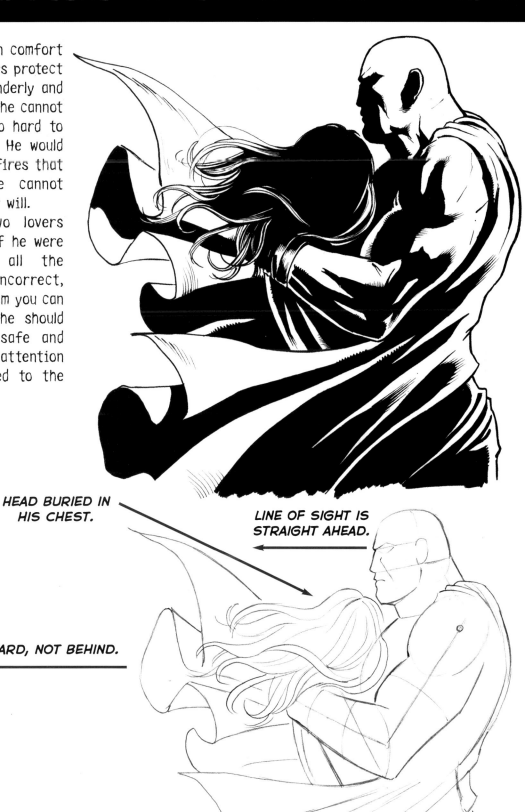

HEAD BURIED IN HIS CHEST.

LINE OF SIGHT IS STRAIGHT AHEAD.

CAPE BLOWS FORWARD, NOT BEHIND.

Unlike the "Pow!" "Blam!" "Zowie!" of standard, action-style comics, the crime noir genre focuses on the human condition of the action hero.

In his civilian life, the costumed hero may be successful and charming. But it all seems superficial to him, because the stakes are so much higher in his secret life as a crime-fighter. He started out thinking he was a good guy. But he's done a lot of bad things for a good cause. Now he's not sure what he is, or where he fits in. And so he's a man walking alone, even in a crowded room at the Waldorf, where he's being feted for his philanthropy. As nighttime falls on the city, he can hear the cold winds blowing. There's trouble coming. And only one man can stop it.

Let's take a look at some good examples of settings that make up the costumed hero's life in the crime noir genre. Many of these scenes, which are laid out for clarity and impact, have multiple characters. They're all accompanied by simplified versions of the compositions, to enable you to practice them.

CHARITY BALL

Our hero may be a wealthy patron of the arts, invited to an exclusive, $5,000-a-plate event. Despite the beautiful people, social climbing, and innumerable "air kisses," his mind is somewhere else.

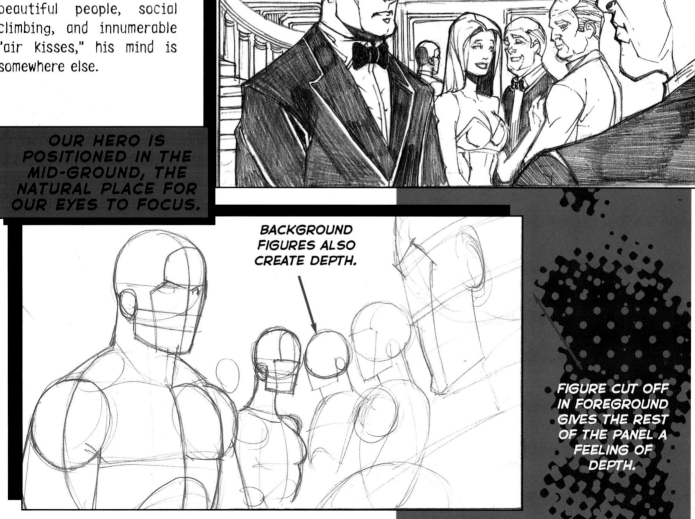

OUR HERO IS POSITIONED IN THE MID-GROUND, THE NATURAL PLACE FOR OUR EYES TO FOCUS.

BACKGROUND FIGURES ALSO CREATE DEPTH.

FIGURE CUT OFF IN FOREGROUND GIVES THE REST OF THE PANEL A FEELING OF DEPTH.

RESPECTS TO AN OLD FRIEND

A visit to a cemetery gives a story some guts, and takes a story from fluff to pathos, which is needed in this genre.

The tilted frame is used to convey a state of flux—something out of sync. This scene cannot then be interpreted to mean that the hero has come to grips with his best friend's passing. Rather, the tilted panel represents a gathering anger that will soon spill over into an act of revenge.

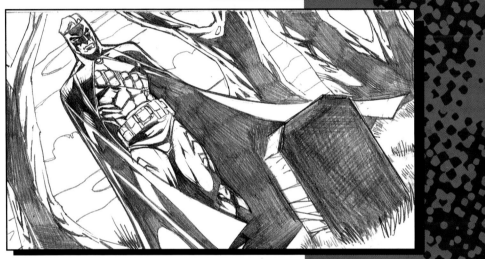

A CRY OF ANGUISH

This is a timeless pose of grief. Yes, he was in time to save the city, but not his one true love. Who will hear his cry over the roar of the subway?

TILTED FRAME WITH HEAVILY TILTED VERTICALS EMPHASIZE EMOTIONAL UPHEAVAL.

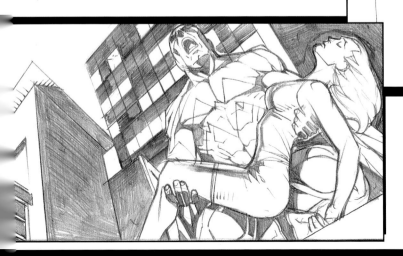

FIGURES ARE POSITIONED OFF TO ONE SIDE OF THE PANEL, NOT IN THE MIDDLE, WHICH WOULD HAVE A CALMING EFFECT.

WHAT ARE YOU THINKING, JOHNNY?

How can he tell her his thoughts, when he can't even tell her who he is, or what he does at night?

LEAVE ROOM IN FRONT OF CHARACTERS WHO ARE LOOKING AT SOMETHING.

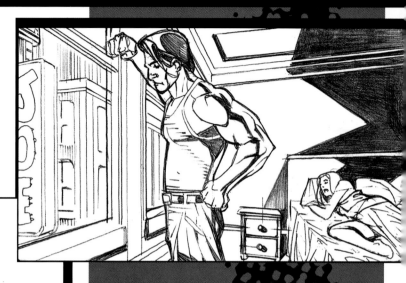

VARY SIZE OF CHARACTERS (FOREGROUND/BACKGROUND DYNAMICS) TO REFLECT LACK OF INTIMACY.

SWEET DREAMS, KID

He doesn't bring flowers. He doesn't even call. And rarely will he stay the night. But damn it, she loves him anyway.

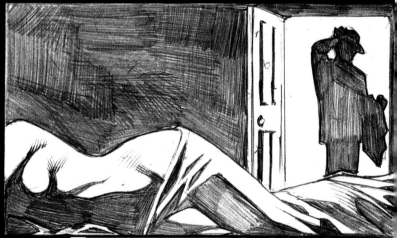

DOOR FRAME PROVIDES NICE OUTLINE AND LIGHT SOURCE FOR SILHOUETTE.

OVERLAP OF BODIES ADDS A FEELING OF DEPTH.

READY TO POUNCE

When your rooftop hero sees trouble, he leans over the ledge and takes a look below.

CORNER BASED ON TWO DIAGONALS IS MORE DYNAMIC THAN HORIZONTAL LEDGE.

THE TILTED SCENE ADDS TO THE FEELING OF MENACE. THE LOW ANGLE SHOWS THAT WE ARE LOOKING UP FROM BELOW.

A LOOK IN THE MIRROR

A panel like this is a "punctuation moment." It's a beat in the story. No dialogue, thought balloon, or caption is even necessary. It's a pause for introspection. Who am I? What have I done? Does anyone love me? The mirror says it all.

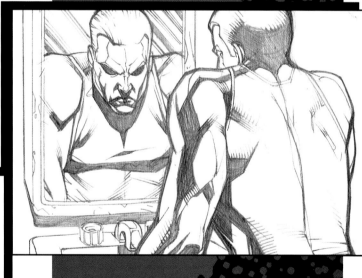

A SHOT OVER THE SHOULDER IS CALLED A "REVERSE ANGLE."

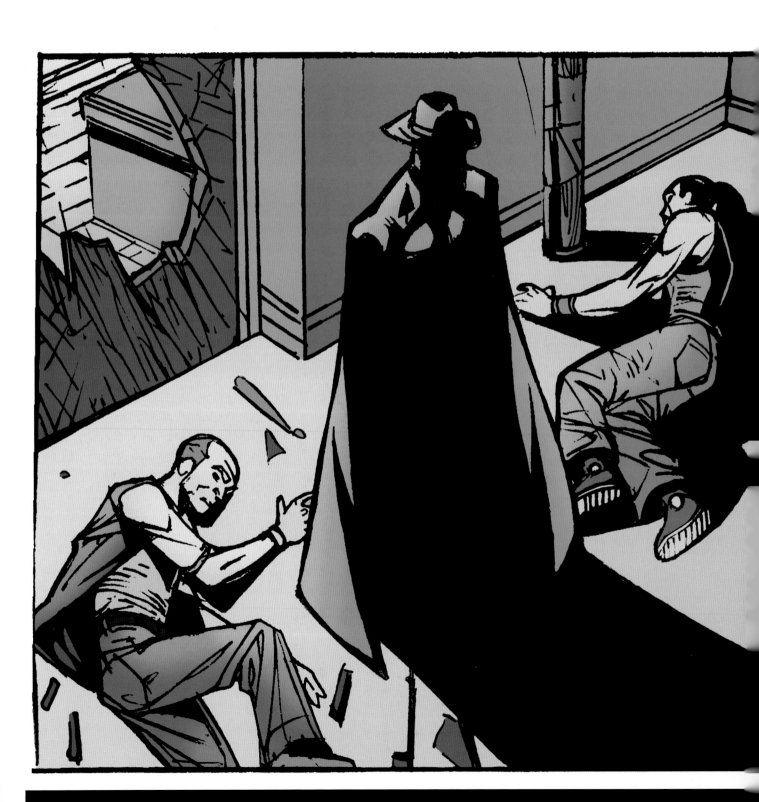

Vigilante Justice

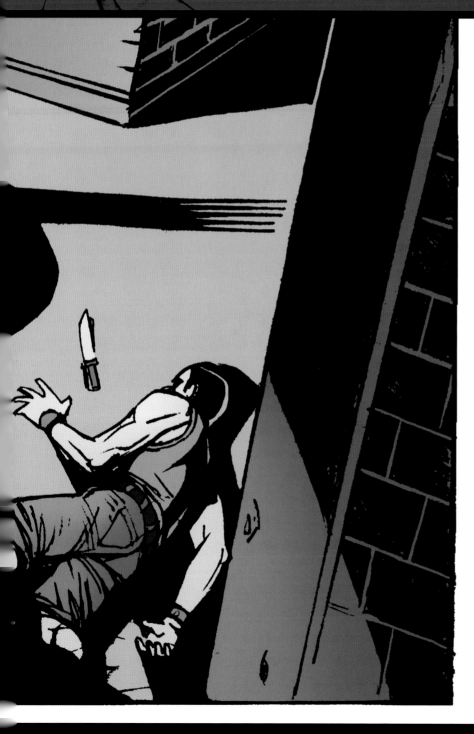

The cops in this town are all on the take. The bad guys own the streets, and they know it. No one feels safe anymore. You can call 911 and wait for a cop, or you can do what I do. I get a little fed up. Some of my associates feel the same way. We take matters into our own hands. The officers on the force don't seem to appreciate our efforts. They probably miss the fact that their meal ticket has just gotten his ass thrown through a plate glass window.

The fact is, if you're gonna walk through my city at night causing trouble, trouble is just what you're gonna get. So if you're a two-bit criminal looking for an easy mark, and you see a homeless guy in an overcoat shuffling down the street, that might just be me, waiting for you. Fair warning. Be seeing ya.

Just grabbing somebody doesn't show brute force. For that, you've gotta position your character so that he's lifting his opponent up, over his head, and pressing him hard against the wall. The opponent's feet must be flailing, off the ground, to heighten the sense of helplessness.

Step-by-Step from Roughs to Inks

In this chapter, we're going to see the various stages a comic book page goes through on its way to completion: Blocking out the scene with simplified figures; refining the characters; crystallizing the characters and adding shadows and pools of black; and, finally, inking.

Each stage is completed before moving on to the next. The current trend is for pencilers to ink their own work; however, it's still much more common for specialized inkers to be assigned to ink over a penciler's original drawings. Often, inkers take on a few freelance penciling gigs, but are known mostly for their inking skills. The majority of pencilers and inkers still specialize, and my guess is that they always will.

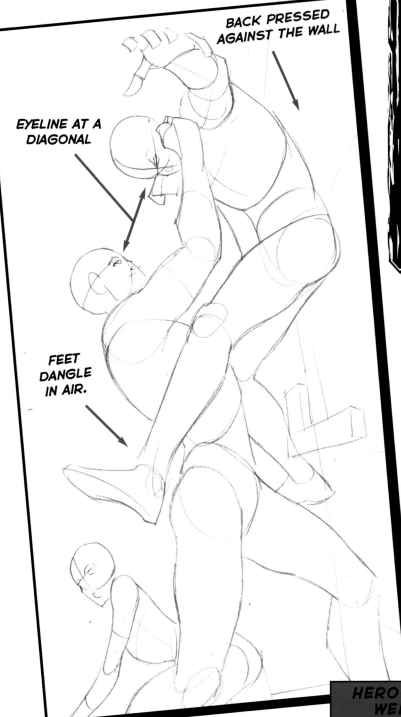

BACK PRESSED AGAINST THE WALL

EYELINE AT A DIAGONAL

FEET DANGLE IN AIR.

BLOCKING OUT THE SCENES

Notice that even though all three charact overlap each other, it's done in such a way t the reader can see each of them clearly. hero's arms are not blocking the bad guy's fe The bad guy's arms and legs aren't obscur our view of the hero. And the girl is lear forward, so that we get a clear look at her, This kind of clear layout doesn't just happen accident. It often takes several attempts readjustments to get it right.

HERO LEANS BACK TO SUPPORT WEIGHT OF HIS OPPONENT.

REFINING THE CHARACTERS

It's at this "refining" stage that you begin to work in the features and expressions, and to sculpt the muscles and costumes. More experienced artists may begin their drawing with a combination of the first two stages: drawing the main characters in detail from the outset, but leaving the surroundings and supporting characters, like the girl and the alleyway, simplified. It's your talent, and your individual path as an artist. Try these standard approaches, but, ultimately, carve out what works best for you.

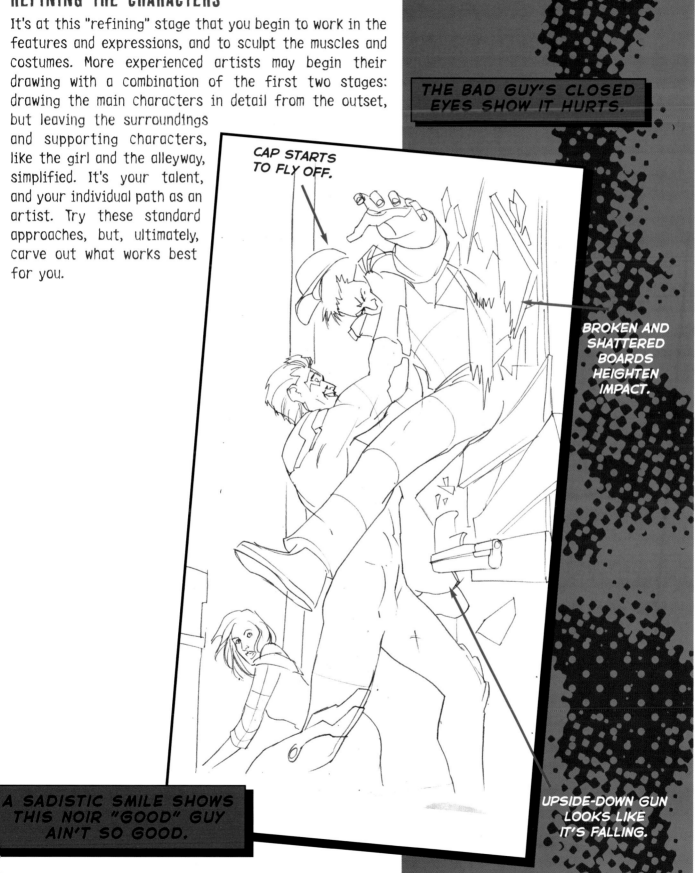

THE BAD GUY'S CLOSED EYES SHOW IT HURTS.

CAP STARTS TO FLY OFF.

BROKEN AND SHATTERED BOARDS HEIGHTEN IMPACT.

A SADISTIC SMILE SHOWS THIS NOIR "GOOD" GUY AIN'T SO GOOD.

UPSIDE-DOWN GUN LOOKS LIKE IT'S FALLING.

CRYSTALLIZING THE CHARACTERS AND ADDING BLACKS

Pencilers mark their pages with small Xs to indicate to the inkers areas they should fill with pools of black. The inker can't read the penciler's mind, and without those visual notes, the inker is liable to misunderstand the more complex areas of the illustration. An inker might fill areas meant to be left white; or leave areas white that are meant to be filled black. Any areas that the penciler has already hand-shaded black, in pencil, will be automatically inked black by the inker.

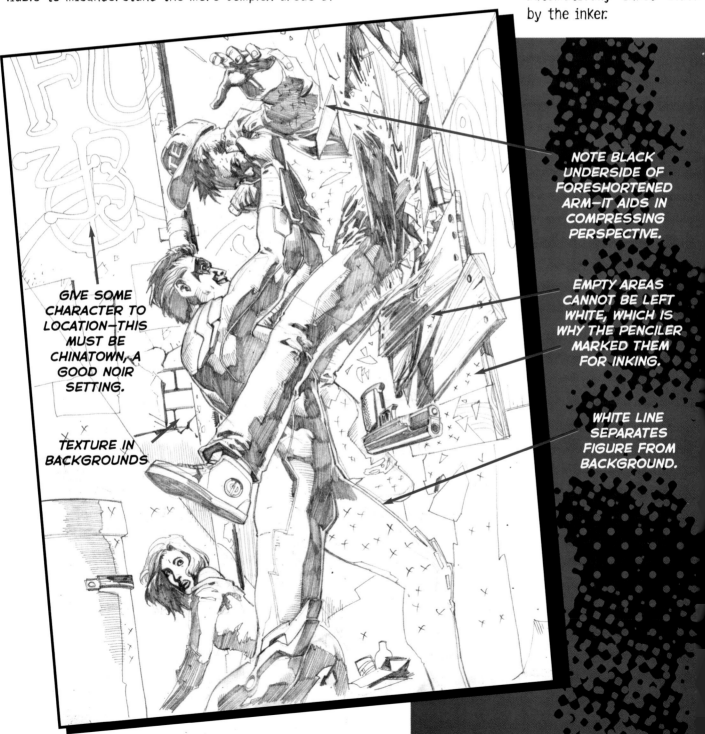

GIVE SOME CHARACTER TO LOCATION—THIS MUST BE CHINATOWN, A GOOD NOIR SETTING.

TEXTURE IN BACKGROUNDS

NOTE BLACK UNDERSIDE OF FORESHORTENED ARM—IT AIDS IN COMPRESSING PERSPECTIVE.

EMPTY AREAS CANNOT BE LEFT WHITE, WHICH IS WHY THE PENCILER MARKED THEM FOR INKING.

WHITE LINE SEPARATES FIGURE FROM BACKGROUND.

INKS

Before the vigilante knocks this two-bit punk's lights out, he's going to make sure he takes his time. No reason to rush through the fun part.

Note the thin, white line that travels the length of the hero's body, separating the blacks of his costume from the blacks of the background. If you look at the previous drawing, you'll see that the white line was indicated by the penciler. If it were not there, much of the heroic figure would be subsumed in the darkness, which is also a good look, but a moody, atmospheric one, not the violent, action-oriented moment we're trying to portray.

The white lines around the broken planks were not indicated at the penciling stage. But when this page was being inked, the inker spotted an opportunity to include them, and made good use of it.

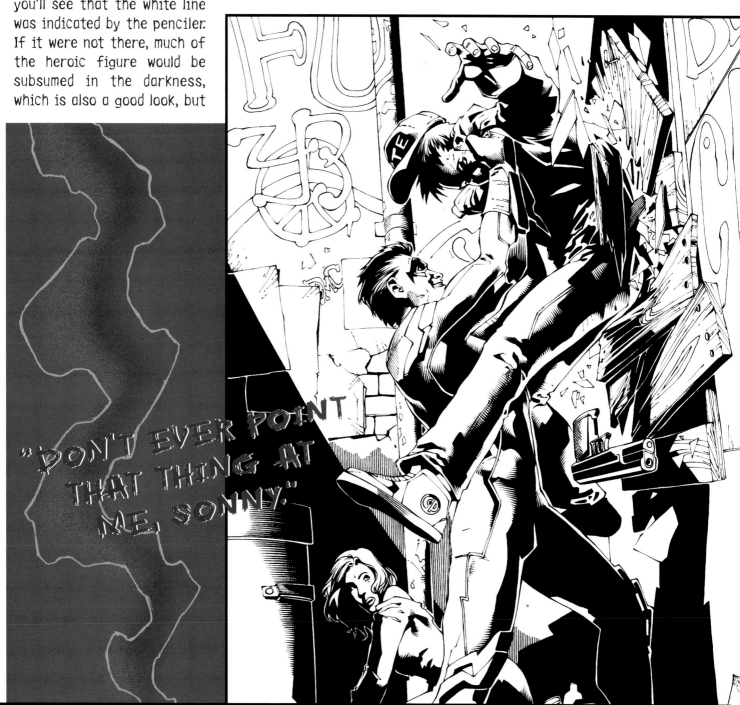

"DON'T EVER POINT THAT THING AT ME, SONNY."

THE AMBUSH

Five to one seems like good odds, but you'd be wrong. Dead wrong.

BLOCKING OUT THE SCENE

In an ambush scene, it's always important for the ambushed character to feel surrounded, front, back, left and right. The verticals in the panel are tilted, giving the reader the uneasy feeling that things are not going to go as planned....

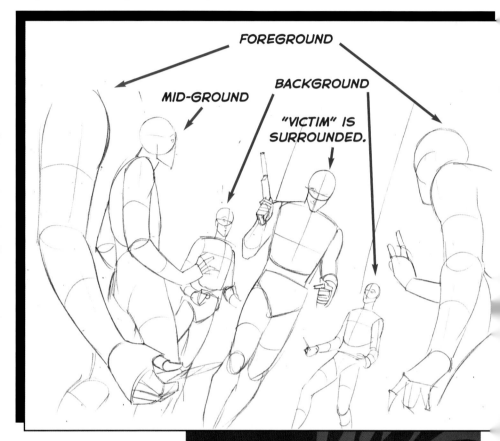

FOREGROUND

BACKGROUND

MID-GROUND

"VICTIM" IS SURROUNDED.

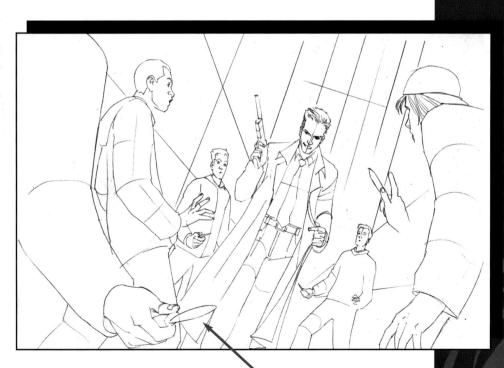

WEAPONS PROMINENT

REFINING THE CHARACTERS

In comics, the one who's smiling is usually the one who wins, especially if the situation's a dangerous one.

CRYSTALLIZING CHARACTERS AND ADDING BLACKS

It doesn't matter how bright it is outside, where your character is, there are always shadows. This is crime noir. The city's buildings cast stark shadows over entire blocks. Gates, streetlamps, busted windows—they all cast patterns of shadows that add flavor to the city.

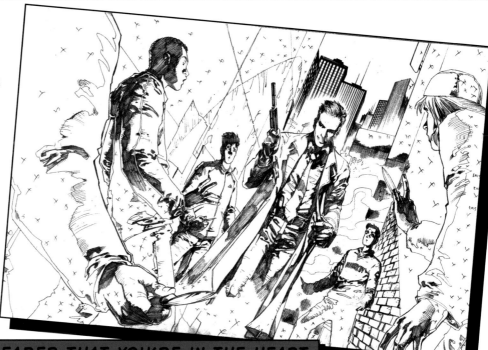

ALWAYS REMIND YOUR READER THAT YOU'RE IN THE HEART OF THE CITY: TALL BUILDINGS, NARROW STREETS, AND STEAM RISING FROM SUBWAY GRATINGS.

INKS

Dark alleyways are always bad for the victim. But in crime noir, it's not always so clear who the victim's going to be.

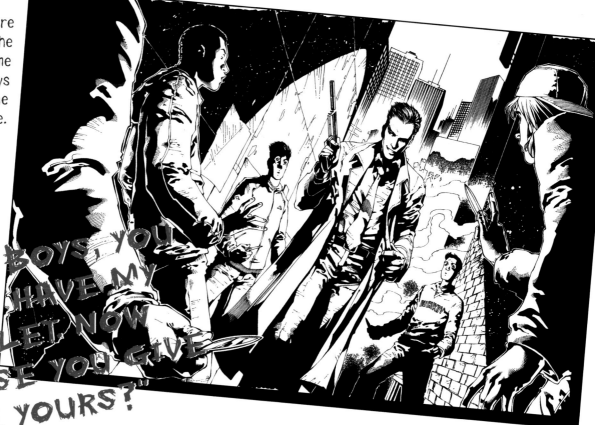

"SORRY BOYS, YOU CAN'T HAVE MY WALLET NOW SUPPOSE YOU GIVE ME YOURS?"

Sometimes a guy can't get a break. How's he supposed to know she'd been robbed three times last month and decided to get even with the next guy to try it?

REFINING THE CHARACTERS

She's decided to make this magic moment last. Your character has to get comfortable. More to the point, she has to *look* comfortable. So what are you going to do with her arms? As an artist, you need to think about things like this. These small questions become important. Look at how this was solved: The back of her chair has been turned into a ledge, which acts as a tabletop for her arms to rest upon. It looks so natural, you probably didn't even notice it. But these things don't just happen by themselves, I can assure you. A less experienced artist might have drawn her gesticulating with her arms from panel to panel through the entire sequence, which would have made me want to tie *her* up and gag her.

BLOCKING OUT THE SCENE

The body language says it all: She's leaning forward, in his face. He's leaning back, but he ain't going nowhere until *she* says, "We're done."

FORWARD-LEANING HEAD IS A SIGN OF STRENGTH, AGGRESSION.

CASUAL HAND POSITION SAYS, "THIS IS GOING TO TAKE A WHILE."

BACKWARD-LEANING HEAD IS A SIGN OF WEAKNESS.

TIED WRISTS FOR A CAPTIVE LOOK

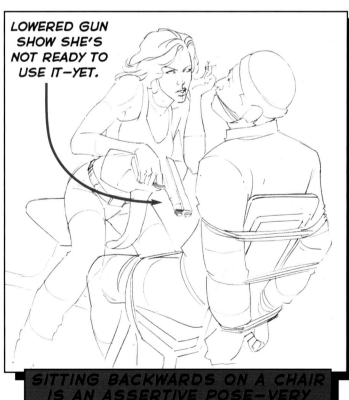

LOWERED GUN SHOW SHE'S NOT READY TO USE IT—YET.

SITTING BACKWARDS ON A CHAIR IS AN ASSERTIVE POSE—VERY SEXY ON AN ATTRACTIVE WOMAN.

CRYSTALLIZING CHARACTERS AND ADDING BLACKS

The two walls of the room are angled so that they intersect at severe diagonals, which provides an unsettling quality pervasive throughout the crime noir genre. A typical "slash shadow" (a shadow at a sharp diagonal) hits the wall, giving the apartment a low-rent look.

SLASH SHADOW

ANGLE OF WALL

ANGLE OF WALL

INKS

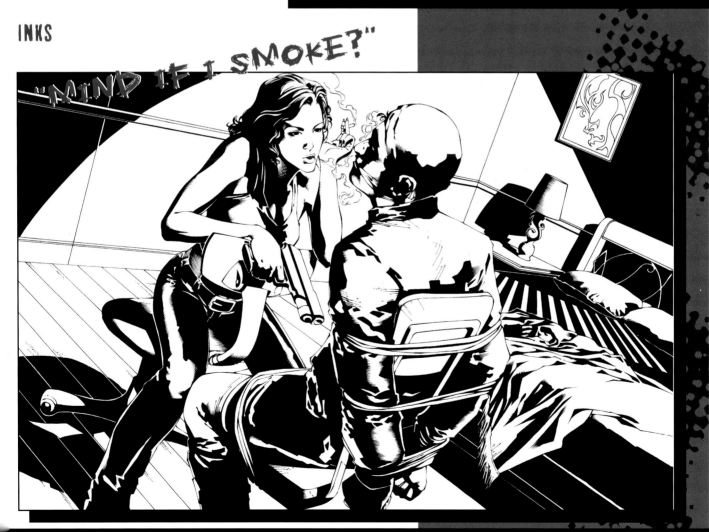

"MIND IF I SMOKE?"

The Professionals

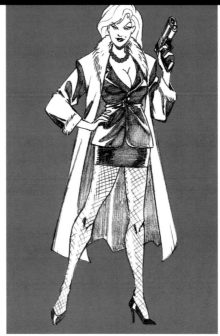

6

The world of crime has a social structure and a hierarchy. Traditions must be observed. Respect paid. Rules followed. When these are breached, the consequences are swift—and often brutal. There's a whole underground infrastructure upon which this foundation is built. We're not talking about two-bit hoodlums who break into bodegas at three in the morning, shoot some immigrant cashier just trying to support his family, and make off with a few hundred bucks, and just as many years in the joint. The guys I'm talking about never get their hands dirty. They have other guys do it for them. They're the fences, the loan sharks, the numbers runners. The grease that makes the wheels go round. They're in every neighborhood with their fingers in every pie. Maybe you'd like to meet some of them. Maybe you shouldn't. Well, we've gone this far. It's a little too late to turn back now.

The difficult thing about bringing these guys to justice is that they also run legitimate businesses. It's just that they happen to run across a steady flow of hot merchandise in their line of work. And they seem to have difficulty telling the stolen items from the regular ones. A great deal of difficulty.

A SIDEWAYS GLANCE AT HIS "CLIENTS"

THIN JAW FOR A SKINNY CHARACTER TYPE

THINNING HAIR (PAWNBROKER IS AN OLD MAN'S PROFESSION)

BARS ON WINDOW TO PROTECT HIM AND HIS MISERLY MANNER

JEWELER'S LOUPE

HUMP FROM HUNCHING OVER JEWELRY

HORIZONTAL LINES INDICATE SHELVING IN BACKGROUND

SHOTGUN FOR PROTECTION

HEIRLOOMS AND VALUABLES

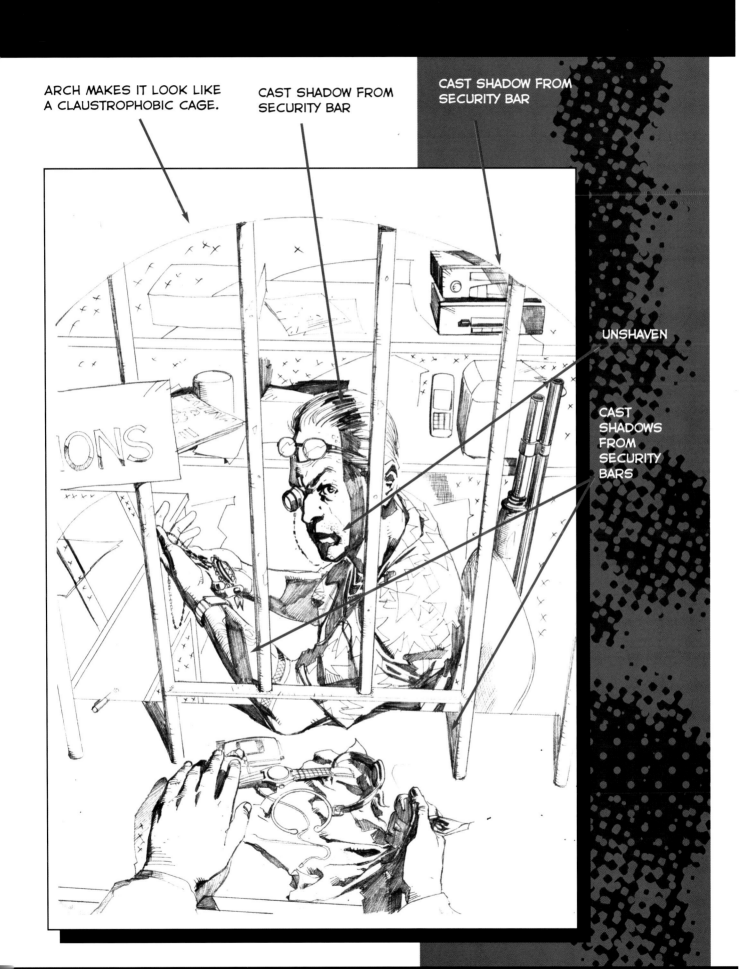

IN THE WORLD THAT THESE HANDS BELONG TO, THE HANDS THAT ARE HOLDING ONTO THESE HEIRLOOMS, THE HANDS THAT ARE DESPERATE FOR SOME FAST CASH, A MAN NEEDS TO RAISE TWO GRAND BY 5:00 P.M., OR TWO FELLOWS ARE GOING TO PAY HIM A VISIT. WHAT YOU SEE HERE, THAT'S ALL THE STUFF HE OWNS IN THE WORLD. AND THERE'S NO TRAIN THAT CAN GET HIM FAR ENOUGH AWAY THAT THOSE TWO MEN CAN'T FIND HIM.

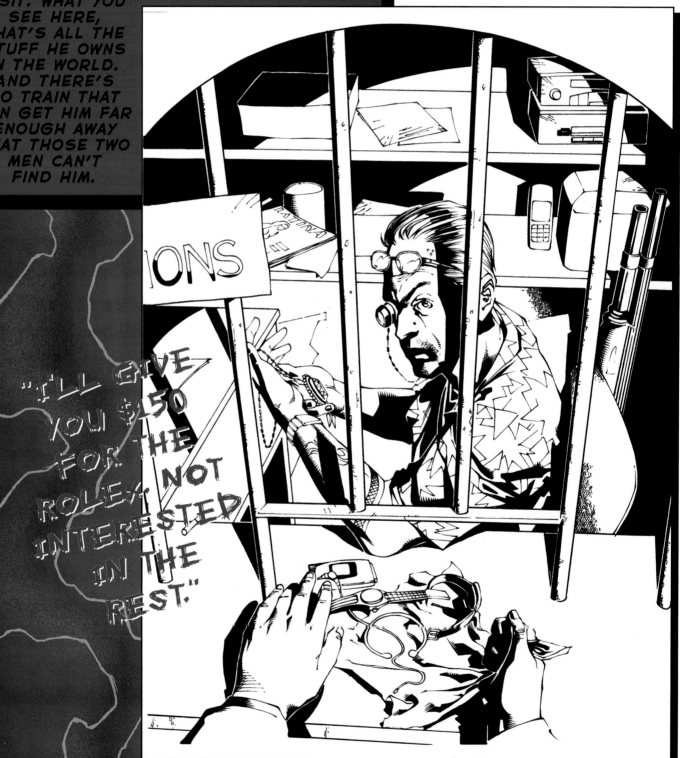

"I'LL GIVE YOU $50 FOR THE ROLEX, NOT INTERESTED IN THE REST."

How do you think all those sleaze joints stay open? Luck? Cops with glaucoma? Try dirty cops. There's only one thing worse than being an informer for the cops. And that's being a patsy for a cop on the take. Because you don't get a payoff. You get to not have your collarbone busted. Don't like those terms? Who are you going to complain to? The cops?

SEVERE DIAGONAL SETS UP DYNAMIC OF POWER TO WEAKNESS.

ON TOES, OFF BALANCE AS COP ALMOST PICKS HIM UP OFF GROUND

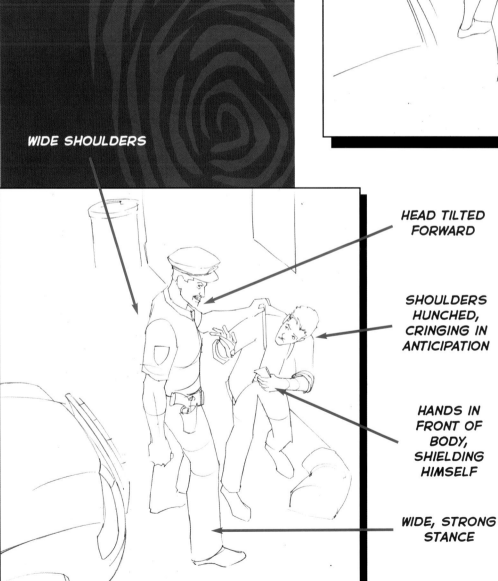

WIDE SHOULDERS

HEAD TILTED FORWARD

SHOULDERS HUNCHED, CRINGING IN ANTICIPATION

HANDS IN FRONT OF BODY, SHIELDING HIMSELF

WIDE, STRONG STANCE

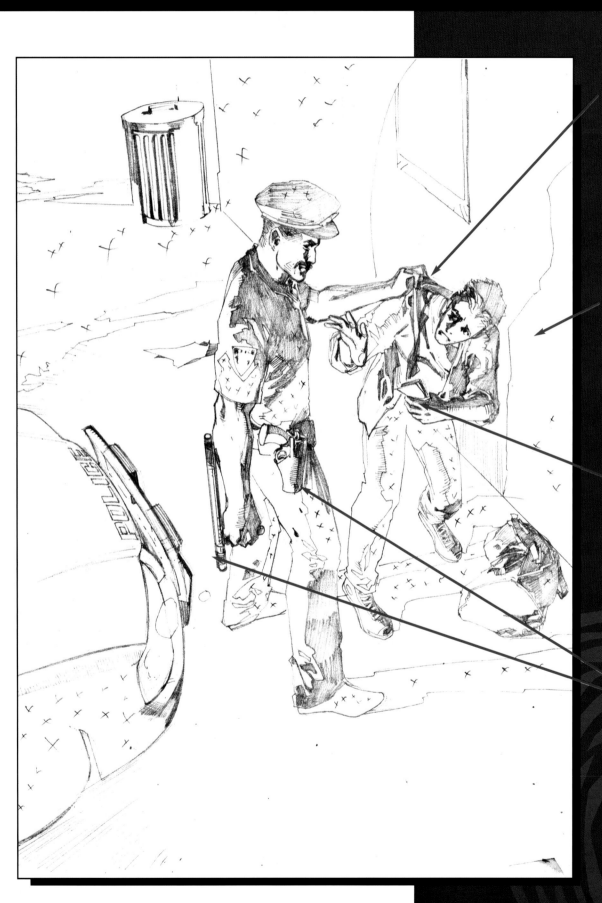

IT'S NOW CLEAR THAT THE COP IS PULLING UP, HARD, ON VICTIM'S JACKET.

COP CASTS IMPRESSIVE SHADOW ON WALL.

CASH PAYOFF IN HAND

WEAPONS IN PLAIN SIGHT: GUN...AND NIGHTSTICK

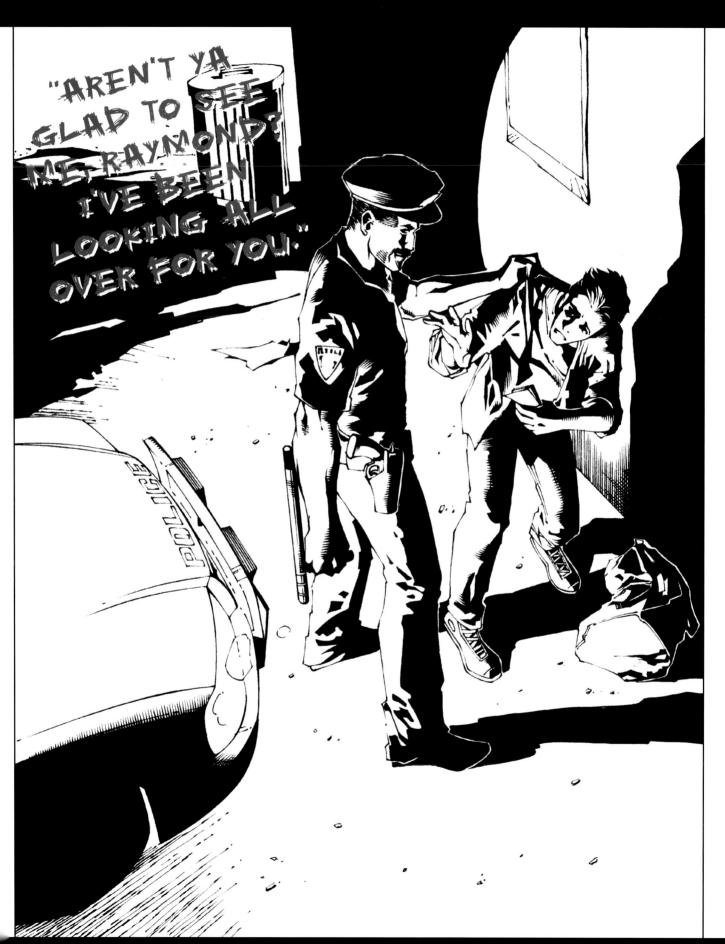

There's a little quirk of the law that gives mobsters a headache: If you show up at a hospital or a doctor's office with a bullet hole in the gut, the hospital staff is required to report it to the police. Then the boys in blue come down and start asking all kinds of pain in the ass questions, like "Who shot you?" and "Who do you work for?" and the always uncomfortable, "Where did you get that Glock?"

As a result, the bad guys avoid emergency rooms. They go to more specialized health care providers, ones who never technically graduated from medical school. But if you're lucky, you might get one who did his training as a vet. No, not a veteran in the army—a veterinarian. The operation can be tough, especially the sterilization part. You can plead all you want, but there's no way the boss is taking you to a hospital, buddy. But don't worry. You're guaranteed to get the best care, the same kind his own poodle gets.

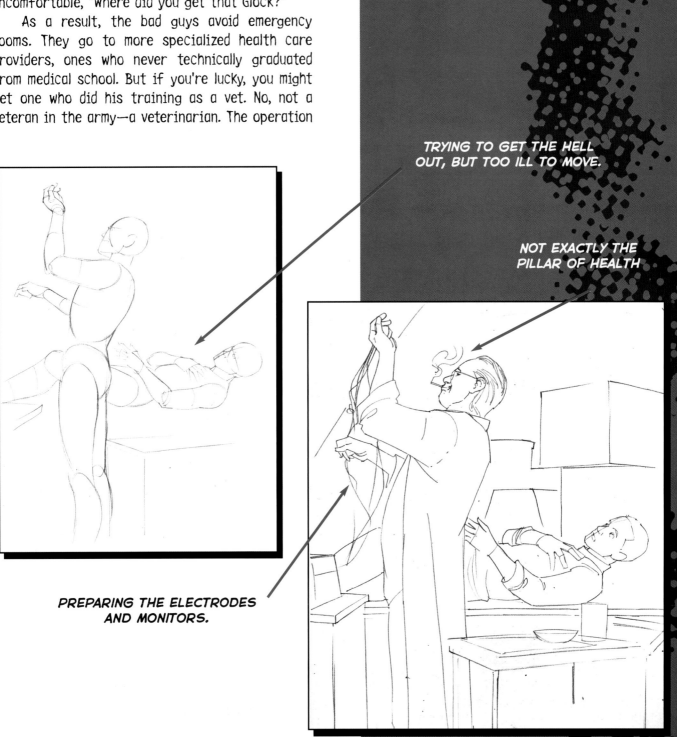

TRYING TO GET THE HELL OUT, BUT TOO ILL TO MOVE.

NOT EXACTLY THE PILLAR OF HEALTH

PREPARING THE ELECTRODES AND MONITORS.

THE DOG FROM LAST WEEK HAS ALREADY BEEN PUT DOWN.

LOTS OF BLACKS AND SHADOWS PERVADE—NOT EXACTLY YOUR TYPICAL OPERATING ROOM.

LOOKS AT TRAY OF BLUNT INSTRUMENTS WITH DREAD.

YOU COULD COMPLAIN, BUT SINCE THERE ARE NO REPEAT CUSTOMERS, WHO'D LISTEN?

WOUND MUST BE APPARENT.

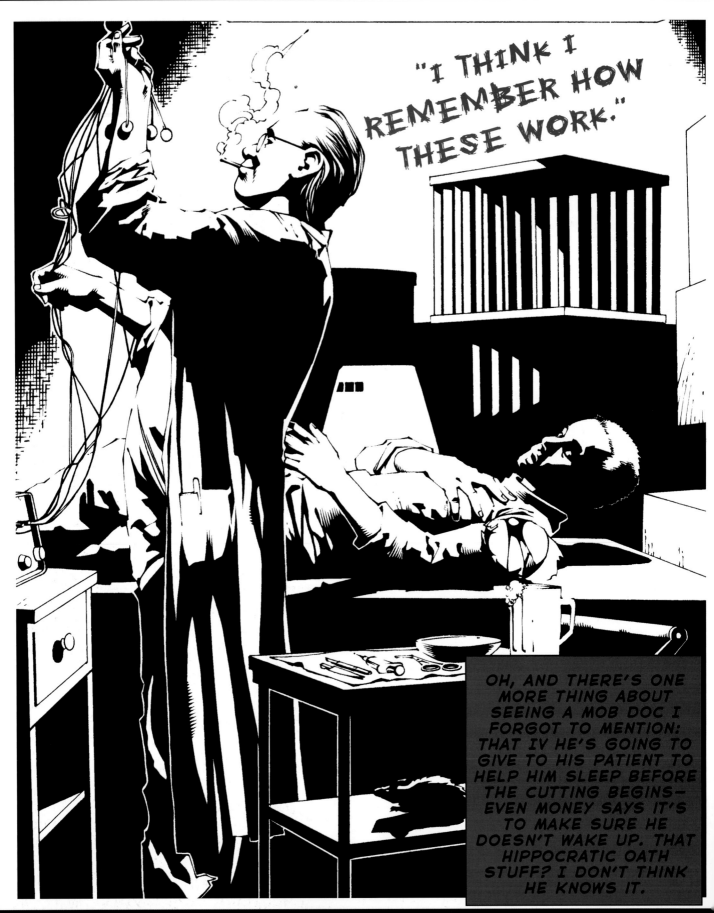

MOBBED-UP LAWYER

Here's another white-collar crook you don't want to be without: a mob lawyer. He sets up shell companies to launder illegal gambling proceeds. And he gives all his clients deniability on the witness stand. When he graduated law school, he was planning to work for one of the big tobacco companies, but he decided to do something more respectable, so he joined the mob.

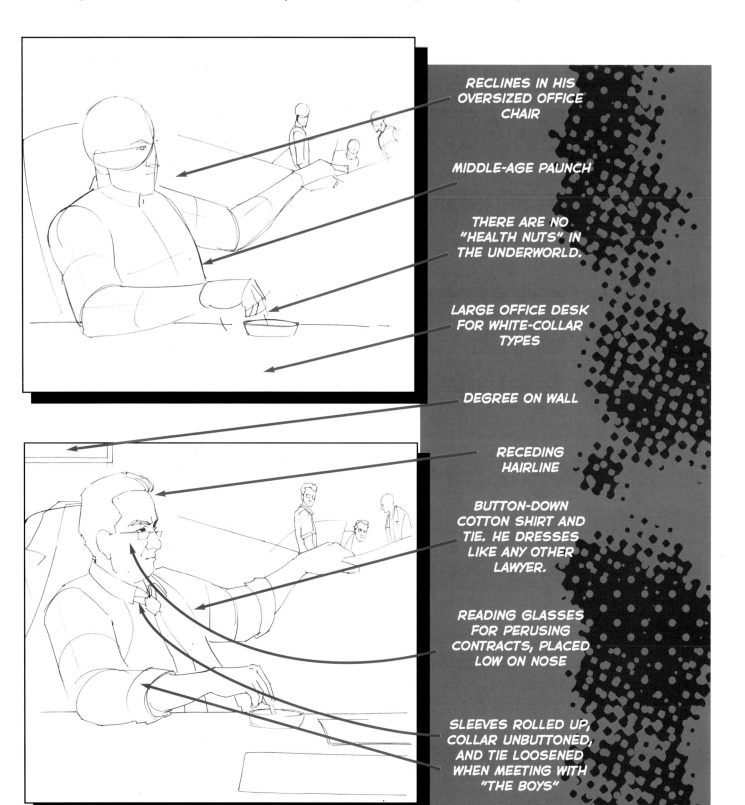

RECLINES IN HIS OVERSIZED OFFICE CHAIR

MIDDLE-AGE PAUNCH

THERE ARE NO "HEALTH NUTS" IN THE UNDERWORLD.

LARGE OFFICE DESK FOR WHITE-COLLAR TYPES

DEGREE ON WALL

RECEDING HAIRLINE

BUTTON-DOWN COTTON SHIRT AND TIE. HE DRESSES LIKE ANY OTHER LAWYER.

READING GLASSES FOR PERUSING CONTRACTS, PLACED LOW ON NOSE

SLEEVES ROLLED UP, COLLAR UNBUTTONED, AND TIE LOOSENED WHEN MEETING WITH "THE BOYS"

Venetian Blinds:
The Classic Noir Shadow Pattern

Into a dimly lit room sunlight pours through the slits in the Venetian blinds. This type of shadow pattern weaves in and around everything it falls on, like a piece of netting draped over a figure. The shadows capture him like the bars of a jail—an apt metaphor for this gritty genre.

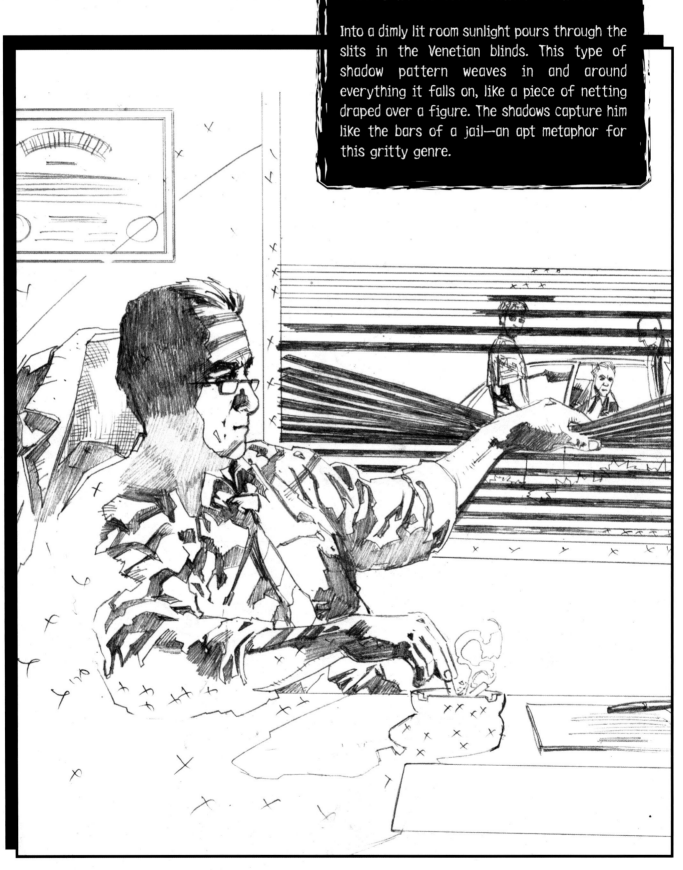

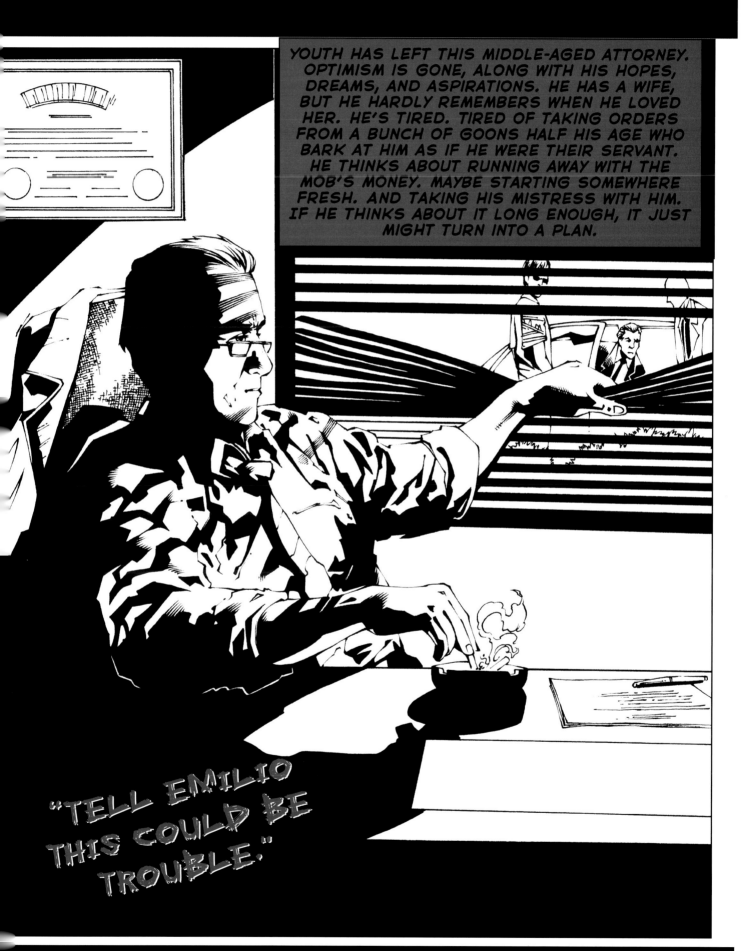

YOUTH HAS LEFT THIS MIDDLE-AGED ATTORNEY. OPTIMISM IS GONE, ALONG WITH HIS HOPES, DREAMS, AND ASPIRATIONS. HE HAS A WIFE, BUT HE HARDLY REMEMBERS WHEN HE LOVED HER. HE'S TIRED. TIRED OF TAKING ORDERS FROM A BUNCH OF GOONS HALF HIS AGE WHO BARK AT HIM AS IF HE WERE THEIR SERVANT. HE THINKS ABOUT RUNNING AWAY WITH THE MOB'S MONEY. MAYBE STARTING SOMEWHERE FRESH. AND TAKING HIS MISTRESS WITH HIM. IF HE THINKS ABOUT IT LONG ENOUGH, IT JUST MIGHT TURN INTO A PLAN.

"TELL EMILIO THIS COULD BE TROUBLE."

This is not your typical street corner entrepreneur with a few Saturday night specials to sell. Our guy works internationally. You don't know where he's from. And you don't ask. You want what he has? You have two minutes to decide.

He supplies the top crews with the heavy-duty equipment used to pull off the biggest jobs on the Eastern seaboard. The rendezvous point for the transactions is a warehouse on the docks. A middle-of-the-night place with no address, no lights outside, and no one around.

The buyer for the crew does the talking, picking out what he wants based on his shopping list and budget. And no, the crew isn't likely to shoot the smuggler and steal his weapons. For one thing, it's too early to resort to those tactics. You need your crew to trust you at this point. Two, it's not worth it: If you're going to pull a double-cross, you should do it for the real money, which will come at the end.

NOTE THE LAYOUT: THE CREW GATHERS IN A CIRCLE, MAKING THE GUNS THE CENTER OF ATTENTION.

THE ARMS SMUGGLER AND THE CREW MEMBERS ARE SPECIALISTS, NOT BRUISER-THUGS. THEY WILL BE EXPLOSIVES EXPERTS, DRIVERS, MARKSMEN, AND COMPUTER SOFTWARE HACKERS. THEREFORE, THEY ARE NOT DRAWN WITH BRUTISH PHYSIQUES.

BECAUSE OF THE ANGLE, LOOKING DOWN, PERSPECTIVE REQUIRES THAT THE LINES OF THE BODIES CONVERGE TOWARD THE MIDDLE.

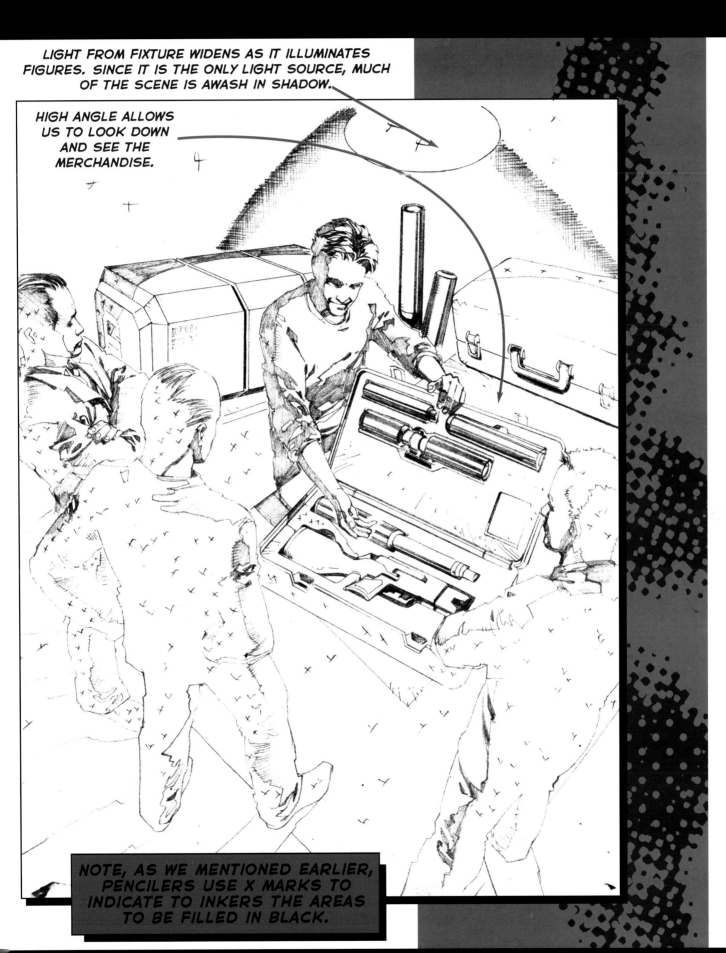

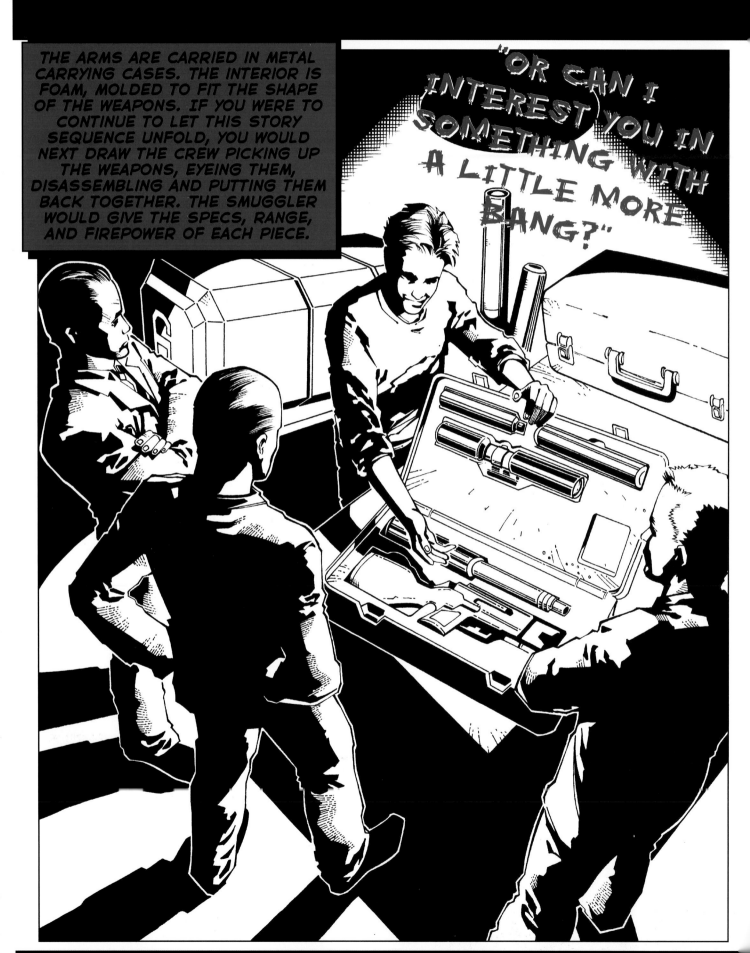

THE ARMS ARE CARRIED IN METAL CARRYING CASES. THE INTERIOR IS FOAM, MOLDED TO FIT THE SHAPE OF THE WEAPONS. IF YOU WERE TO CONTINUE TO LET THIS STORY SEQUENCE UNFOLD, YOU WOULD NEXT DRAW THE CREW PICKING UP THE WEAPONS, EYEING THEM, DISASSEMBLING AND PUTTING THEM BACK TOGETHER. THE SMUGGLER WOULD GIVE THE SPECS, RANGE, AND FIREPOWER OF EACH PIECE.

"OR CAN I INTEREST YOU IN SOMETHING WITH A LITTLE MORE BANG?"

Whether it's poker or pool, there's always someone who looks like an easy mark, but who'll clean your clock when the money is right. And for stupid macho guys, it's hard to resist defending big egos against the likes of a girl.

Comics aren't always filled with non–stop action. There are lots of steamy, atmospheric scenes. Mood shots, dialogue, reaction shots—that's a lot of it. It's important to give your characters something to do—with actions or props—while they talk, in order to keep the page visually interesting, rather than "illustrating talking heads" as they say in the industry. Shooting pool is a good example of an action that supports a scene with lots of dialogue.

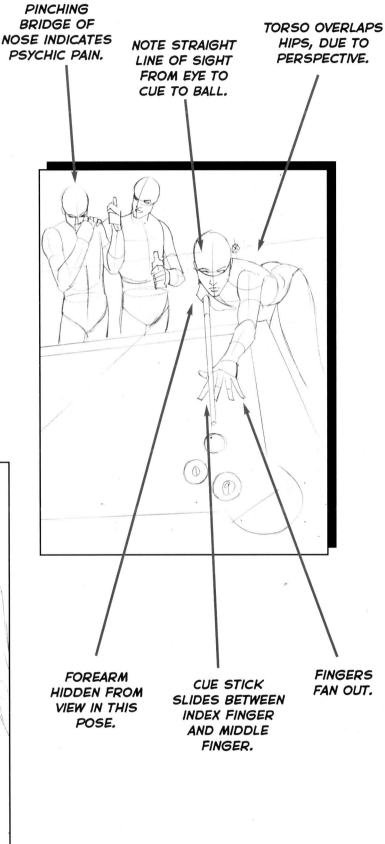

PINCHING BRIDGE OF NOSE INDICATES PSYCHIC PAIN.

NOTE STRAIGHT LINE OF SIGHT FROM EYE TO CUE TO BALL.

TORSO OVERLAPS HIPS, DUE TO PERSPECTIVE.

FOREARM HIDDEN FROM VIEW IN THIS POSE.

CUE STICK SLIDES BETWEEN INDEX FINGER AND MIDDLE FINGER.

FINGERS FAN OUT.

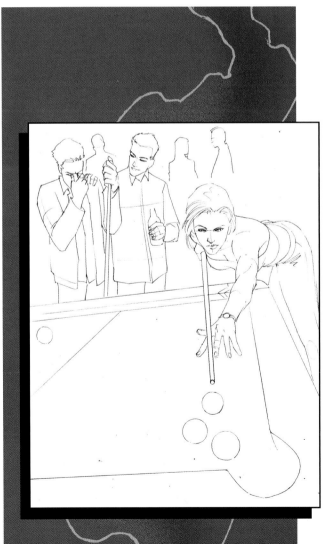

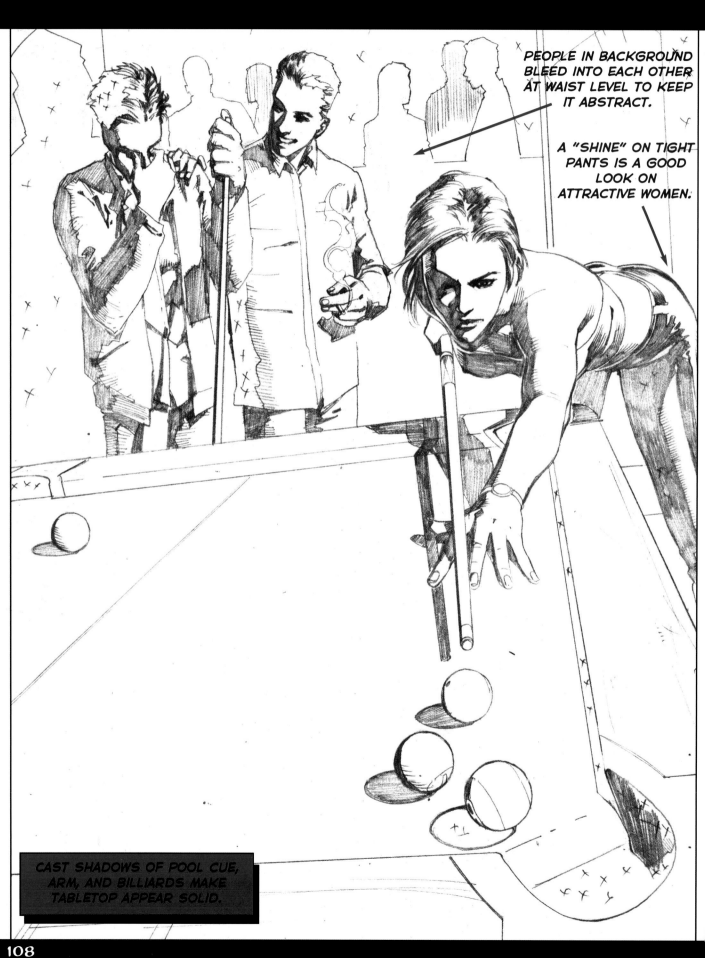

PEOPLE IN BACKGROUND BLEED INTO EACH OTHER AT WAIST LEVEL TO KEEP IT ABSTRACT.

A "SHINE" ON TIGHT PANTS IS A GOOD LOOK ON ATTRACTIVE WOMEN.

CAST SHADOWS OF POOL CUE, ARM, AND BILLIARDS MAKE TABLETOP APPEAR SOLID.

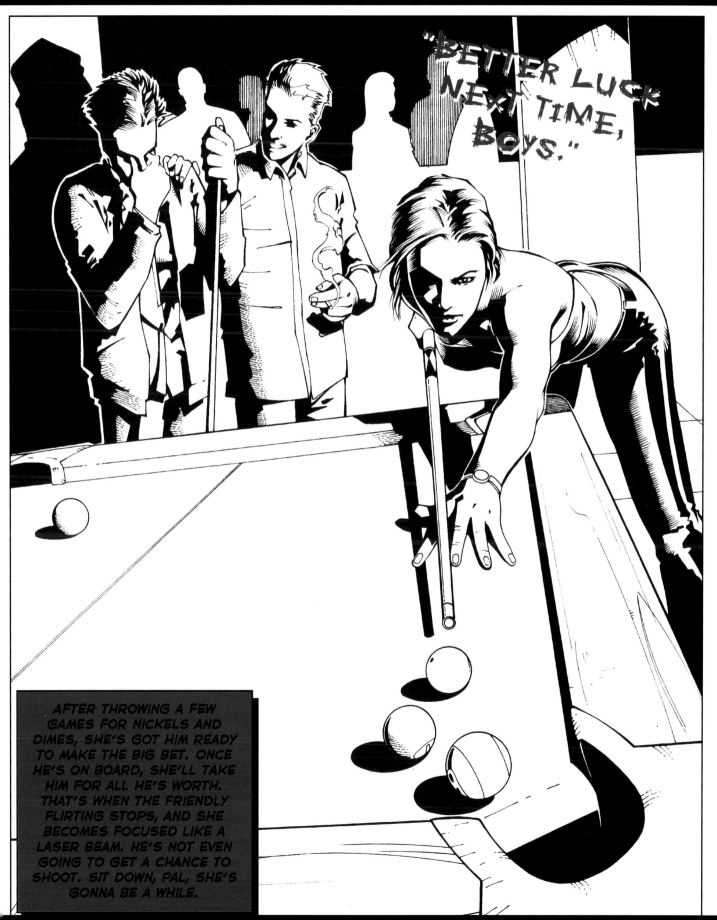

"BETTER LUCK NEXT TIME, BOYS."

AFTER THROWING A FEW GAMES FOR NICKELS AND DIMES, SHE'S GOT HIM READY TO MAKE THE BIG BET. ONCE HE'S ON BOARD, SHE'LL TAKE HIM FOR ALL HE'S WORTH. THAT'S WHEN THE FRIENDLY FLIRTING STOPS, AND SHE BECOMES FOCUSED LIKE A LASER BEAM. HE'S NOT EVEN GOING TO GET A CHANCE TO SHOOT. SIT DOWN, PAL, SHE'S GONNA BE A WHILE.

Sometimes, even a logical argument isn't enough to convince someone that doing something is in his own best interest. That's when you have to offer a little encouragement. By bringing out the hardware. It's amazing how reasonable people become, once they see things from your perspective. Let's make a pit stop for a quick review on how to draw state-of-the art weapons.

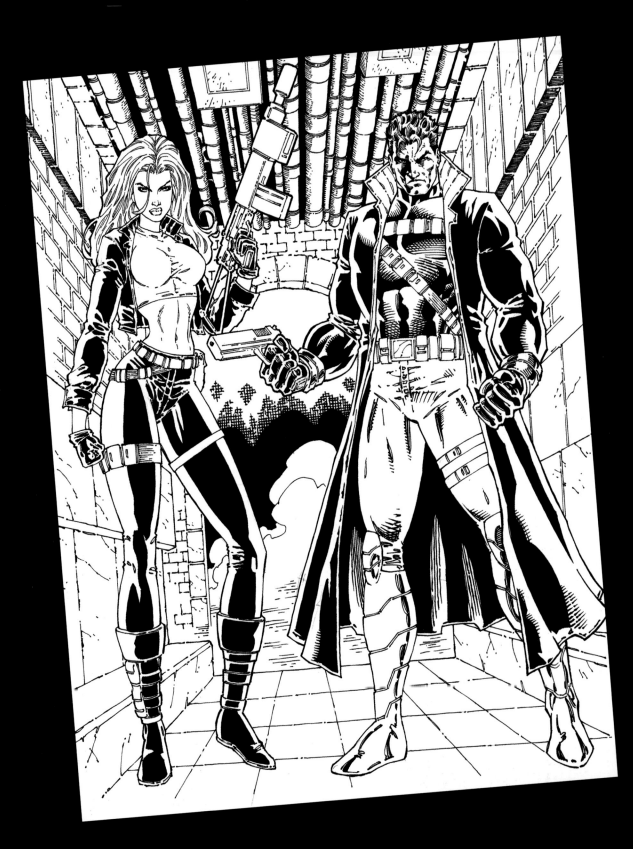

Handguns

Easily concealed inside a jacket or in a lady's purse, a handgun is the most popular weapon. It's light, deadly, and you can ditch it in the river with a simple toss. And you don't have to use it unless things take a turn for the worse. After all, you can't enter the room with an assault rifle and hide the fact that you're armed.

GOES WITH BIG SENSITIVE TYPES

A MUST-HAVE FOR EVENING WEAR

Types of Blasts

The charge from a fired gun makes a design, so don't forget to use it. Here are three of the most popular types:

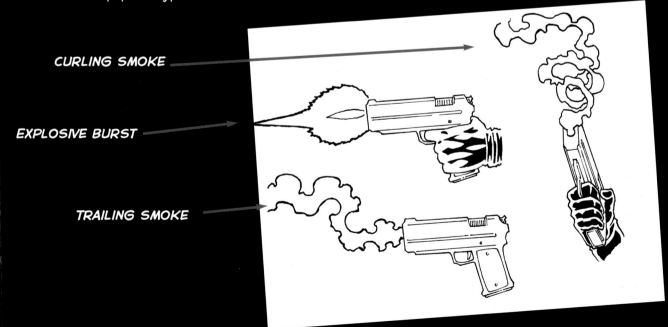

CURLING SMOKE

EXPLOSIVE BURST

TRAILING SMOKE

Big jobs require big guns. And big guys to use them. A guy with this much firepower would be a typical player in a well-organized plan to steal the world's largest sapphire. Probably from a closely guarded museum in Paris, at the height of the tourist season, when they're having a special display. And extra security. Besides money, bad guys love a challenge. Rifles are assembled horizontally, with scopes resting on top of the body of the gun.

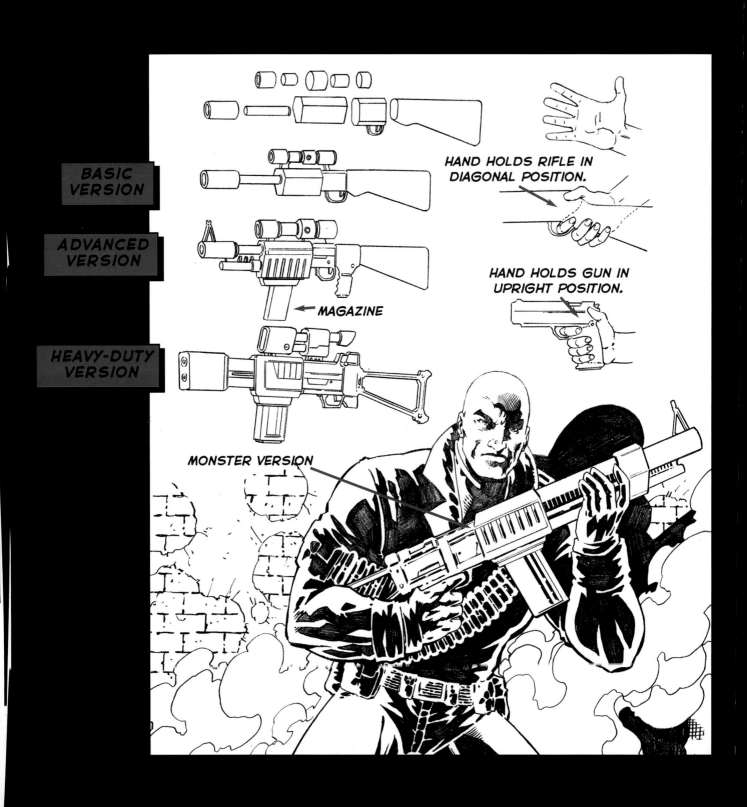

BASIC VERSION

ADVANCED VERSION

HEAVY-DUTY VERSION

← MAGAZINE

MONSTER VERSION

HAND HOLDS RIFLE IN DIAGONAL POSITION.

HAND HOLDS GUN IN UPRIGHT POSITION.

Hit men are very particular about their weapons. It's a sociopath thing. Add modifications to the basic rifle shape to emphasize specific aspects of the gun, as shown in the examples below.

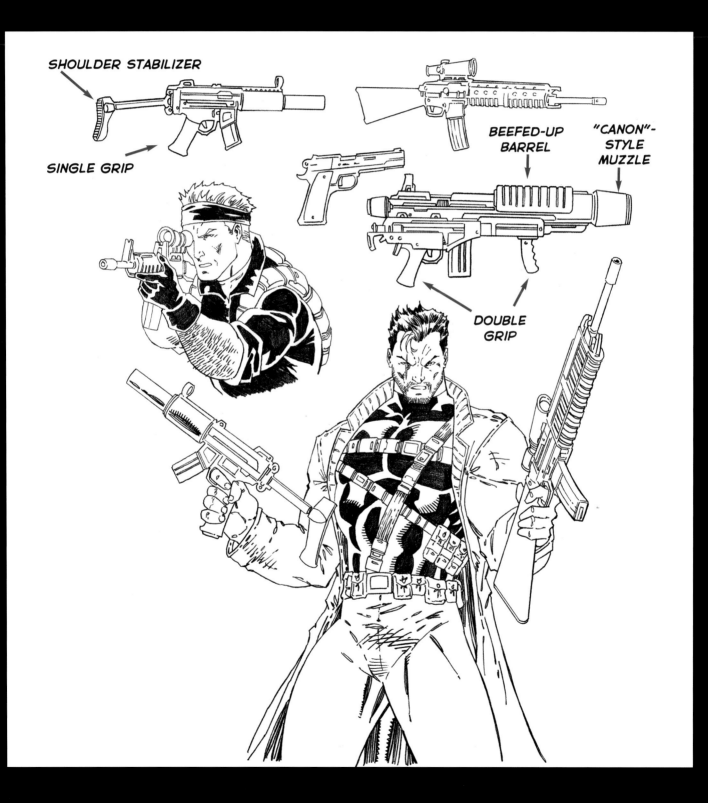

SHOULDER STABILIZER

SINGLE GRIP

BEEFED-UP BARREL

"CANON"-STYLE MUZZLE

DOUBLE GRIP

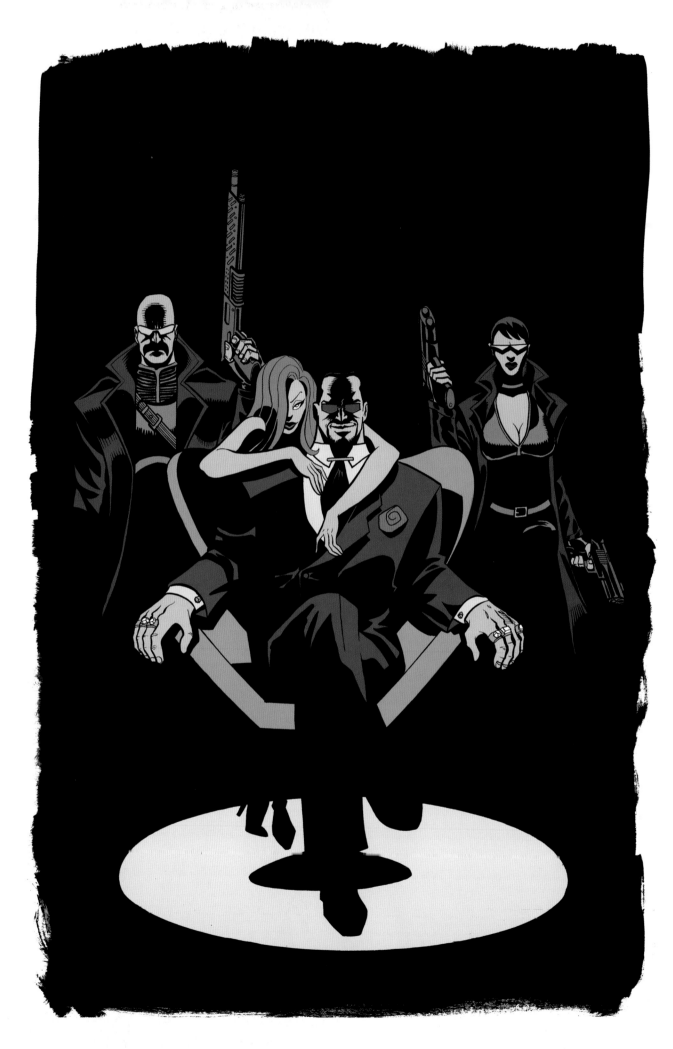

Crime Bosses & Their Minions

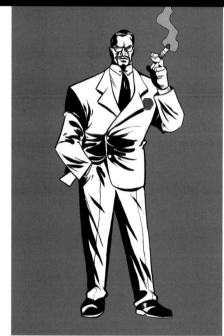

7

If you open the door to your apartment, and see these guys gathered in your room for a surprise greeting, it means they've been thinking about you. And they have something in mind. It's a job. But you thought you retired. Left that life behind, closed the book on it. But you've just been asked to do one more job. This is the one that just might get you killed. The problem is, if you don't take it, you'll end up dead anyway. So all things considered, it's a pretty attractive offer.

Crime bosses prefer to have other people do their dirty work for them. So most of the action in crime noir stories follows the foot soldiers. They're the knock on the door you've been dreading. Let's meet them. Just don't make any sudden moves.

In comics, just as in life, you can tell a lot by the clothes a person wears. A bad guy's clothes reflect his world view: mean, dark, sadistic—sometimes elegantly sadistic, as in the case of the crime boss. Clothes are also designed to intimidate. A guy in a linen suit just doesn't put the fear of god into a mark the same way someone in a trench coat and commando boots does. Now let's take a look at the differences between the action-hero genre villain and the crime noir villain.

In these examples, you're going to see the same character drawn twice: once in the action-hero genre style, and once in the crime noir style. The one point I want to hammer home is that style is not just a bit of flair you add to a basic drawing, the "icing on the cake": Style IS substance. It's the whole enchilada. It's the stuff great characters are made of. They won't tell you that in art school. But then, that's why you read these books, isn't it?

ACTION-HERO GENRE

CRIME NOIR GENRE

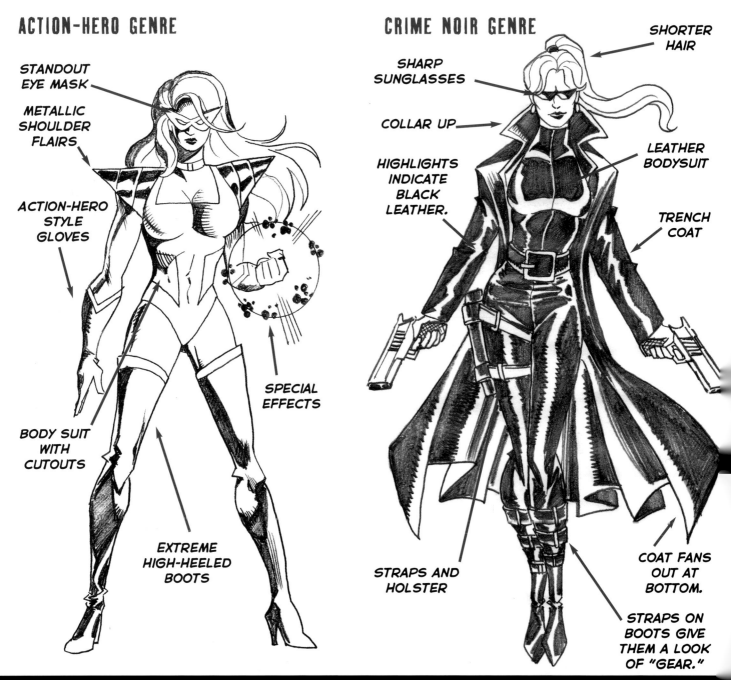

STANDOUT EYE MASK

METALLIC SHOULDER FLAIRS

ACTION-HERO STYLE GLOVES

BODY SUIT WITH CUTOUTS

SPECIAL EFFECTS

EXTREME HIGH-HEELED BOOTS

SHARP SUNGLASSES

COLLAR UP

HIGHLIGHTS INDICATE BLACK LEATHER.

SHORTER HAIR

LEATHER BODYSUIT

TRENCH COAT

COAT FANS OUT AT BOTTOM.

STRAPS AND HOLSTER

STRAPS ON BOOTS GIVE THEM A LOOK OF "GEAR."

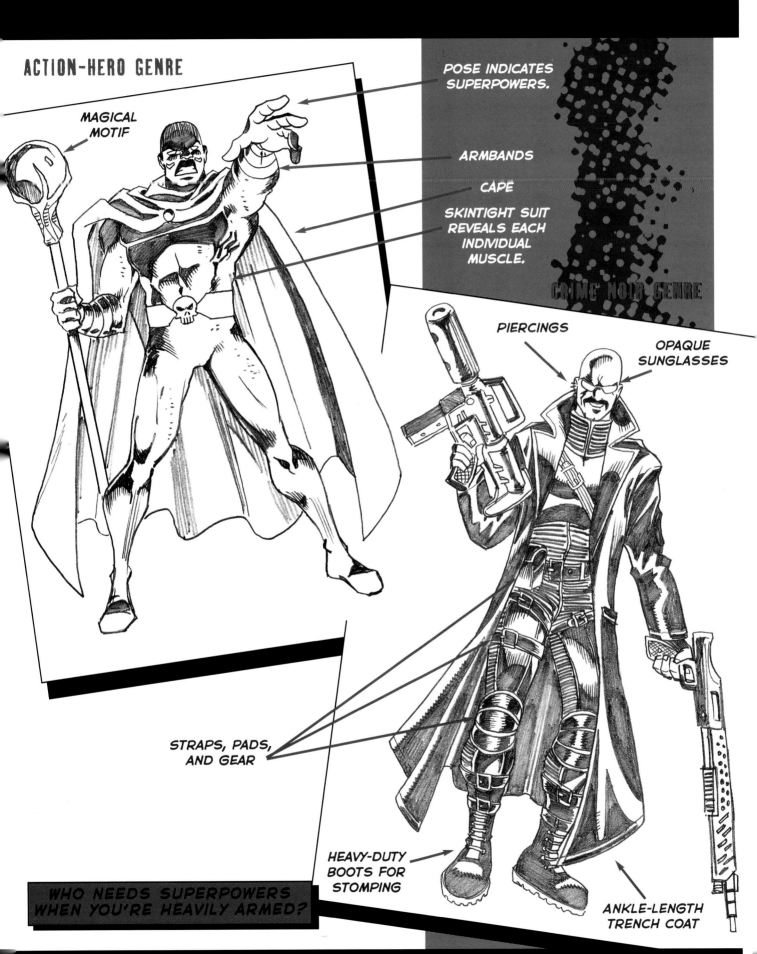

ACTION-HERO GENRE

MAGICAL MOTIF

POSE INDICATES SUPERPOWERS.

ARMBANDS

CAPE

SKINTIGHT SUIT REVEALS EACH INDIVIDUAL MUSCLE.

CRIME NOIR GENRE

PIERCINGS

OPAQUE SUNGLASSES

STRAPS, PADS, AND GEAR

HEAVY-DUTY BOOTS FOR STOMPING

WHO NEEDS SUPERPOWERS WHEN YOU'RE HEAVILY ARMED?

ANKLE-LENGTH TRENCH COAT

ADDING FINISHING TOUCHES

Once you've gotten the basic style down for crime noir villains, the next step is to add the finishing touches. You do this by ratcheting up—or exaggerating—the costume, pose, and expression in order to increase the psychopathic personality of the character. Here are some examples of areas comic book artists look to exploit when fine-tuning a character.

STANDARD NOIR VILLAIN

. . . WITH FINISHING TOUCHES

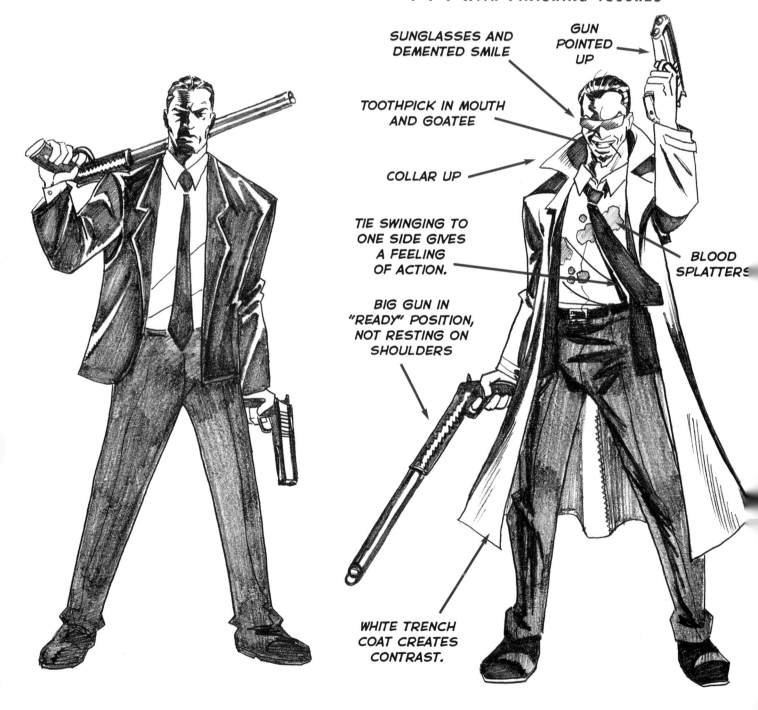

SUNGLASSES AND DEMENTED SMILE

GUN POINTED UP

TOOTHPICK IN MOUTH AND GOATEE

COLLAR UP

TIE SWINGING TO ONE SIDE GIVES A FEELING OF ACTION.

BIG GUN IN "READY" POSITION, NOT RESTING ON SHOULDERS

BLOOD SPLATTERS

WHITE TRENCH COAT CREATES CONTRAST.

You were expecting a guy? How unenlightened of you. If someone needs to be taken out, she's always up for it. If she's in a particularly good mood, she might even throw in a freebie. One look at her posture tells you that she's the best in the business. Today's hit men use two handguns. Always two. It's more dramatic, visually, to see two bursts of gunfire coming from a single character.

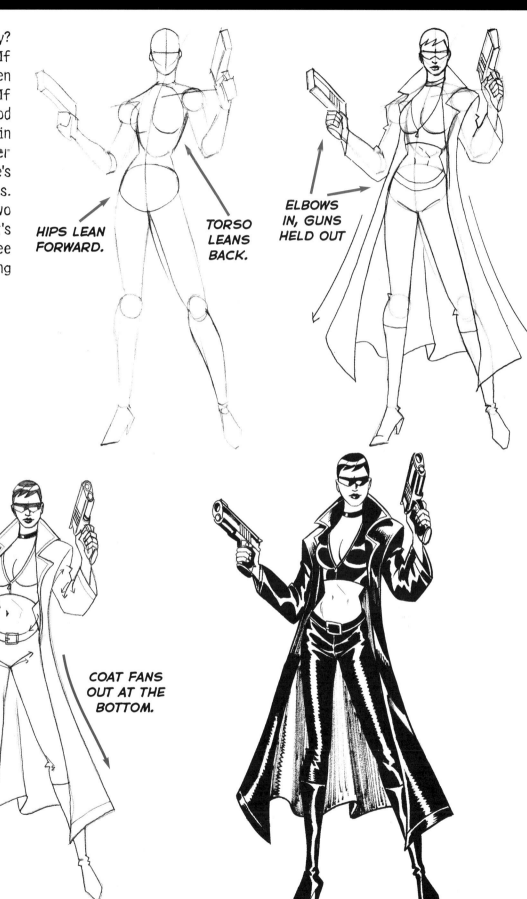

HIPS LEAN FORWARD.

TORSO LEANS BACK.

ELBOWS IN, GUNS HELD OUT

COAT FANS OUT AT THE BOTTOM.

When two hit men, each with two handguns, attack each other, the scene is among the most eye-catching in comics or on the silver screen. Neither character backs up or even dodges bullets, but instead continues to advance toward the other while firing away. Here are some examples of explosive layouts that pit one hit man against another in a deadly duel. The guns are always held out in front, with arms outstretched, toward the opponent.

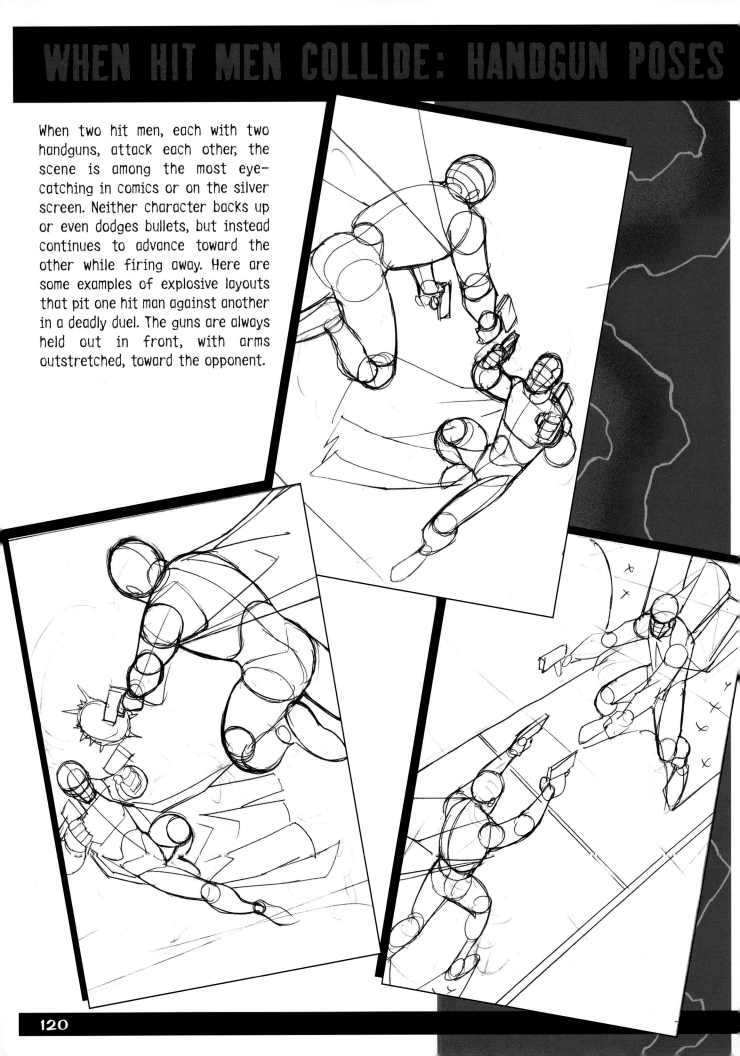

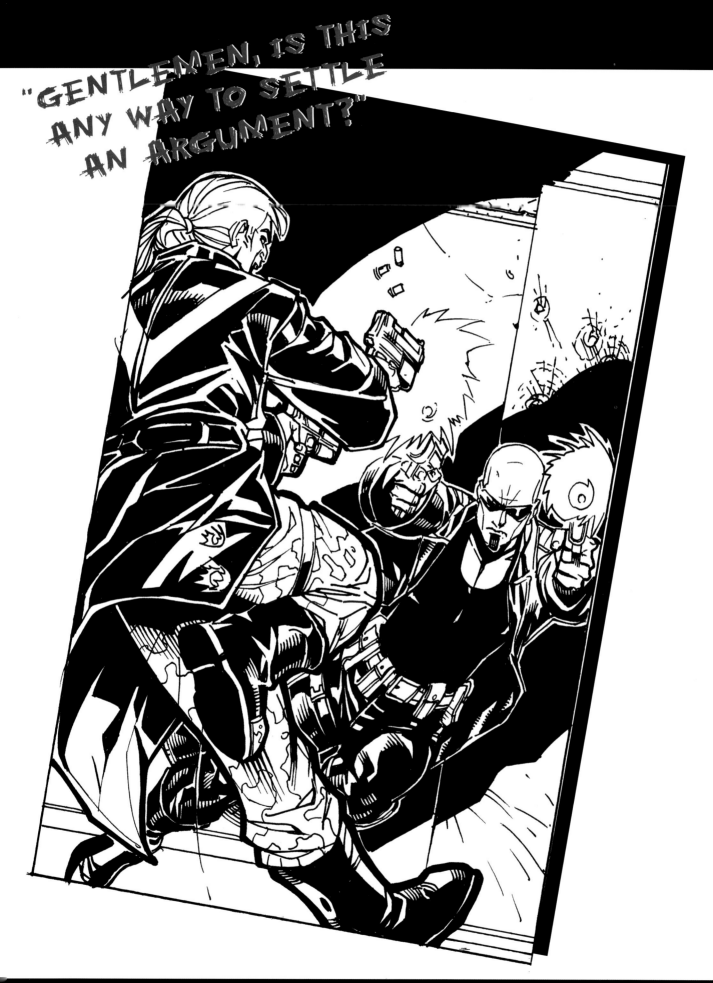

Don't ever cross him. You could steal a million or five bucks, it's all the same to him—it's his money. He holds a grudge. And believe me, you'll feel his pain. He's powerful, both in a physical sense and with the muscle from his organization. His influence extends into all areas of this corrupt city. And if you're smart, you'll leave it that way. The way he likes it. Problem is, guys like me, we're just not that smart. It's my line of work to take him down. And it's his job to stop me.

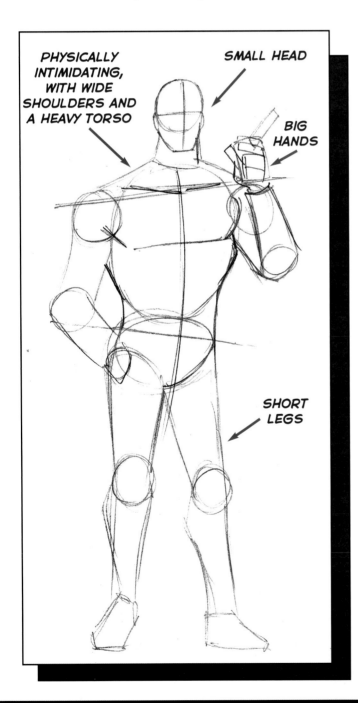

PHYSICALLY INTIMIDATING, WITH WIDE SHOULDERS AND A HEAVY TORSO

SMALL HEAD

BIG HANDS

SHORT LEGS

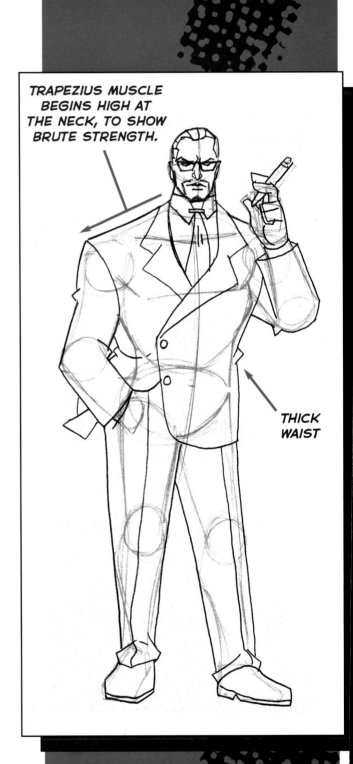

TRAPEZIUS MUSCLE BEGINS HIGH AT THE NECK, TO SHOW BRUTE STRENGTH.

THICK WAIST

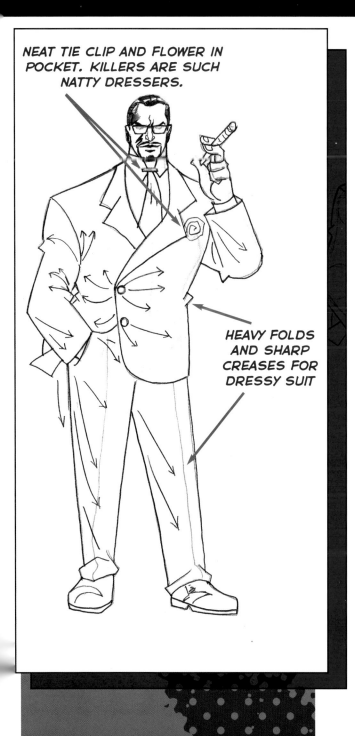

NEAT TIE CLIP AND FLOWER IN POCKET. KILLERS ARE SUCH NATTY DRESSERS.

HEAVY FOLDS AND SHARP CREASES FOR DRESSY SUIT

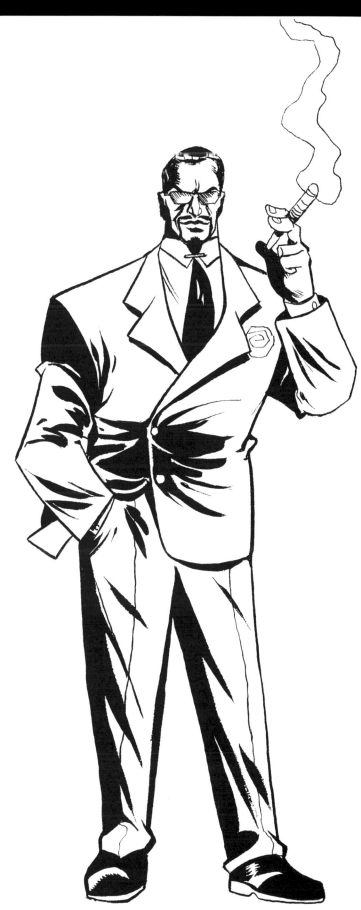

EVIL SCIENTIST

Not all crime noir villains are gunfighters, thugs, or mobsters. Crime bosses are known for having plans to terrorize entire cities. To do this, they need the expertise of a scientist with a background in biology, and a subspecialty in viruses. There are a lot of interesting projects for the right scientist. Not that they would benefit mankind in any way. Unless you were willing to pay to make sure that the experiment never takes place. Say, a few billion dollars?

SCIENTISTS AND OTHER BRAINY TYPES ARE NEVER PORTRAYED WITH ATHLETIC PHYSIQUES.

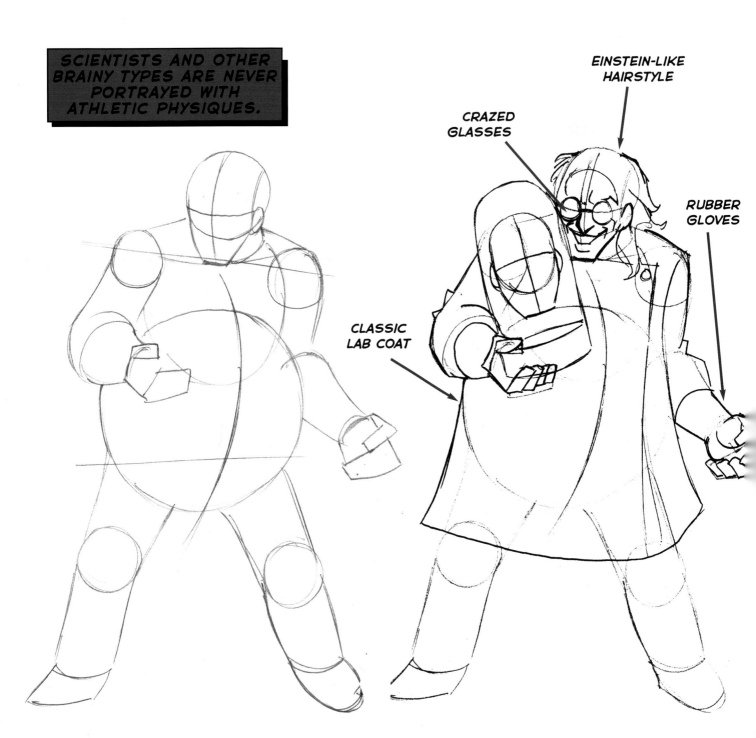

EINSTEIN-LIKE HAIRSTYLE

CRAZED GLASSES

RUBBER GLOVES

CLASSIC LAB COAT

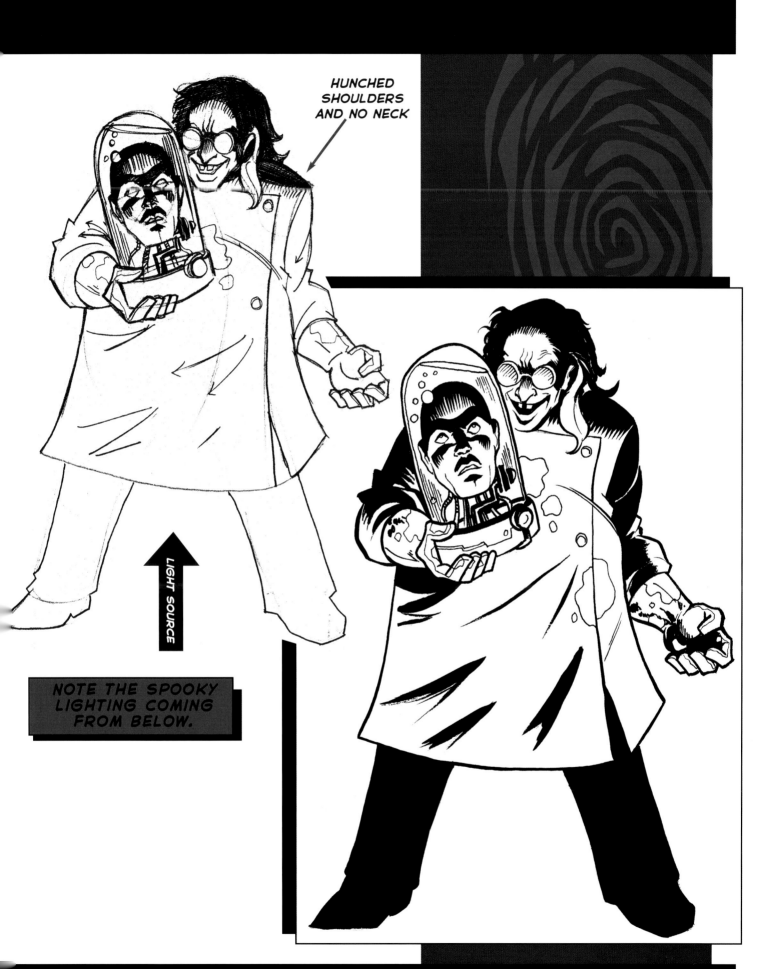

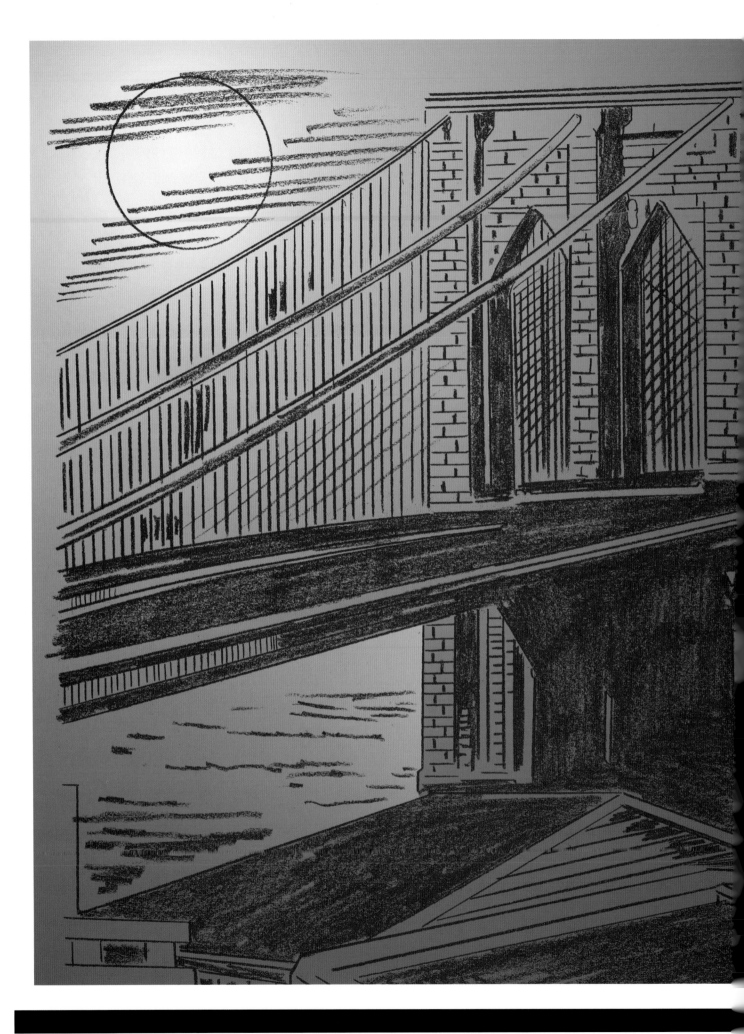

Rainswept Streets & Moonless Nights

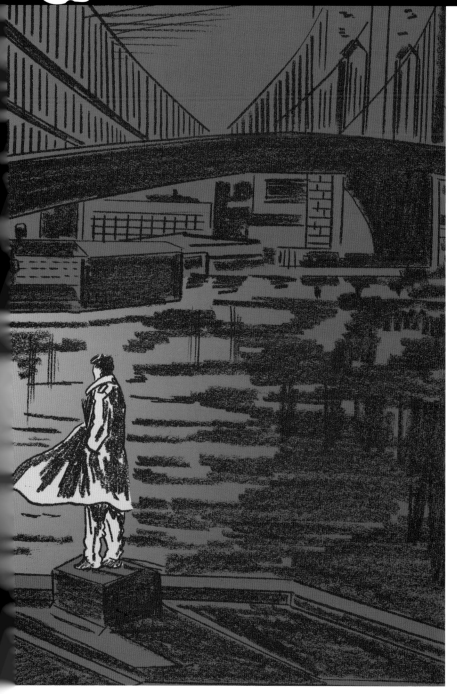

You can set up a noir scene before a character even walks into a panel. And you ought to. Because noir is more than a bunch of characters. It's a world. It's a look at things through a lens that has lost all hope. It may be bright, but it's the glint of sun-baked tiles on the roof of a tenement building. It's the puddles of rain that gather at the feet of busted street lamps that crackle and spark on a stormy night. The newspapers that blow down an empty alley, making you wonder, is it safe to go there? These are the streets of crime noir. These are the streets where our characters live. Home sweet home. Get out your pencil. You're about to lay out the canvas on which your masterpieces will be drawn.

Daytime. Lunch hour. People milling about. This is the city. Midtown in somewhere. Middle-class— maybe a little below, maybe a little above. A mix of white and blue collar. Typical, pleasant. No real mood going on here. Freeze this in your mind. Now we're going to take this exact same street, these exact same buildings, and this exact same angle, and turn it into a crime noir scene.

TRADITIONAL CITY STREET SCENE—DAY

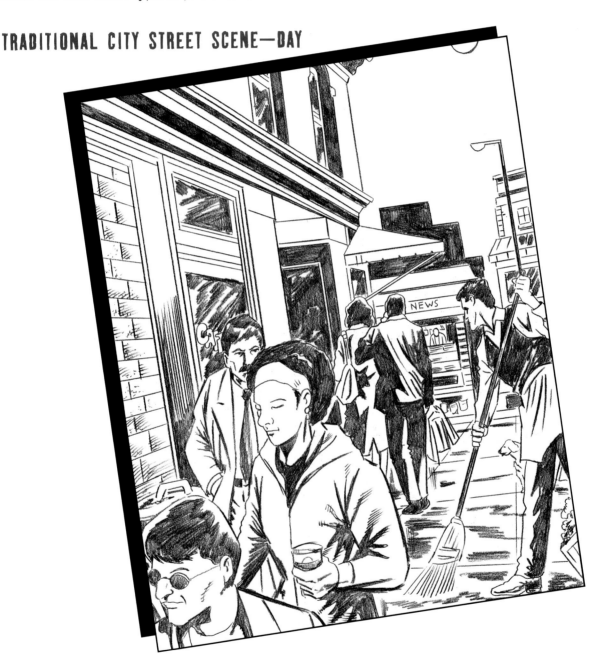

CRIME NOIR CITY STREET—NIGHT

Nighttime. Desolate. Lonely. No awnings. No newsstands. Just rain and dark. And there's a man. On the move. He's going toward an apartment. He's got a job to do. It won't take long. And then it will be over. One more person will be gone and this city won't know the difference....

Notice all the details that tell you this is a crime noir scene: the boarded-up storefronts, the blowing newspapers and trash, the deep shadows, the slashing rain, the slick, soaked streets, the garbage cans, and the cold rain blowing at a severe angle.

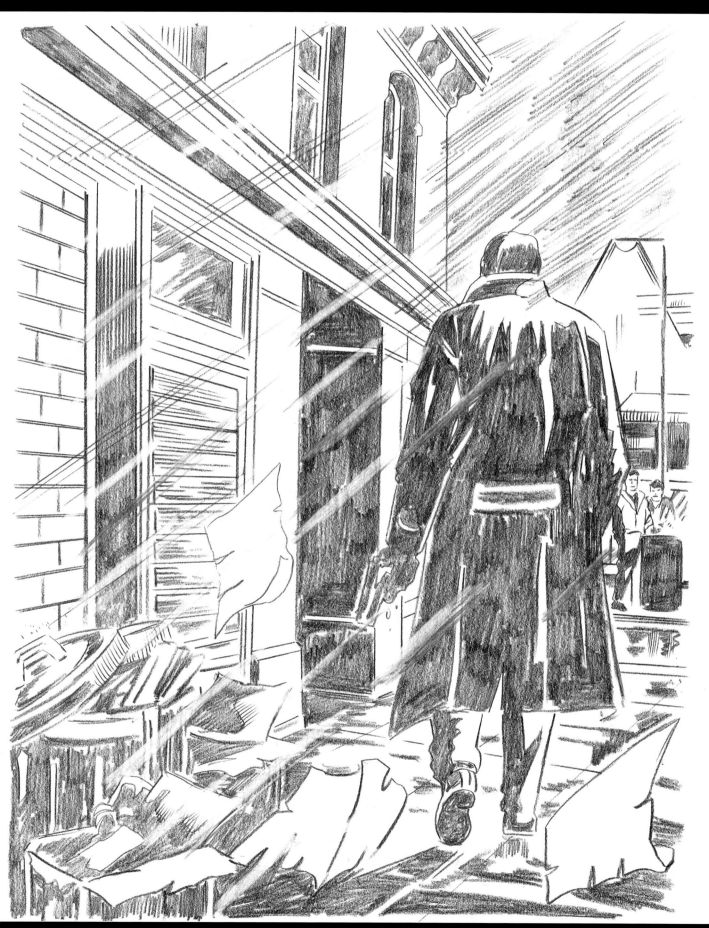

Typically, a mobbed up area of the city. Things that come in and go out have to pay a special tax, and it's not one that goes into the government's coffers. If you don't pay it, you might find an ice pick in your back. But that's at night. During the day, most of what you see going on here is regular shipping business: crates being loaded and unloaded by tough guys. Lots of boxes, netting, and rope.

TRADITIONAL SCENE—DAY

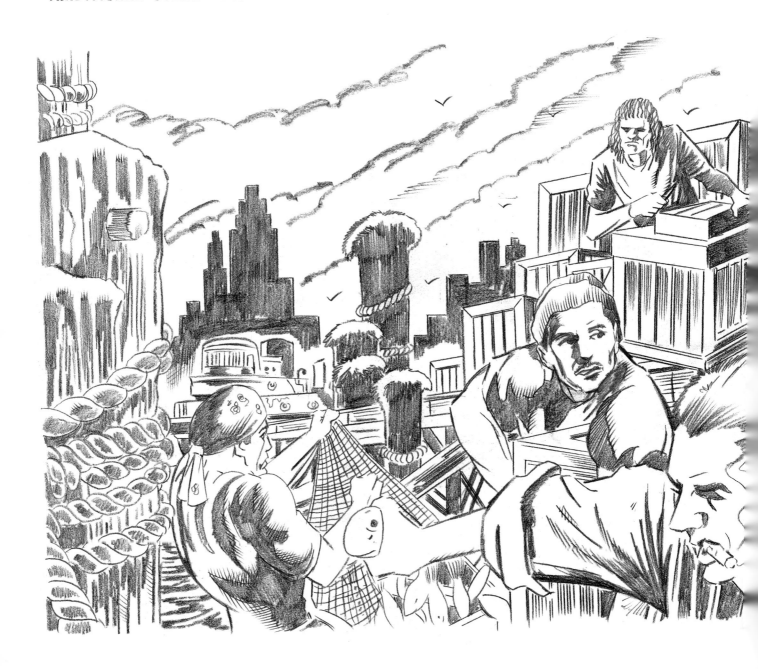

CRIME NOIR AT THE DOCKS—NIGHT

By turning it into an abandoned, nighttime scene, the docks becomes classic crime noir. The chilly waves lap at the pier. This is a place that's seen a few bodies dumped into the harbor. Without the commotion of packing and hauling, there is a haunting loneliness. The mood of murder hangs in the air—and on the crates, where the shadows of two men with guns appear. The pier itself is a metaphor for death. It's a gangplank, a short walk down a dead end. A lonely figure stands out against the horizon. Yeah, that's me, with the suitcase full of cash. That's what they want. It's why they came. It's chilly outside. Raw. That's why my hands are in my pockets. Of course that also happens to be where my guns are. When one of these guys goes to grab the case, that's when I'll make my move.

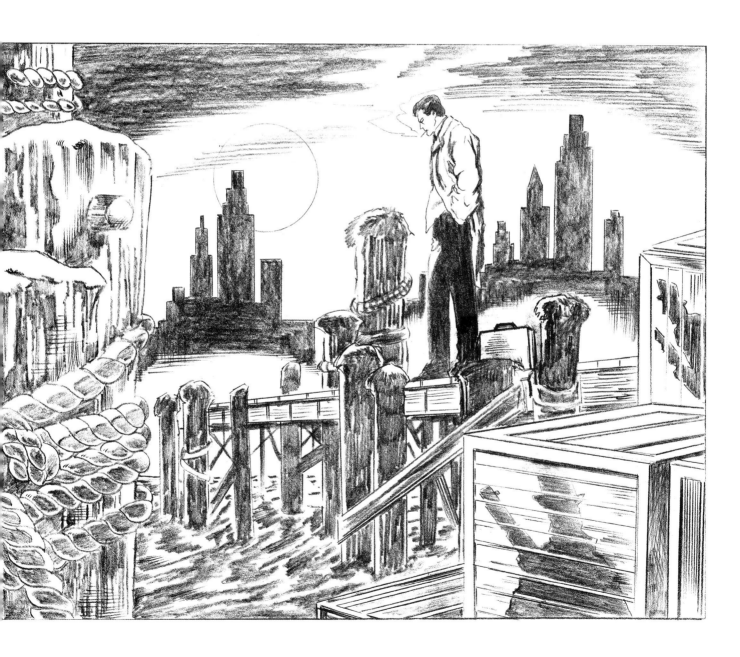

Not all scenes need to be drawn at a distance in order to create an impression of mood on the reader. This is especially true if the mood you're trying to create is one of fear. The rule is: If something bad is going to happen, make it get in your face. I could blab about this some more, but it's better if I just show you. So take a look. I think you'll be impressed by the stark difference being close up makes, versus being at a distance from the character. Perhaps it's a primitive fear of heights, but a scene like this should terrify the audience. If it doesn't, you're not doing it right.

FURTHER AWAY FROM CHARACTERS— LESS IMPACT

Too much room around a character does something odd: It makes him look comfortable in the panel. This produces the opposite effect of your intention.

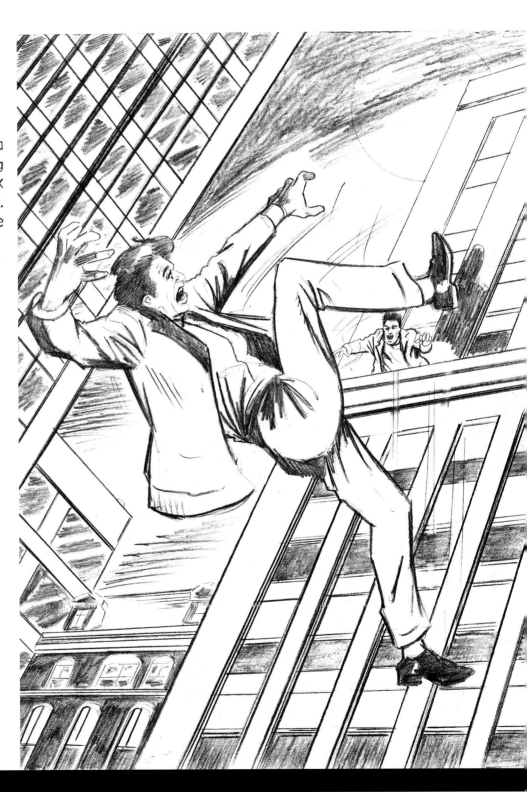

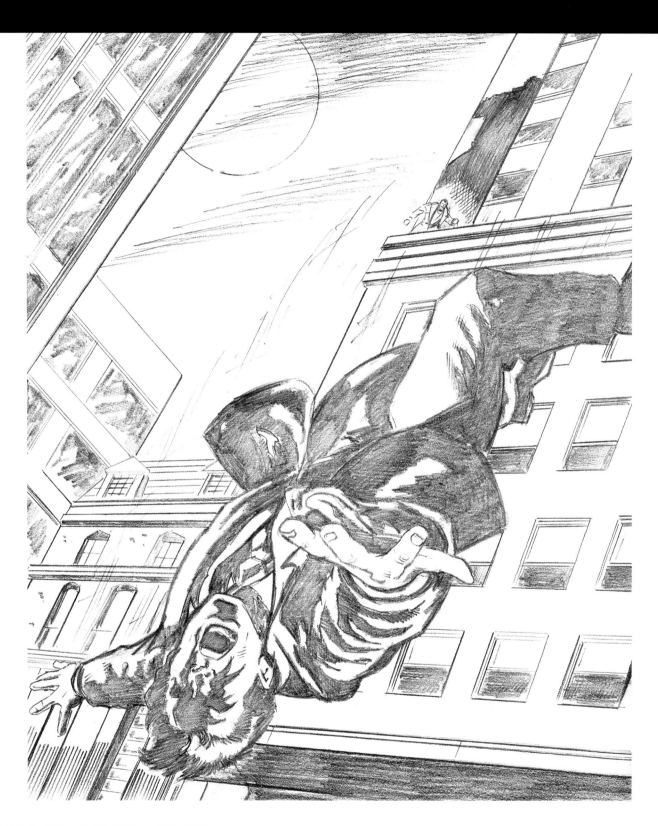

CLOSE UP—GREATER IMPACT

This unfortunate soul is falling toward us headfirst on his way to a rather messy death. He's cramping the borders of the panel. He's also turned in a three-quarter view, which compresses the figure, making it more dramatic than a flat side view, which you can see in the previous drawing. You can feel the terror of the moment. As they say in crime noir, "Oh well. Got a cigarette?"

CLASSIC SCENE: STAGED ACCIDENT

Make it look like an accident. If you've got a swamp nearby, problem solved.

FURTHER AWAY FROM CHARACTERS—LESS IMPACT

If you can't see the terror on the victim's face, then you, as the artist, have let your reader off the hook. Your job is to make your reader squirm. This is a thrill ride on paper, and you've got to milk it for all it's worth.

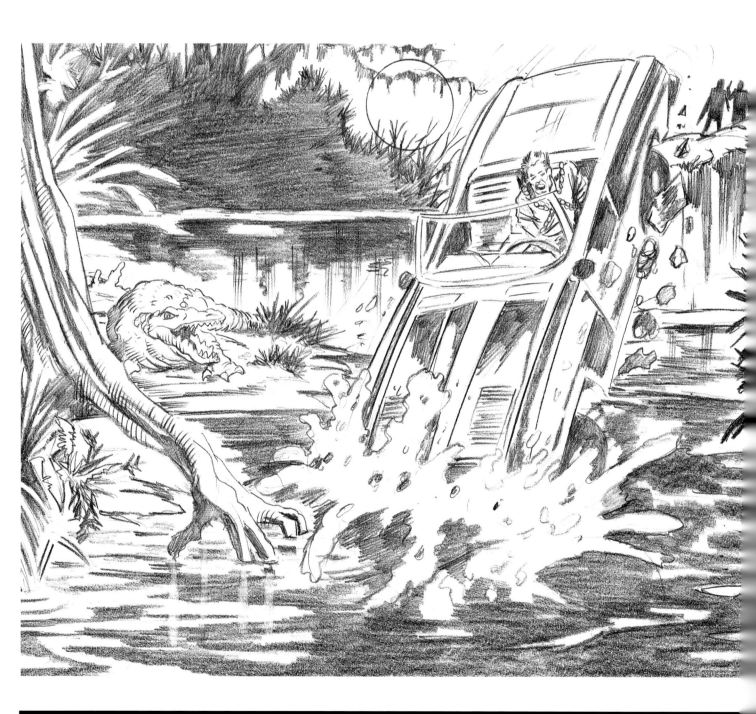

CLOSE UP—GREATER IMPACT

Now we see it: the face, the man, the bound hands. He'll go down struggling. It'll be slow, and it won't be pretty. We won't want to watch it. But we will. We'll watch every second and we won't be able to take our eyes off it until that last bubble rises up from the swampy water and disappears into an ever-widening ring.

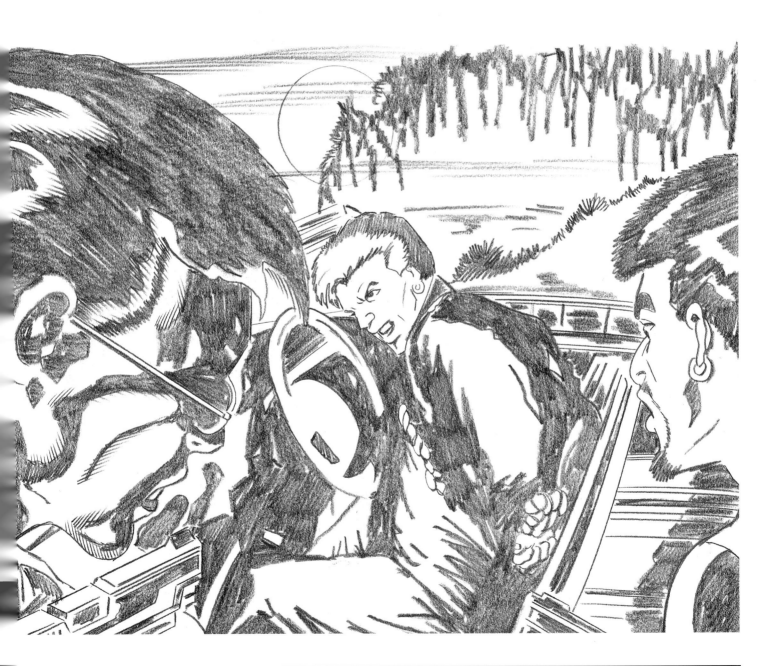

One of the sharpest and freshest looks to come out of graphic novels in the last ten years is the treatment of shadows specific to the crime noir genre. In this new approach, all line work is eliminated so that only the shadows are drawn—the rest is left white. The result is a flat look with an impressionistic feeling, almost a design, rather than an illustration. It is stark, harsh, high concept, and high contrast. Perfect for its subject matter.

FIRST THINGS FIRST

FIRST, SKETCH OUT THE FIGURE, AS YOU WOULD ANY OTHER DRAWING.

LIGHT SOURCE

LIGHT SOURCE

REFINE THE FIGURE, AGAIN, PART OF THE USUAL PROCESS. BUT NOW, BEGIN TO "DOUBLE-OUTLINE" THE AREAS YOU WANT TO HIGHLIGHT WITH WHITE. CHOOSE A LIGHT SOURCE.

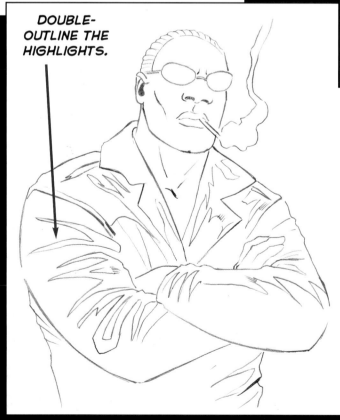

DOUBLE-OUTLINE THE HIGHLIGHTS.

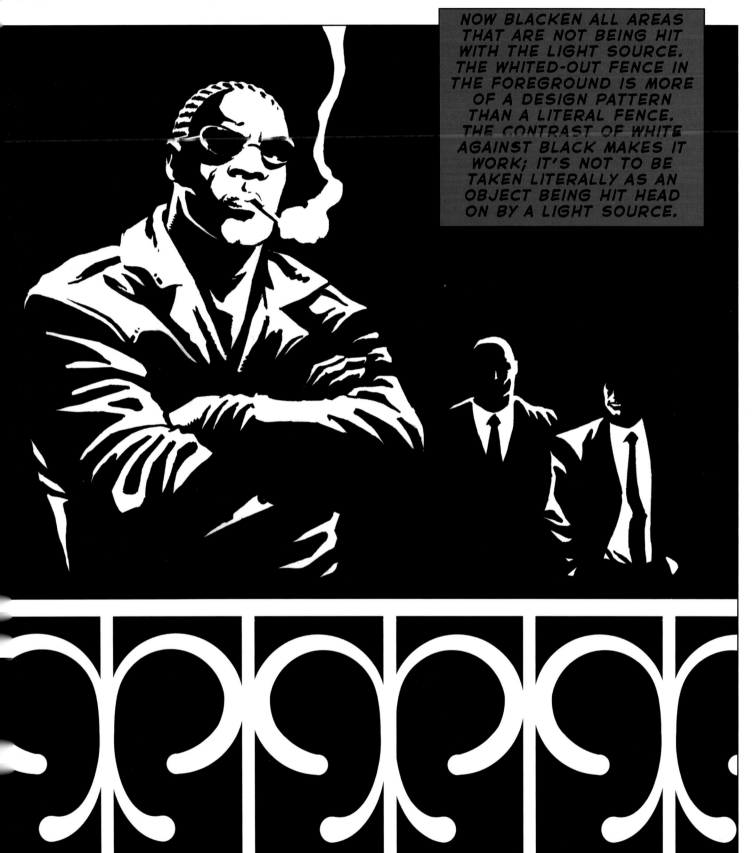

NOW BLACKEN ALL AREAS THAT ARE NOT BEING HIT WITH THE LIGHT SOURCE. THE WHITED-OUT FENCE IN THE FOREGROUND IS MORE OF A DESIGN PATTERN THAN A LITERAL FENCE. THE CONTRAST OF WHITE AGAINST BLACK MAKES IT WORK; IT'S NOT TO BE TAKEN LITERALLY AS AN OBJECT BEING HIT HEAD ON BY A LIGHT SOURCE.

GRAPHIC FIGURES WITH BACKGROUNDS

Backgrounds get the same treatment as the characters. And don't be afraid to pour light on the subject. It doesn't all have to take place in the dark. Throw light on areas the same way you throw shadows. Notice the thin black lines that make up the slats of the wooden floors—hey, sometimes you need to cheat a little and add a couple of lines here and there. It's necessary, because otherwise, the floor would look like a big slab of nothing. But if you begin to rely on line work to define lots of things, you'll blow the whole look. So keep it to a minimum.

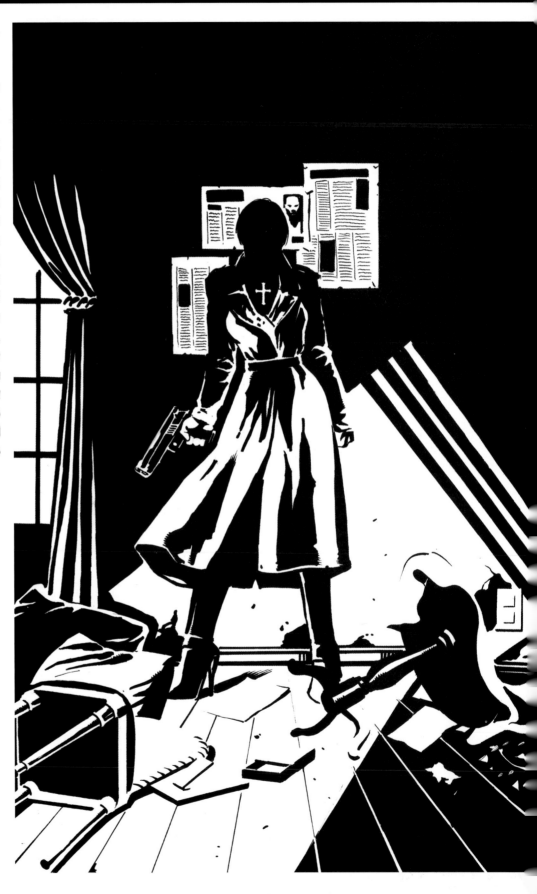

BLACKS INTO BLACKS AND WHITES INTO WHITES

The attractiveness of this look is in how the different objects meld into each other and seem to disappear due to the lack of contrast. Black objects disappear into the blackness of shadow.

White objects lose their features in the glare of whiteness. It creates a tough world, an unforgiving world, a world where good and evil lose their objectivity.

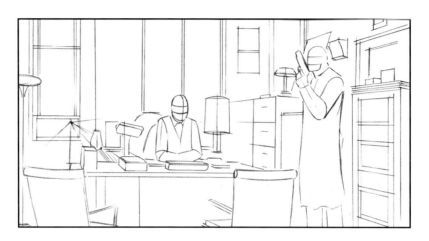

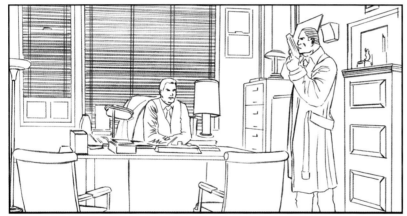

FILE CABINETS BREAK APART IN THE WHITENESS OF THE WALLS.

WALLS, PLANTS, AND BLINDS ALL BLEND INTO ONE.

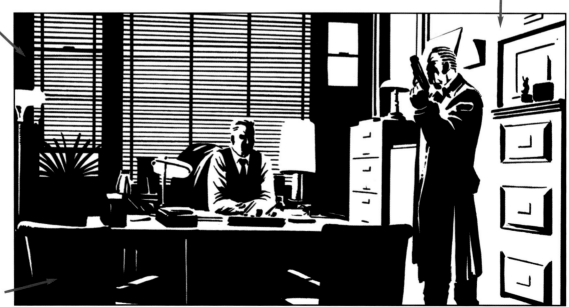

CHAIRS BLEND INTO THE BLACKNESS OF THE DESK.

ALTERNATING SHADOWS TO CREATE DEPTH

The drawing calls for a guy standing in the doorway, a few yards from another guy slumped in the foreground. The scene could be flat. Or it could have depth. Let's make it look like those few yards between them are a hundred miles. Like that walk makes the difference between life and death. How are we going to do that? By laying down shadows, alternating with pockets of light, between them. These pockets of light need to have texture in them, too. Suddenly, those few steps from the doorway to the guy sitting in the foreground feel like they're going to take an eternity.

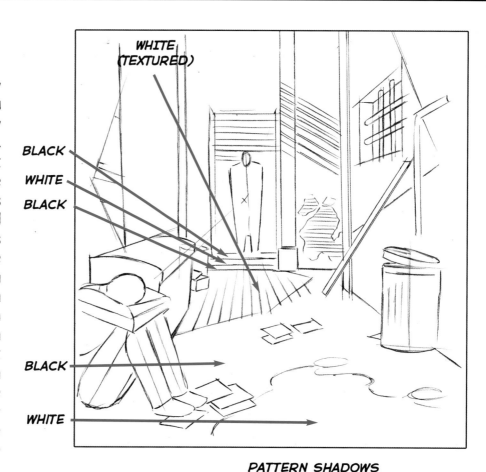

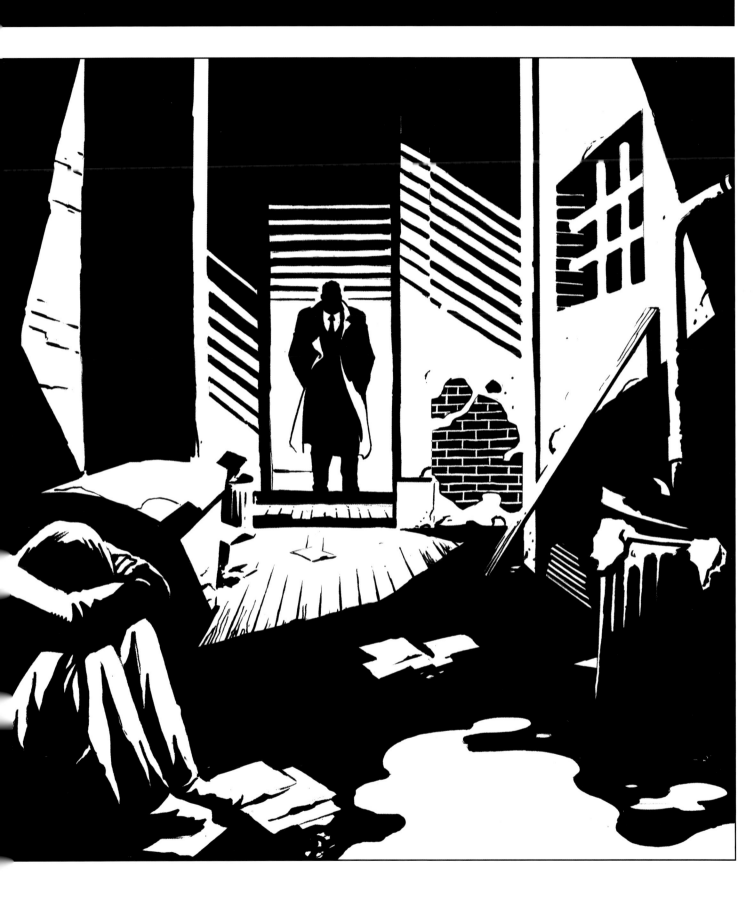

Crime noir is an intense genre. When there's a charged moment, a suspenseful beat, it's time to go in for a close-up. But this genre allows us the luxury of spending more time going in closer, and staying closer, than other genres. For one thing, the reader is generally more sophisticated. Second, that feeling of being too close, that uncomfortable feeling, that claustrophobic panic, well, that's all part of the appeal. It's what makes you sweat, along with the ticking bomb. Here's a spread of consecutive close-ups, each cutting in tighter than the last. There's no room for the reader to breathe. No place to run. You're as trapped as the character is.

TIGHT CLOSE-UPS

And you don't have to draw your close-ups like these. Maybe your sequence ends with a close-up of a gal's lip, as she bites it in fear. Or a close-up of her ear, which only catches a bit of her eye, and which tells the reader that she's overhearing a plan to kill her.

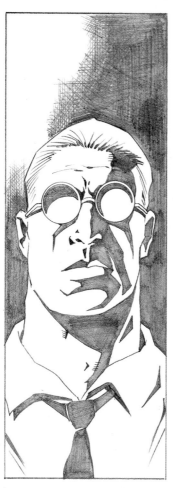
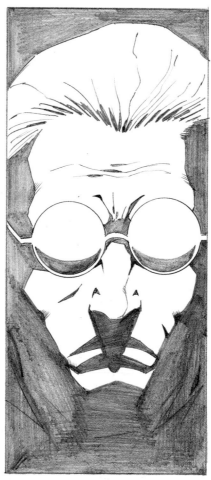

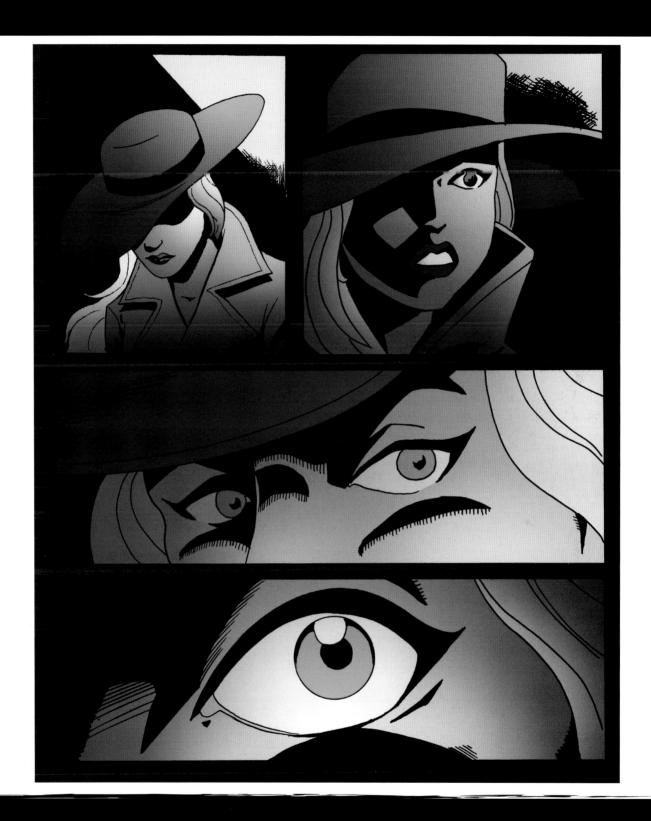

One Last Thing... These things, like everything else in crime noir, are your call. You hear what I'm saying? You're ready to take the helm, to call the shots. All I've done, all anyone can do, is lay out the tools before you. They're good tools, powerful tools. We've walked some tough streets together, you and me. I feel that I know you by now. You're the type who never gives up on a challenge until you conquer it. All I can say is, I hope you use these skills for good, not evil. Because there's a lot of bad out there. And we could use someone like you on our side. So go to it, and good luck. Now get out of here, kid, and don't look back.

INDEX

arms smuggler, 104–106

backgrounds, 76, 78
 graphic figures with, 138
black(s), 99
 contrast of white against, 137, 138, 139, 141
 crystallizing characters and adding, 84, 87, 89
 fading into, 46
 to indicate folds, 25

characters
 actions and, 107
 fine-tuning, 118
 props for, 23, 64, 65
 refining, 83, 86, 88
 traditional versus crime noir, 22–23
city scenes, traditional and crime noir
 (day and night)
 loading docks, 130–131
 street, 128–129
close-ups
 pushed from building, 133
 staged accident, 135
 tight, 142, 143
cops, bad, 95–97
costumed heroes
 brooding, 74
 emotions and expressions of noir-style, 68–72
 inner life of, 76–79
 revealing inner demons of, 72
crime noir
 background of, 7
 heroes in, 49. See also costumed heroes
 streets of, 127–133
 traditional villains versus, 116–118

doctor, mob, 98–100

exaggeration, 118
eyes, 10, 12, 16, 17, 47, 142, 143

faces, 12, 16, 17, 71. See also heads
 the enforcer, 48
 the intense hero, 49
 shading, 47–49
fear, creating mood of, 132, 133, 134, 135
females, 22, 54
 eyes, 16, 17
 heads, 15, 16, 70
 lips, 15, 19
 lipstick and lace, 55
 mobster's girlfriend, 58
 nightclub singer, 56–57
 noses, 16, 18
 poses for, 54, 55, 58, 59, 62–63, 88, 119
 props for, 64, 65

shoulders, 26, 52, 56, 60
 sinful women, 51–65
 working girls, 62–63
figures, 24–27
 female assassin, front and side view of, 26–27
 graphic, backgrounds with, 76, 78
 trench coat guy, front and side view of, 24–25
folds, 103
 indicating, with pools of black, 25
 randomizing patterns of, 28
 and wrinkles, drawing, 28–33
frames, tilted, 77, 79

guns, 52, 60, 61, 86, 92, 104
 big, 25, 112, 113
 in handbag, 64
 hands mimicking shape of, 54
 lowered, 88
 poses for, 120–121
 positions of, 118, 119
 sex appeal and, 55
 types of blasts from, 111
 upside-down, 83

heads, 10, 11, 15, 16, 69, 70. See also faces
high heels, 26, 53, 54, 55, 65, 116
highlights
 double-outlining, 136
 pocket of, for eyes, 47
 for tight clothes, 27, 33, 108

inkers, 82, 84, 85, 105
inks, 85, 87. See also black(s)

lawyer, mobbed-up, 101–103
layout, 136–141
light sources, 38, 58, 105, 125, 136
 from above, 44
 from behind, 45
 from below, 40, 41
 for shading faces, 48
 shadows and, 36, 37
lips, female, 15, 19

males. See also characters; costumed heroes; poses
 eyes, 10, 12
 heads, 10, 11, 69
 mouths, 14
 noses, 13
Mr. Big, 122–123

noses, 13, 18, 71
 male versus female, 16

pawnbroker (aka "the fence"), 92–94
pencilers, 82, 84, 85, 105

pool shark, 107–109
poses, 122
 brooding costumed hero, 74
 for females, 54, 55, 58, 59, 60, 61, 62–63, 88, 119
 handgun, 120–121. See also guns
 indicating superpowers, 117
 primal scream, 73

reverse angle, 79

scenes
 ambush, 86–87
 blocking out, 82–89
 classic, 132–135
 mugging a mugger, 82–85
 my personal hostage, 88–89
scientist, evil, 124–125
shadows, 87, 93, 96, 99, 105, 108
 alternating, to create depth, 140–141
 blocking out, 52
 body trailing off into blackness of, 46
 cast from features, 49
 classic noir patterns of, 102
 "correct" versus graphic, 38–39
 for eyes, 12
 in front of figures, 37
 hardened expressions awash in, 72
 lengthening, for mood and power, 36–37
 light sources and, 36, 37, 40, 41. See also light sources
 merging, 47
 objects disappearing into, 139
 patterns on walls and other stuff, 41
slash, 89
small, on faces, 47
 on textured surfaces, 42–43
 treatment of, specific to crime noir genre, 136
silhouettes, 38
 partial, 44–45
strength, depicting, 36–37, 122–123
sunglasses, 54
 men's styles, 13, 20
 opaque, 117, 142
 women's styles, 16, 21
 worn indoors, at night, 57

teeth, drawing clenched, 69
torso twist, 31
twinning, avoiding, 60

weapons, 86, 96, 106. See also guns
 drawing state-of-the-art, 110–114
 variations on, 113
whiteness, glare of, 139

144